776 CD7
£17.95

T

**Books are to be returned on or before
the last date below.**

1 2 NOV 2004

2 2 DEC 2004

-3 FEB 2005

2 1 FEB 2005

2 4 FEB 2012

WITHDRAWN

LIBREX —

D1424126

DIGITAL
SCI-FI
ART

A STEP-BY-STEP GUIDE TO CREATING STUNNING, FUTURISTIC IMAGES

Michael Burns

ILEX

First published in the United Kingdom in 2004 by
ILEX
The Old Candlemakers,
West Street,
Lewes,
East Sussex,
BN7 2NZ
www.ilex-press.com

Copyright © 2004 by The Ilex Press Limited

This book was conceived by
ILEX, Cambridge, England

Publisher: **Alastair Campbell**
Executive Publisher: **Sophie Collins**
Creative Director: **Peter Bridgewater**
Editorial Director: **Steve Luck**
Editor: **Stuart Andrews**
Design Manager: **Tony Seddon**
Designer: **Jane Lanaway**
Artwork Assistant: **Joanna Clinch**
Development Art Director: **Graham Davis**
Technical Art Editor: **Nicholas Rowland**

Any copy of this book issued by the publisher as a
paperback is sold subject to the condition that it shall
not by way of trade or otherwise be lent, resold, hired
out, or otherwise circulated without the publisher's
prior consent in any form or binding or cover other
than that in which it is published and without a similar
condition including these words being imposed on a
subsequent purchaser.

British Library Cataloguing-in-Publication Data
A catalogue record for this book is available from the
British Library

ISBN 1-904705-32-4

All rights reserved. No part of this book may be
used or reproduced in any form or by any means –
graphic, electronic, or mechanical, including
photocopying, recording, or information storage-and-
retrieval systems – without the prior permission of the
publisher.

Printed and bound in China

For more on Digital Sci-Fi Art visit:
www.scfiuk.web-linked.com

Contents

1 Introduction

2 Light Sabres at the Ready

3 Playing God

4 The Gallery

Introduction

Science fiction is a hot topic for digital artists. The breadth and quality of the artwork in this genre is astounding, and more exciting work is being created every day. In this book, you'll see digital art inspired by all manner of science-fiction themes as well as some of the techniques used to create it. No matter what the subject, it's the ability and imagination of the artist that makes the difference between great science-fiction art and derivative or poorly executed fan pictures. Developing these powers is what this book is all about.

The book is divided into four chapters. The first introduces the inspirations that have fed digital sci-fi art, offers a brief history of the genre and takes a look at the principles behind the major 2D and 3D graphics applications. As there is a wealth of software available, it would be overwhelming to cover all products, so what follows is a select overview of the market. The chapter also includes images created in the most popular or representative of the 2D and 3D applications, annotated with tips and information about the software used. In some cases, a full step-by-step workthrough is included, designed to show what these applications can do in the hands of a skilled artist.

The following chapters cover the techniques used in creating sci-fi art and explore the central themes of the genre. Finally, the gallery features the work of some of the best digital sci-fi artists around, including many of those who share their methods within this volume. You'll also find a list of resources to take you further into the artistic world of tomorrow.

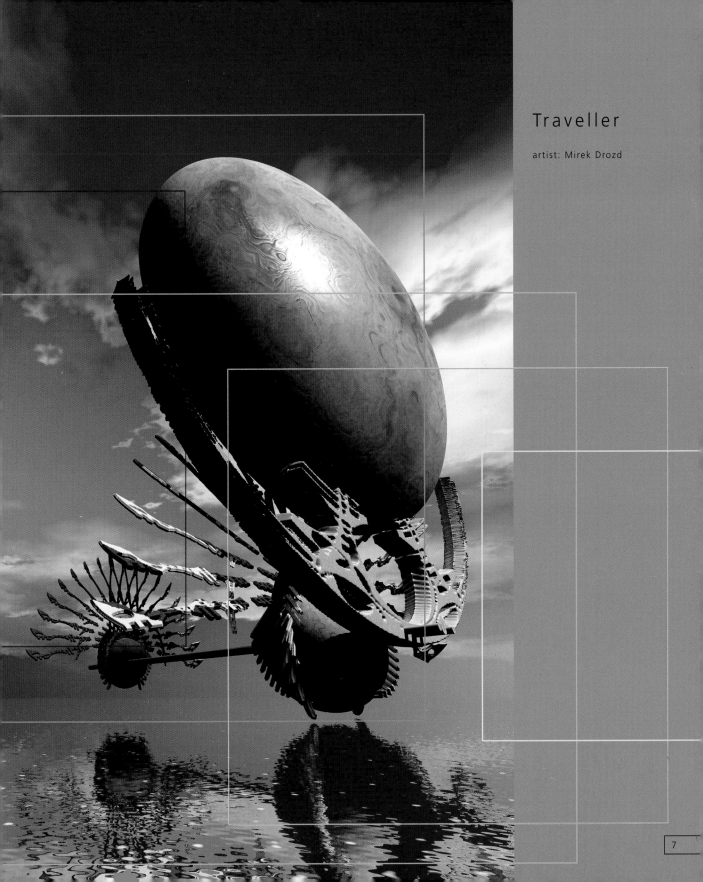

Traveller

artist: Mirek Drozd

The Digital Sci-Fi Artist

Science fiction goes hand in hand with digital content creation. Most of the software in this book has – in some part – derived from the computer graphics technology used for years in science-fiction film visual effects. It's not surprising, then, that the style and imagination shown in *Star Wars*, *Blade Runner* and *The Matrix* have inspired artists to come up with ways of bringing their wildest science-fiction visions to life in the digital domain.

VISIONS OF THE FUTURE

The artists in this book have all been heavily influenced by science fiction in the cinema. A truly international medium, sci-fi films have a long and venerable history. Films like *Metropolis* and *The Shape of Things to Come* were based on social commentary, yet they fired the imagination of artists, writers and film-makers of the day, and their influence is still being felt now. These grand cityscapes were echoed in later films, notably the seminal *Blade Runner*, and in modern sci-fi images such as Robert Czarny's *The Plant* (*see page 144*) or *Megastruktur Komplex* by Frank Meinl (*see page 155*).

The 'flying saucer' films of the 1950s and 1960s also left an indelible mark on popular culture, and consequently the imaginations of artists. Science fiction often looks back on itself – usually with a quantity of nostalgia or irony – and you can feel the presence of these earlier works in films as recent as *Independence Day* and *Signs*, while a great example of the genre can be seen in *Visitors* by Mirek Drozd on page 153.

The 1960s saw the first series of *Star Trek* in the USA, a concept that would go on to spawn several films and new versions on television up to the present day, as well as a host of imitations. When films like *2001: A Space Odyssey* and, of course, *Star Wars* arrived, the genre gained a definite new look, with more realistic spacecraft and believable future technology. After *Star Wars*, it seemed that every film featured a giant spaceship filling the screen with laser fire. Long confined to the pages of books by authors such as Robert A. Heinlein, Edward E. Smith, Larry Niven and Frank Herbert, future warfare had arrived in a big way. Countless pieces of sci-fi artwork feature futuristic battle scenes – there are more than a few such examples in the gallery – and this is reflected in the several pages devoted to the genre later on.

Sci-fi can explore more 'individual' themes too, in books by Philip K. Dick, Michael Moorcock, Thomas M. Disch, Robert Silverberg and Ursula Le Guin, or in the UK with TV serials like *Doctor Who* and *Blake's Seven*. Artists too breathed life into adventurers and exotic humanoids and featured them in fantastic settings. In this book, Ian Grainger's artwork (*see page 140–141 and elsewhere*) seems to offer a new story every time you revisit it, but his are just examples of the many narrative-driven works to be found in the following pages.

Asteroid

artist: Armin Schieb
software used: Cinema 4D by Maxon

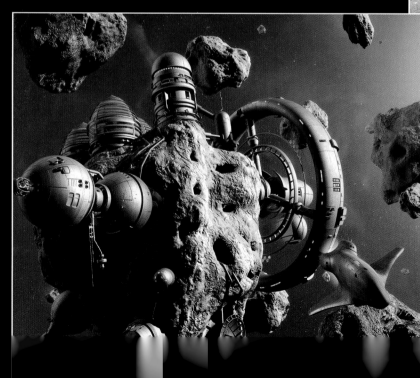

BRAVE NEW WORLDS

Back in the movie world, *Alien* arrived to update the killer creature trend in the sci-fi story in a big way. Its visual design, and that of its sequel, *Aliens*, has been hugely influential on futuristic design ever since. Coming full-circle, the major sci-fi serial of recent times, *The X-Files*, is based on conspiracy and alien abduction concepts rooted in the UFO films of the 1950s and 1960s. Another favourite subject, extra-terrestrials, can come in all shapes and sizes. The super-intelligent aliens of Jerry Potts, for example (*see pages 104–105*) resemble giant versions of the ancient sea creatures of our own world.

Alien also paved the way for the cybernetic killers of *The Terminator*. While not always homicidal, robot characters feature heavily in the work of the artists in this book. Adam Benton's inquisitive mechanoids on pages 134 and 135 are an example, as are *The Charathian Minder* by Glen Southern (*see pages 98–101*) and the hyper-real "nannybot" *Cody* by Henrik Boettger and Max Zimmerman at FiftyEight 3D (*see pages 94–97*).

Science fiction is an international movement and many excellent concepts, themes and stories have come from authors not writing in the English language – the word robot was famously coined by the Czech playwright Karel Capek, the *Perry Rhodan* series is wildly popular in German-speaking countries, the Polish SF writer Stanislaw Lem is popular almost everywhere, and the Frenchman Jules Verne is rightly hailed as the father of science fiction for his novels *Journey to the Centre of the Earth* and *20,000 Leagues Under the Sea*. It's plain to see as you continue on through *Digital Sci-Fi Art* that all of them have influenced many of the artists in this book.

GRAPHIC REVELATIONS

Another form of literature has also played a major part in the formative years of digital science-fiction art. Comic books and strips dealing with science-fiction themes have always been popular – one only has to look at the preponderance of futuristic themes in offerings by America's D.C. and Marvel groups in the 1960s, while *Barbarella* and *Dan Dare* are just two of a large number of European comic characters to appear at around the same time. The UK comic scene, and interest in science fiction in general, was revitalized in the mid-1970s by the launch of *2000 AD* – a ground-breaking title that introduced the world to futuristic lawman *Judge Dredd*, among others. The comics world has since exploded, making this a whole subject to explore on its own, and one that we can only delve into slightly in the final section of this book, with the excellent tutorial by Sean Ellery (*see pages 128–129*) and his gallery contributions.

A new medium that is also becoming highly influential to science-fiction artists is computer gaming. Best-selling titles use concept artwork by artists such as Mark Gibbons (*see pages 36–39*) in an effort to create a distinctive visual look. This in turn motivates others to take up the pen and graphics tablet. When the same 3D applications – Discreet's 3ds max, for example – are used to create the games and the sci-fi artwork inspired by them, this is one genre that is sure to provide much inspiration for artists in the future.

Finally we must recognize the inspiration provided by the sci-fi artists of the past – those men and women who illustrated book jackets, record covers and film posters armed only with an airbrush and their imagination. The digital artists in this book may be using different methods, but they are their rightful successors.

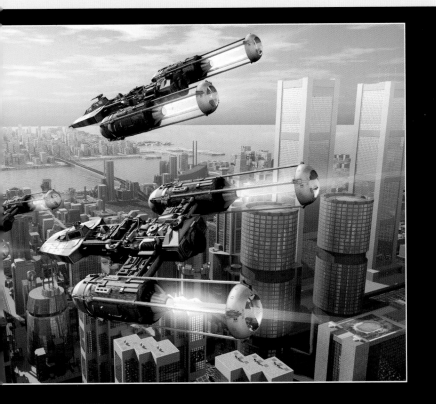

Guardians

artist: Robert Czarny
software used: Vue d'Esprit by e-on Software

Creating Artwork in 2D

The first tool many digital artists start with is the free paint package bundled with their operating system. Later, they may move on to complex software applications capable of producing high-quality works of art, complete with natural media tools and photorealistic manipulation features, but they'll still follow the same principles learned in their first humble 2D graphics program. It is perhaps this continuity that makes 2D software so popular among digital sci-fi artists – that and the similarity between this type of application and traditional painting techniques.

2D applications basically fulfil the following functions: drawing, painting and image editing. The first two are self-explanatory – methods that have made the transition from the analog world of watercolours, oils and pencils to the digital, with the added bonus that you can quickly erase errors and don't have messy brushes to clean up afterwards. The third is more wide-ranging, bringing in techniques from photography, video and 3D applications. Image editing encompasses everything from adding special effects to a scene, raising contrast and adjusting colour, adding blur or depth of field to the frame, to just filling in the gaps in an image rendered from a 3D application.

TECHNOLOGY

The science behind 2D graphics is enough to fill most of this book, but there are basically two ways of representing images on the screen. Some applications use vector graphics: outlines of shapes created with lines and curves and filled with a colour or pattern. Applications based on image editing commonly use bitmap graphics, which are made up of a grid of tiny coloured dots placed on the screen by the computer as the artist works. These dots are called pixels (shorthand for picture elements), and when viewed on the computer screen, they appear as a continuous tone image. When an artist applies 'paint' to an image using a digital brush to hide a spot or change the colour of someone's eyes, he or she is really changing the pixels in the bitmap image.

Pixels are the key to computer graphics, and the way they are displayed on the monitor is one of the biggest factors to affect the overall quality of the image. The more pixels that an image contains, the more of them can be squeezed into a one-inch grid on the screen, and the clearer and more natural the image becomes – we call this the image's resolution. A low-resolution image looks blocky and unclear, while a high-resolution image appears crisp and sharp.

To apply the paint and manipulate the digital tools, the designer uses a mouse or graphics tablet. The latter is a pressure-sensitive board and pen that closely replicates the use of a paintbrush, or more commonly, an airbrush.

APPLICATIONS

If 2D graphics software has a reigning champ, then it is Adobe Photoshop: an application used by almost every artist in this book. We'll devote more time to Photoshop later, but for now, here's a quick overview of some of the other packages out there.

GIMP (GNU Image Manipulation Program) is a freely distributed image-editing application with advanced scripting. Often compared with Photoshop but lacking the hefty price tag, GIMP is widely used by artists. It has a full suite of painting tools, including brushes, pencils, airbrushes and a clone tool.

Some software applications let designers paint using a variety of natural materials, all replicated by the computer. Corel Painter, for example, has a whole digital palette of substances including watercolour paint, ink, airbrushes, chalk and crayon, as well as some weird materials, like liquid metal and a brush (the *Image Hose*) that can spray seashells

Painting Tips

According to commercial artist Roberto Campus, a good sense of observation and self-criticism are two of the key requirements for the painting process. While he paints, Campus often flips the canvas horizontally (in Photoshop, this would be under *Image* > **Rotate Canvas**). In doing so, he can instantly see if anything is out of place. Additionally, the artist often zooms out until the image is much smaller than the current size he is working on, so that it can be seen in its entirety. This technique also helps him discover flaws. It's also sometimes useful to make a copy of the current state of the artwork and desaturate it, and then look at it for a few minutes to try and discern problems with contrast and volume.

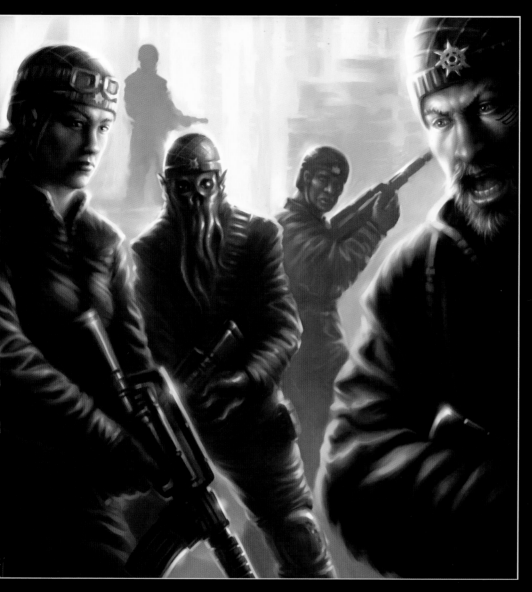

Brigade

artist: Roberto Campus
software used: Corel
Painter and Adobe
Photoshop. This
image demonstrates
the power of 2D
applications in the
hands of a commercial
artist. It was designed
as an illustration for the
Shadowfist trading
card game.

or flowers onto a digital canvas. These options have made Painter a highly popular tool, especially among traditional artists moving to the digital domain.

Another of the most popular pixel-pushing applications is Paint Shop Pro by JASC. This budget-priced Windows package combines photo editing with some vector illustration tools inside a common interface. The software's *Picture Tubes* feature allows artists to paint with a series of objects in a similar fashion to

Painter's *Image Hose*. Corel's Photo-Paint is equipped with a similar sprayer brush, along with customizable tools, advanced masking features and special lens effects.

Expression by Creature House is a natural-media tool that paints in vector-based 'skeletal' strokes. This lends it an advantage over Painter and other painting programs in that the strokes – and thereby the natural media effects – can be extended, shortened or repositioned whenever you want. Expression also offers

some unique layer-based effects, natural-looking soft-edged paintbrushes and some interesting editing tools.

Satori PhotoXL takes a different approach, combining vector and bitmap image processing in a single environment, with a wide range of tools. PhotoXL thinks more in terms of discrete visual elements than pixels, and uses a 'nondestructive' work flow. Satori claims that this improves upon the pixel-editing method used by the likes of Photoshop.

Adobe Photoshop

Without a doubt, Photoshop is the most popular bitmap image-editing program available today. Every artist in this book has probably used it at one time or another. With this digital darkroom and graphics toolset, the user has access to brushes, filters, selection tools, special effects and a range of custom colours and patterns. Photoshop's use of layers has been a major factor in its success. Arranged like an onion skin, these allow you to work on one element of an image without disturbing the others. In fact, you can change the composition of an image just by changing the order and attributes of layers. In addition, special features such as adjustment layers, fill layers, blend modes and layer styles let you create even more sophisticated effects.

The Photoshop artist's palette also consists of a variety of specialized tools. Brushes and other paint tools can be controlled by a mouse, but also by a digital pen and pressure-sensitive tablet. The *Marquee* tools allow for rectangular, elliptical, single-row and single-column selections of the image, which can then be moved, cut or cropped. In addition, freehand or polygonal (straight-edged) selections can be made with the *Lasso* tools, while the *Magic Wand* tool selects areas of a similar colour or tone. There are also *Paint Bucket* and *Gradient Fill* tools for applying colour to large areas, as well as *Blur*, *Sharpen*, *Smudge*, *Burn* and *Dodge* tools and a host of effects and filters. These effects include the ability to clone areas of the image onto each other, paint parts of the image as a pattern,

manipulate or replace colour and 'heal' parts of the image. All these tools can be accessed from a central *Toolbox*.

Photoshop's basic options are bolstered by a multitude of advanced features and filters. Among other things, these offer artistic, texture, distortion and lighting effects, including glows, spotlights and the lens-flare effect loved by spaceship artists everywhere. Other Photoshop filters include the *Liquify* tool, which provides image warping, and the *Turbulence* brush, which mixes up the pixels in the image.

Photoshop is ideal for sci-fi illustration because of its flexibility and ease of use. At any point during the creation of a picture, you can resize, recolour or relocate any part of the image, giving the program a clear advantage over traditional media – and there's no cleanup afterwards.

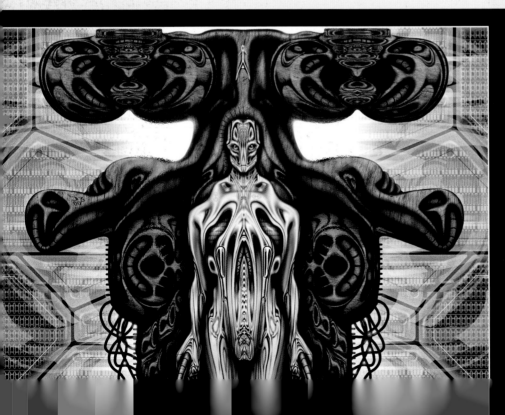

Thoughtengine

artist: Phillip James

Phillip James employs Photoshop to create disctinctive sci-fi art full of dense tones and subdued colour. He works in monochrome or duotone, adding tints through *Hue/Saturation* adjustment layers towards the end of the process.

Distant stars were created by using fuzzy brushes set to the *Dissolve* blend mode. By choosing various dark browns, blues and purples, it's relatively painless to create the minute specks of light that make up a clear night sky. The only drawback of the *Dissolve* brush setting is that pixels are opaque and hard-edged. To soften the effect, it is useful to make the stars on their own layer. Then you can scale, blur, blend and otherwise augment the stars to taste.

When choosing a colour for the night sky, keep in mind that although you shouldn't use true black due to its flatness, an overly saturated blue should also be avoided. A sky is dark because generally it does not refract the light in its atmosphere and contains blue only because of refracted light. For this sky, a very deep greyish-blue, purple-black colour was used almost everywhere except near the horizon. At the horizon, the atmosphere bends the light of the sun enough to create a subtle glow, depending on the time of night and whether cities are nearby.

The Astronomer

artist: Kristen Perry

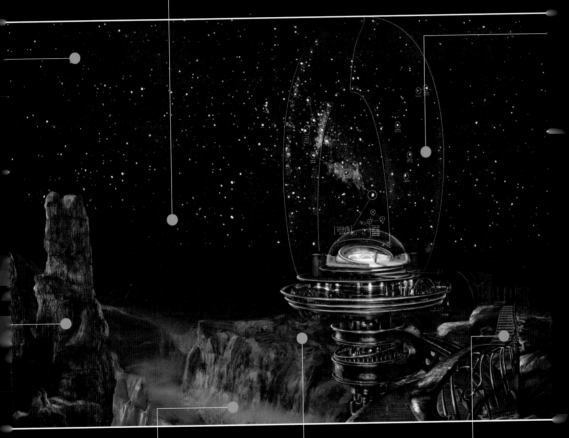

In addition to all the handwork and other details muscled into rock textures, a quick and dirty way to get extra grit into a cliff face is to add a bit of light noise. This is a useful trick for most materials, since real-life objects will have some sort of grain to their finish, if only a subtle matte. This also helps objects seem less plastic by diffusing the surface texture.

A common mistake when making fog is to use white and merely lower the *Opacity*. Fog has volume and is therefore subject to environmental influences – it reflects the sky and lighting around it. Depending on the scene and atmosphere desired, it may be more effective to use a darker colour, such as the steel blue-grey used here.

Blurring can be just as important as crisp imagery when portraying depth. To show the greater distance of the background mountain versus the middle-ground cliffs, the *Blur* tool, coupled with a large fuzzy brush, was carefully layered on a flattened version of the artwork. This effect can be applied on anything to aid depth: it was used here on everything from the back end of the bridge to the far edge of the observatory forcefield.

Sometimes filter s frustration. The m is just such an exa created by makin low-pixel lines on very slight *Inner E* style. From there, (to avoid bevel bl it skewed into pla of the texture we transformed to cr mesh receding in

Creating Artwork in 3D

To understand 3D software and how to create artwork using it, you first need to understand 3D space. This closely mirrors the world we live in and should thus be easy to grasp. In fact, thinking in three dimensions just means adding depth to the horizontal and vertical axes we use when we locate points in 2D space. This gives us X, Y and Z axes, and any points in 3D space can be defined by these three values.

MODELLING

Creating artwork in 3D goes through a series of processes. First there is modelling – where tools are used to edit basic geometric shapes and assemble them into a recognizable scene. Often the artist will base his or her models on a sketch, and there are applications that allow you to bring drawn artwork straight into the modelling workspace. However, not everyone who uses 3D software has

mastered the skill of freehand drawing, so there are plenty of alternative methods.

One of the building blocks of modelling is the polygon, any geometric shape made up of at least three lines. Polygons are joined together to form the surface of objects in 3D – typically spheres, cones, cubes and so on – and you can use these to build more complex constructions.

Shapes can also be created out of simple curves and lines (a line is just a straight curve in 3D modelling terms), using tools that carry out operations. Extrusion is one example: creating an object directly from a basic section (a circle, for example) with multiple segments of varying size. Once you have the shapes, however, a whole new set of tools and procedures come into play.

If you look at a wireframe view of a 3D scene, you'll normally see objects that are made up of triangular and rectangular

segments. These are polygons, and the surface they create is known as a polygonal mesh. The corner points (known as vertices) of the surface mesh can be pulled and manipulated to create new forms.

You don't need to keep creating shapes out of polygons yourself, however, because 3D applications will provide you with a set of 'primitives'. These are standard objects like spheres, cubes and cylinders, which can be manipulated and combined to form more complex shapes.

Other more complex types of shapes called NURBS also exist; these have their own set of tools. Instead of being defined by lines in 3D space as polygons are, NURBS objects are made up of curves constructed from mathematical formulas. Don't worry – all you need to know is that NURBS objects often have smoother and more defined surfaces, but drawing them takes up more processing power. Artists

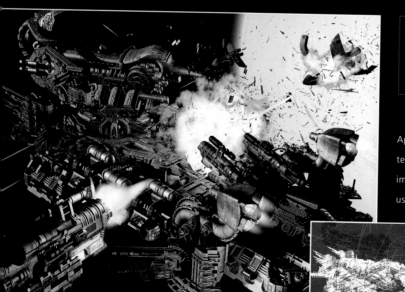

Zero Gravity

artist: Ivo Kraljevic
software used:
3ds max by discreet

Applications like 3ds max are excellent for creating complex textures, explosions and realistic space-battles like those in the image shown here. The elements of the scene are first created using a variety of modelling techniques, then they are

assembled in a workspace, also shown here in unrendered wireframe mode. Once rendered, postwork in a 2D application can sometimes help to clean up an image.

often use NURBS to create more organic-looking objects, and modelling with NURBS is like moulding clay with your hands. This is because when modelling NURBS objects, a 'control cube' appears around the objects in question. Moving the sides of this cube allows you to manipulate the object without touching its surface, like having an invisible hand pressing into the object. Once you have drawn a NURBS shape, there are tools that allow you to increase or decrease the number of points in an object to make a more editable shape, or create a smoother and more organic surface. Some applications further refine modelling by creating subdivision surfaces from polygon objects. These act as a control cage to create smooth, rounded surfaces inside. This is a quick and powerful method of modelling that allows you to add detail only where it's needed.

LIGHTS, CAMERAS – RENDER

In 3D modelling, you can choose any view for working on a model – above, below, from the side or any number of angles. Most applications display a working scene in three dimensions, where you can place and manipulate the components of your scene. A two- or four-window view is also very common, showing different views of the model at the same time. You can switch between views as well as zoom, pan and rotate around the objects in your scene as you assemble them.

It's not only shapes that are important in 3D – materials are crucial, too. Adding materials and textures to the surfaces of models is a major factor in getting a scene to look right, and artists take much care to get the mix to work. Textures are usually 2D images that are mapped onto a 3D object, providing a quick way to depict surface relief – such as the bark of a tree – without building a complex model. Surface materials can be made up of many attributes: clever algorithms, called 'shaders', can define how a material handles highlights, colour, transparency, reflectivity and surface relief (a 'bump map'), to name but a few.

Like a film or photography studio, 3D applications also allow you to position any number of lights in the workspace around your model, with varying beams and levels of intensity. Lighting affects the way that the materials applied to the surface of objects appear. Cameras, also borrowed from filmmaking, provide a means of viewing the scene. Like lights, these also have controls to affect their behaviour.

Rendering is the stage that brings all these component parts together – the objects, the lights, the materials and the textures – and outputs a 2D scene from the selected camera's viewpoint. 3D applications carry out this process using different methods to calculate the action of lights, colours and textures. Some are simple. Others, like raytracing, calculate the visual effect of each ray of light (reflected or direct) on every single pixel of every object in the scene.

Even more advanced variants exist. One – radiosity rendering – is becoming increasingly popular. Here the interplay of light between different surfaces is taken into account for a warmer and more organic-looking result, with soft shadows and colours that bleed into one another. Of course, the more complex the rendering engine, the higher the image quality – but the longer it takes to process. Photorealism doesn't come for free!

Ride

artist: Ivo Kraljevic
software used:
3ds max by discreet

Ride shows some of the effects that can be achieved once a 3D scene is rendered into a 2D image. Texture maps and surface materials give the impression of rusty metal, gleaming steel and sandy desert. Smoke, fire and laser blasts can be created using particle effects and volumetric materials, while blur and depth of field can be generated by applying rendering effects to the scene.

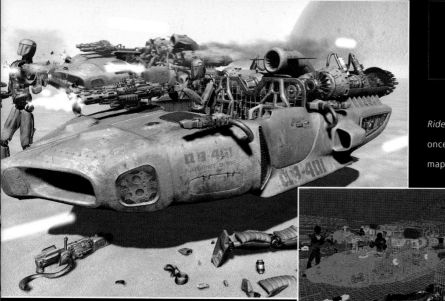

3D Software

3D software is a more complex area than 2D graphics. A huge variety of applications are available to digital artists, from simple modelling tools to the complex 3D powerhouses found on the workstations of Hollywood visual-effects artists.

Starting small, you would do well to choose Amapi 3D by Eovia, a modelling tool that takes advantage of a feature-packed toolset to create organic-looking shapes. It's an ideal introduction to 3D. As well as being able to create scenes using the two standard modelling methods (NURBS and polygons), along with subdivision surfaces and Dynamic Construction History (the program 'remembers' the stages of an object's construction, allowing each element to be reworked), the application is also capable of basic animation and realistic rendering.

Caligari trueSpace is another useful beginner's 3D tool. A Windows-based NURBS and polygon modeller, this takes advantage of Metaballs – a type of modelling that works with spheres (and in trueSpace, other primitives as well), merging them according to proximity to create fluid, organic shapes. TrueSpace has a more intuitive interface than some rival applications, and the added advantage of a radiosity renderer.

Still hovering around the entry level, but perhaps more appropriate for advanced users, is Carrara Studio by Eovia – an extendable solution for modelling, animation, rendering and special effects. It features *Spline* and vertex-based modelling, a particle system, volumetric effects, a material editor and an intuitive 'room'-based structure. It also enables real-time scene manipulation and high-quality 3D rendering, including caustics: a rendering feature that models the way in which light is reflected, refracted and diffused over objects in a scene.

In the midrange, we find Newtek's Lightwave 3D and Maxon Cinema 4D. Both are modelling, rendering and animation tools with high-end capabilities, supporting subdivision surfaces and advanced rendering facilities. Much praised for its excellent lighting system and rendering engine, Lightwave 3D's highlights include radiosity, raytracing, caustics, volumetric rendering, a sky-rendering system called *Skytracer* and *Digital Confusion* – an image filter that adds very realistic depth-of-field effects.

Cinema 4D is also renowned for its rendering and lighting, especially its fast raytracing. It also features *BodyPaint*, a 3D painting component that allows paint to be applied to an object's mesh in real time, including in raytrace mode.

In the big league of higher-end 3D applications, one of the most popular is 3ds max by Discreet. This features a fast and accessible toolset for a wide variety of modelling, animation and rendering solutions. Highlights include a very powerful material editor, NURBS, polygonal and subdivision surface modellers, and tools for complex surfacing, texturing and mapping. Soheil Khaghani shows off the power of this high-quality 3D package in *02*, an image based on characters from a Japanese anime film.

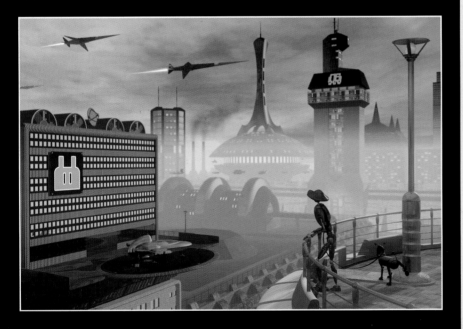

Before Dawn

artists: Christine Clavel and P.O. Boidard
software used: Amapi 3D by Eovia

Lighting

By using the *Volume Light* effect, you can create a sense of atmosphere for indoor as well as outdoor scenery. Using *Exposure Control* can help you fine-tune the exposure levels, brightness and colouring. If you are a beginner, select *Automatic Exposure Control* to get basic parameters with standard values, and carry on from there.

Glow

Use the *Lens Effect > **Glow*** when creating sparks, explosions, lights or, as here, glowing eyes. First choose a *Material Effects Channel* in the *Material Editor* window. Then add *Lens Effect* to your rendering effects list and pick *Glow* from the *Parameters*. Under *Glow Elements*, click on the options flap and in the *Effects ID* box enter the number you chose for the *Material Effects Channel*. Everything with that material will glow when rendered.

02

artist: Soheil Khaghani
software used: 3ds max by discreet

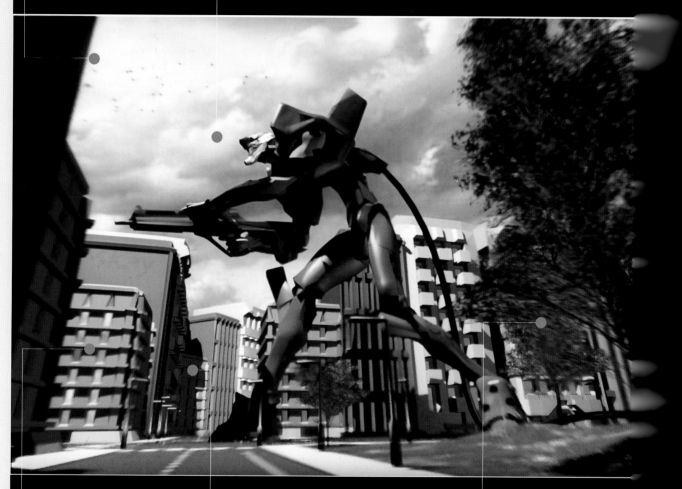

Modelling

The two primary modifiers (tools) used in this image were *Edit Mesh* and *Smooth*. *Edit Mesh* was used to model the objects and *Smooth* to add detail by keeping some edges sharp. To do this, select the *Smooth* modifier after modelling, check the box for *Auto Smooth*, and then just raise the value to smooth over some edges and ignore others, giving the mesh a more detailed look.

Lighting

An easy way to create realistic outdoor lighting is by using *Skylight* and *Sunlight*. Start with placing the *Skylight* right above the object or scene – this will cause the illumination in the viewport to increase. Now choose *Rendering > **Advanced Lighting***. On the *Select Advanced Lighting* menu, choose *Light Tracer* from the drop-down list. In the *Parameters* menu that appears, you can fine-tune the properties of the light until you like the result. Sunlight is a lot easier to use, but often you will have to use additional lighting to get the backlighting just right.

Blur

A way of making an object the main point of focus is to blur its surroundings with *Radial Blur*. This also brings a sense of movement and sharpness into the picture, as opposed to using *Depth of Field*. Using these effects within the 3D application lessens the need for postwork in Photoshop later on.

3D Software

Two high-end applications stand out in the field of 3D. Mainly used in the production of visual effects for films, television programmes and commercials, Alias Maya and SOFTIMAGE|XSI have much to offer the more experienced digital artist.

The main products have tumbled in price in recent years, and both companies have released free 'learning' editions of the applications, which are ideal for experimenting with the high-end tools on offer from these packages.

Maya by Alias is a hugely versatile piece of software, covering 3D modelling, painting, animation and rendering with a depth that other packages can only envy. Maya supports polygon, NURBS and subdivision surface modelling – as well as surface deformers – and has accurate simulators for digital fabric and hair. Subcomponents like *Artisan* and *3D Paint*, are designed to aid in sculpting models and painting textures and attributes onto NURBS and polygons, while *Paint Effects* – an array of advanced brush types including natural media (such as chalk, oil and pastels) – is used to create 3D scenes and 2D canvases with a realistic, more organic style. It also features a range of effects brushes to create lightning, clouds, rain, explosions, fire and sparks.

With a highly customizable interface, Maya's workspace can be divided into multiple panels and floating menus. It features a 'node'-based system architecture, where node attributes control and determine the shape, position, shading and construction history of all objects. A shader editor, *HyperShade*, allows the user to create complex shader networks such as skin, dust and rusty surfaces, while the *Visual Outliner* component offers a selection of libraries of textures and image swatches. Maya uses selective raytracing for rendering and features *Interactive Photorealistic Rendering* (*IPR*) to provide instantaneous editing of colour, texture, lights and other effects. For illumination, there are point, spot and area lights as well as realistic glows, fogs, lens flares and atmospheric effects. In addition, the application features 3D motion blurs and depth of field for photographic realism.

Maya's rival, SOFTIMAGE|XSI is a nonlinear system that provides a wide range of tools in a unified, integrated 3D environment. XSI has easy polygon- and NURBS-modelling tools and one of the best implementations in the industry for fast subdivision surfaces. It also features a very high-end interactive renderer that incorporates the Mental Ray v3.2 rendering engine, so what you see in the *Render Region* interface is what you get in the final rendering. The package also features a graphical shader network called the *Render Tree*, as well as advanced texturing tools and support for global illumination. In addition, XSI provides fully integrated hair, fur, particle, fluid, cloth and soft-body simulations.

In the images on these pages, SOFTIMAGE|XSI expert Jason Brynford-Jones (known as Chinny) demonstrates the power of this application by focusing on the key tools and techniques used to create the alien female Manta.

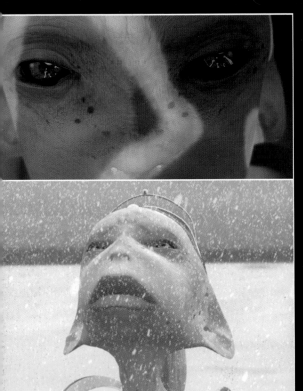

Manta

artist: Jason Brynford-Jones
software used:
SOFTIMAGE|XSI

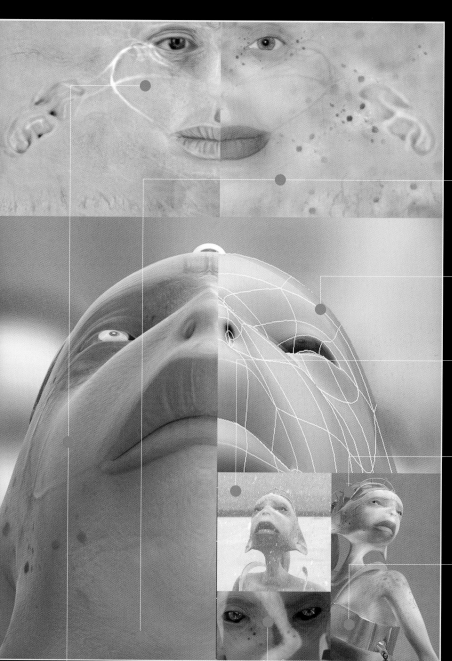

Textures and Lighting
When adding a texture (in this case alien skin), it is important to note that its lighting environment will change its look, colour and 'feel'. XSI has unique subprojections to apply the textures in the right place quickly, and its global illumination and image-based lighting help create photorealistic renders.

Level of Detail
XSI has amazingly fast subdivision surfaces with the ability to use any polygon model and add smooth detail instantly. This makes for swift interaction and manipulation, not to mention easier texturing and faster animation.

Environments
For adding environmental effects like snow, you can use particles with tiny sprites to vary size and to make irregular edges. Using real particles and not an image effect means the particle motion is driven by a physical environment, which allows the user to create correct movement and interaction.

Cloth Simulation
Pieces of clothing, flags or ship sails are the types of objects that benefit from cloth simulations. Cloth simulations save a lot of time when animating complex motion. XSI has the added benefit of simulating lower-resolution meshes and then being able to use subdivision surfaces with no extra calculations.

Raytracing
XSI uses the Mental Ray engine to accurately calculate the requirements for photorealistic rendering, such as reflections and refractions. XSI can handle reflections of the surrounding environment or can generate self-reflections. Another method is to use reflection maps, which fake the surrounding environment. This is not quite as good-looking but is faster to calculate.

Poser by Curious Labs

This 3D character design and animation tool by Curious Labs is an essential part of many digital artists' palettes. Its advanced rendering and export capabilities mean artists can use Poser to populate their 2D and 3D scenes with realistic figures. Poser objects are also literally loaded with controls to adjust the figures' features and positions. Almost every part (known as an element) of the body can be adjusted in some way in real-time, using dials or a mouse to control the Poser editing toolset. You don't even need to create anything from scratch – the hierarchical *Library*

palette provides a wealth of content, not just human figures but animals, cameras, textures and props. These are 3D objects that can be added to the scene, and can be anything from a gun to a circus ring. Figures can interact with, wear and pose on props, and they can be manipulated just like any other element. You can change the colour, shape and material, or even replace body parts with props.

Poser ships with a variety of props, but you can make your own in 3D applications and export them to any of the program's supported formats. Another option is to download free or commercial props from

a huge number of Internet sites (see the Sources section at the back of this book for some addresses). As a variation on this theme, you can also buy full 3D figures from third-party developers, which you can import and use in Poser. These are often of very high quality and will add even more realism to your scene. Names to look for are Dacort and Daz Productions, but there are also many artists out there who offer their own custom-built figures for download or sale.

Controls for lighting in Poser are among the simplest in 3D software. You create and delete lights, set their

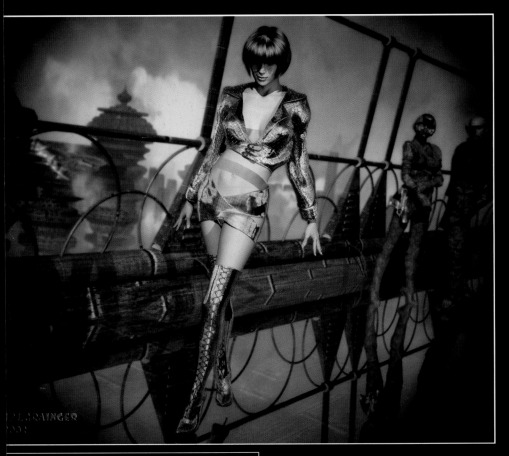

T'arna

artist: Ian Grainger

Ian Grainger uses Poser as a basis for his human figures, before rendering the character and landscape in Corel Bryce.

properties and position them by clicking or dragging icons and circles around a sphere that represents the focus of the scene. Each scene starts with three infinite lights – but you can add as many as your system will support, change their colour, adjust their intensity and so on, all in real time. Poser also lets you change your display styles (wireframe, cartoon, flat-shaded, silhouette and so on) for the whole scene, on a figure-by-figure basis, or just for each individual element.

With successive versions of the application, the feature set has become more complex, but correspondingly, so has the potential of what you can do. Far from the simple artist's mannequin of old, Poser figures can be transformed into almost anything using *Morph Targets* – custom parameters added to body parts or props, which allow you to reshape the chosen part. These deforming tools can make creating an alien face from a standard human head simple. Most standard figures come with morph targets, but it's easy to add more and save them to Poser's *Library* palette.

At the time of writing, the latest enhancements to Poser include a *Material Editor* for creating shaders, a *Face* room where photographs can be mapped onto the heads of Poser models, and *Hair* and *Cloth* rooms, where you can grow hair, add clothes to models and apply real-world dynamics such as gravity. Poser's new render engine, FireFly, uses raytracing and shader trees for added realism, and its new *Morph Putty* tool allows you to sculpt morph targets visually and see the results in real time as you work.

With these and other new additions to its feature set, Poser is bound to become a more popular tool than ever for depicting science-fiction themes in digital art.

Space Tourist

artists: Ian and Dominic Higgins

The figure was modelled and positioned in Poser using the high-quality 'Victoria' female model from Daz Productions as the starting point. Her features were remodelled using *Morph Dials* and the *Magnet* deforming tool.

The figure was illuminated using a combination of *Omni* and *Spot* lights. Poser gives you a lot of control over lighting, so don't think of it as merely a way to illuminate your scene, but rather as a valuable tool for enhancing your model.

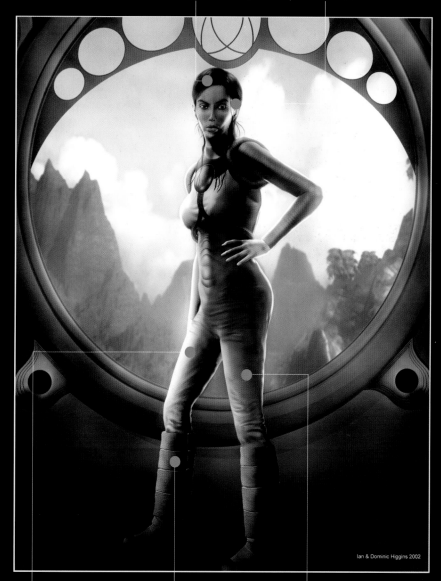

Ian & Dominic Higgins 2002

A tip for using *Magnets*: With the *Magnet*'s zone selected, go to the *Display* menu, select the *Element* style and then choose *Wireframe* from the option list. This will give you a 3D view of the *Magnet*'s zone.

If you're using Poser Pro or a later iteration, take full advantage of the *Multiple View* option when working, as this allows you to see your model from different angles simultaneously.

The basic catsuit clothing prop for Victoria, available from Daz Productions, served as the starting point for the character's costume. The shoulder piece was created using a simple torus prop.

ZBrush by Pixologic

ZBrush by Pixologic is a hybrid 3D modelling and painting tool, which is best used to create organic models. It has a very powerful free-form modeller that feels as though you are sculpting with clay, while also providing a range of 2D tools and brushes that allows the artist to add detail and depth to a model by simply painting on it in a true 3D environment.

As well as the familiar primitive geometric objects used in 3D modelling, ZBrush adds gears, spirals, helixes, arrows and terrains. All the 3D primitives feature initialization settings that modify the way they appear when first created.

The *ZSphere Modeller* is a powerful tool for building 3D meshes with real-time interactivity. It allows you to construct a skeletal shape over which you can stretch a skin, forming a mesh object. Various modifiers provide control over the final mesh, which let you specify the smoothness of the mesh, following the skeletal contours precisely or loosely, and even stretch webbed membranes across joints and intersections. The mesh density is also highly adjustable, creating objects with extremely low-polygon or high-polygon counts. Unlike most 3D modelling programs on the market, ZBrush can create and handle polygon meshes that are extremely dense – the latest version can accommodate meshes of over one million polygons on a basic PC or Mac.

ZBrush provides its own powerful scripting framework in the form of *ZScripts*. A *ZScript* could be anything from a tutorial, to a helpful utility, a recorded session, or anything else that might use automated or programmed ZBrush actions. One *ZScript*, called *Projection Master,* is a powerful tool that helps when creating detailed models. It allows you to drop a 3D model on the canvas and paint details onto it. *Projection Master* helps create features like creases, wrinkles, blemishes, bark and so on – all the fine detail that in other applications would be created using bump and displacement maps. Add to that an extensive range of texturing and UV mapping tools, and ZBrush starts to sound like a must-have program.

Glen Southern has used ZBrush for a number of years and finds it especially good for creating science-fiction art, whether it be strange and exotic aliens or distant lunar landscapes. Southern created this image, *Bassau Warrior*, in ZBrush to be used as part of a poster campaign. The brief was very open to interpretation, so the artist started out by sketching an alien, using basic 2D brush tools in the ZBrush document window. Using that as a blueprint, he created the individual parts of the model as separate 3D objects and then composited the whole figure in a multilayered canvas.

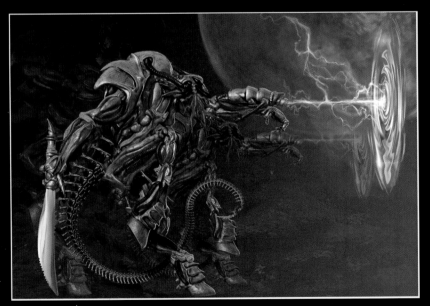

Bassau Warrior

artist: Glen Southern

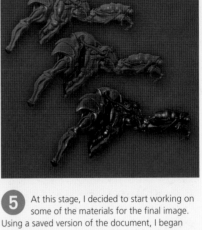

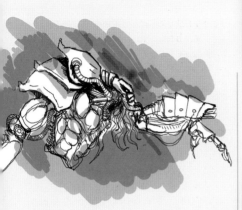

2 The next stage of the process was to create all the required parts of the model. Newer versions of ZBrush have *ZSpheres*, which allow you to create full figures in one mesh. For this project, I chose to take a primitive object and sculpt it into each of the required parts for the figure, then I composited all these parts into the final image.

5 At this stage, I decided to start working on some of the materials for the final image. Using a saved version of the document, I began picking metallic materials for the armour and a more plastic look for the pipes. I added more noise and different levels of specularity on the model.

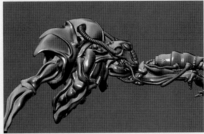

1 ZBrush has a very powerful scripting language. With very little experience in coding or HTML, I was able to write a ZScript that gave me brush tools to match 2H, HB and 2B pencils and a white sketchpad. With these tools, I find it easy to sketch straight into ZBrush with a Wacom tablet as if I were using the natural media.

3 Once I had created most of the objects, I started to assemble them into the document window. ZBrush has a layer facility similar in some ways to Photoshop, but with an added dimension of *Depth* along the Z axis (in and out of the window). This image shows how the top half of the model started to look as the parts were added. At this stage, I painted them all with a very basic plastic-looking material.

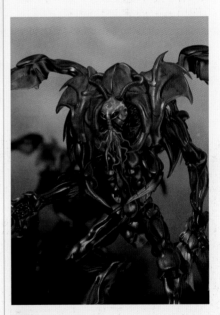

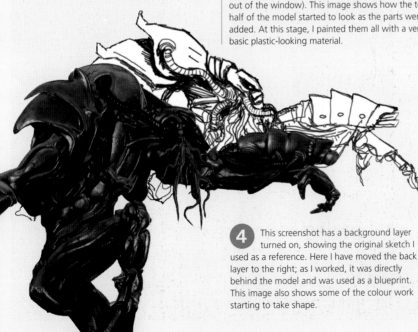

4 This screenshot has a background layer turned on, showing the original sketch I used as a reference. Here I have moved the back layer to the right; as I worked, it was directly behind the model and was used as a blueprint. This image also shows some of the colour work starting to take shape.

6 I was fairly happy with the final pose and composition of this piece. I did, however, try a number of other poses by taking the model parts and laying them out in different ways and from different perspectives. The image shown is from one of these experiments.

I added a number of lights to the scene before the final rendering. I took the render into Photoshop and added the lunar background and the 'Stargate' ripples using basic filters. I carried out a lot of 2D postproduction work in the final image, including the comic-style blue lighting coming in from the right of the picture.

BodyPaint 3D by Maxon

Painting textures for 3D models using a 2D painting application can be an arduous task. It's easy to end up shuttling textures back and forth between 2D and 3D programs to test render and adjust images numerous times until everything looks right. You are also usually engaged in painting separate maps for colour, bump, displacement and so on, which can work well together only once they are rendered in your 3D application. However, a solution is at hand: BodyPaint 3D by Maxon allows you to paint right on the geometry in real time, and to paint all the layers simultaneously. It can paint on up to ten channels with a single stroke, so a brush can define an entire material rather than a single colour.

The application includes three automatic UV unwrapping algorithms, its *RayBrush* technology lets you view real-time results of your painting in a rendered image, and the *Projection Painting* tool lets you paint across UV seams or multiple objects in a scene. A completely integrated module for Cinema 4D, BodyPaint 3D also includes free plug-ins that let you exchange models and textures with other major 3D applications.

Here, Cris Palomino demonstrates the technique she used when creating *Desolation*. As well as the main BodyPaint 3D application, Palamino made use of Poser by Curious Labs, Photoshop by Adobe, Painter by Corel and the Michael 3 Poser model from Daz Productions.

1 I imported my model from Poser, where I'd morphed and posed the main figure with this painting in mind. I used the BodyPaint 3D module, which integrates into the main Cinema 4D application – the advantage being that I could use its modeller, if needed, then switch over to BodyPaint with ease to start my texture. I was going to paint my backgrounds, but I also wanted the figure to stand on a prebuilt, eroded column. Therefore, some magnet work would be required to get the surface of the column to meet my Poser figure's feet.

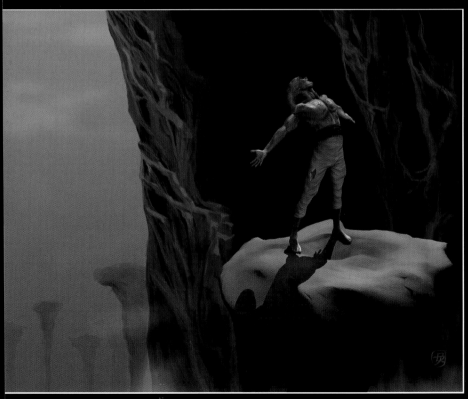

Desolation

artist: Cris Palomino

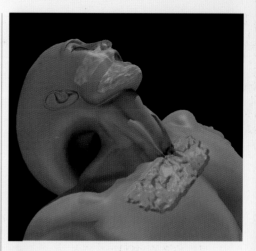

2 I had prepared the figure in Poser and imported it as a welded single object, but it contained far too many materials. I distilled them down to five materials representing the major areas of the body I was thinking of painting. I then assigned the size of maps I was going to use for these body parts and created a channel each for *Color* and *Bump*, because I planned to paint these simultaneously.

4 BodyPaint will work with a variety of image formats. I most often use jpegs, tiffs and psd files, depending on the size and resolution of my final image. I had created a set of textures to try on the figure in Photoshop, and these could be quickly added to the *Pattern Library* in BodyPaint by copying them into the directory and then reloading it (*Color Manager > Texture Paint > **Reload Directory***). This allows me to preload as many files as I wished.

6 You can also create coloured textures. To do this, use the colour assigned to the file, then create a corresponding greyscale of the same coloured texture (remembering that white is the highest point and black is set to surface or zero), and use it in the *Bump* channel. I chose to paint with a solid colour while at the same time painting with the *Bump*, which textured the colour I was applying. If I wanted to use only one at a time in any given area, I toggled the channels off and on.

3 By selecting the body and head materials in the *Object Manager*, I could toggle between them in the *Material Manager*. Activating the *Color* and *Bump* channels meant I could paint on each channel separately, but turning both on meant I painted on both simultaneously. I could also have chosen to create and paint simultaneously in the *Diffusion, Luminance, Transparency, Reflection, Environment, Alpha, Specular Color* or *Displacement* channels. I filled each of the body areas with a ground colour on one layer, then began painting with colours and textures on a secondary set of layers.

5 BP3D has a unique feature called *Raybrush Mode*, which allows me to paint in a prerendered view in real time and in 3D. This was a big help in letting me see what effect my different textures had in each channel. It was akin to having a physical model that I simply turned in space and painted on directly. It was pretty close to what I would see when the image was fully rendered, so it saved me an impressive amount of time.

7 As with Photoshop, it is a good idea to use more than one layer in any of your channels. This lets me create and experiment with colours and bumps to see their effects without committing everything to one layer. Once the texture was completed, I went back to the *Modeller* layout. I added lights and the model of the weathered column and rendered the scene with *Multi-Pass* to conserve the various channels and effects in separate layers. I imported the render to Photoshop, where I adjusted the layers, then painted the rest of the scene with both Photoshop's tools and those in Painter.

World-Building Software

One branch of 3D software that has become incredibly popular in recent years is world building. Several applications exist that can generate terrains, atmospheres and even whole planets using mathematical modelling procedures. These include Bryce from Corel, e-on Software's Vue D'Esprit and Terragen by Planetside Software, all of which are covered later. Other packages can be largely split into those that accept geographic data or greyscale maps to form landscapes, and those that generate and render terrain from an internal set of procedures or fractals.

3DEM by Visualization Software produces 3D terrain from a wide variety of freely available data sources. These include Digital Elevation Models from sources like NASA, geographical satellites, national government mapping bodies and research institutes, and can be downloaded free from several websites.

Matthias Buchetics's and Dirk Plates's ScapeMaker, a free tool for Windows, is another terrain generator. Its *Topology Generator* generates height maps to simulate different types of terrain, including those affected by water erosion. These can be exported for use in other applications. The *Texture Generator* creates surface textures to match. Extrapolated from small texture materials such as grass, rock or snow, these are configured for the terrain according to customizable gradient and height settings.

ScapeMaker's *Object Generator* allows you to populate the landscape with 3D objects like trees, again configurable according to terrain settings. Fog, clouds, shadows, sea effects and lighting can also be configured and added to the landscape. ScapeMaker's *3D Engine* takes advantage of vertex-shader and pixel-shader technology – as built into modern

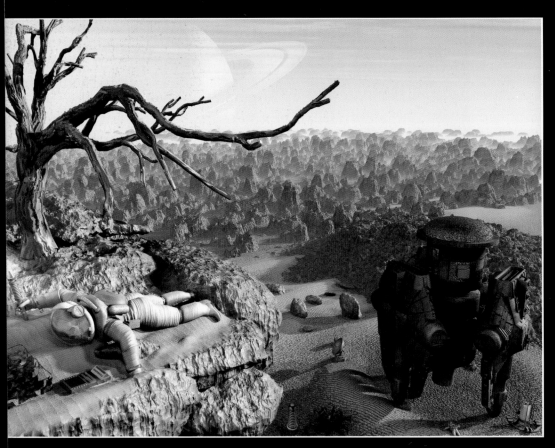

Explorers

artist: Robert Czarny
software used:
Vue d'Esprit
by e-on Software

3D-graphics hardware – to allow you to move freely through rendered landscapes and take screenshots at any position.

3D Nature's World Construction Set is a photorealistic terrain-modelling package that allows you to create high-quality images ranging from close-ups to entire planetscapes. These can include terrain, textures, foliage, 3D objects, water, skies, basic fog, atmospheres and other landscape elements. Scene Express, an add-on to World Construction Set, allows users to export projects for use in formats like 3ds max or Lightwave 3D, where final scenes can be rendered.

WorldBuilder from Digital Element is a procedural modeller and fast standalone renderer that creates both plants and terrain. It offers the powerful *Variator* tool, which lets you create varied content automatically. It integrates seamlessly with most modelling and rendering packages.

Pandromeda's MojoWorld Generator can create whole solar systems using procedural fractal textures. Photorealistic worlds can be created to be viewed from any distance, at any resolution. Powerful editors can control all aspects of your planet by adjusting parameters like terrain, materials, clouds and atmosphere, while a

preset library of materials offers a one-click pick of a sky, a planet-surface texture or a full galaxy of stars. The *Planet Wizard* tool lets you create a personalized planet instantly. MojoWorld has a strong user community dedicated to modelling and sharing new worlds, which can be shared and explored using the free MojoWorld *Transporter*. The application currently models a single planet, but, according to Pandromeda, later versions will model solar systems, galaxies, nebulae and an entire synthetic universe.

Details for all software can be found in the Sources pages at the end of this book.

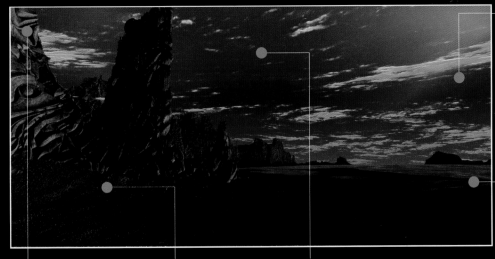

Moon
MojoWorld can create a moon in the sky with mathematical efficiency and an unmistakable sense of scale. The default MJW planet is a great place to start if you want to learn how to configure 'real' moons. You can control the orbit, scale and light of the moon, and you can also create more than one. You can also import objects to create low-orbit satellite stations or ships.

Water
MojoWorld can create an ocean for your planet with its *Water* feature. By using a ridged function with a displacement texture, you can create realistic waves. Colour and transparency can be changed to whatever suits your image.

Rendering
MojoWorld has the ability to line up images for batch rendering. The *Uplink Queue* lets you store settings for more than one image at a time. Simply start the queue rendering, and later you'll come back to a whole world of images. This is great for testing renders with shadows turned on and off, different times of day seasonal shifts across your landscape.

Terrain
All texture effects and scale in MojoWorld terrains are fractal-based. Texture parameters change how the surface texture will look in your final image. To match colour to height, you choose surface position, not world position, for your texture. You can create colour and texture variation in your scene by using multiple terrain layers ('leaves') and then varying the way they are blended together.

Sky
Using MojoWorld, you can add multiple layers using different types of elements – including sky backgrounds, atmosphere layers and cloud planes – to create an alien sky. Unlike other software, it is possible to combine these layers in one render, each with a multitude of individual characteristics including height, density, shadows, terrain avoidance and colour. By keeping the atmosphere density low, you can still see stars and moons in your render.

Light Years from Home

artist: Kate Andersen
software used: MojoWorld by Pandromeda

Corel Bryce

Bryce is much more than mere world-building software, although it does that very well. It is often used as a texturing and rendering tool, as well as a stage for assembling elements created in other 3D applications such as Poser or 3ds max.

The *Create* palette contains tools for adding objects to your scene. These can include simple primitive geometric shapes, lights and planes for earth, water and clouds, as well as procedural objects like terrains, trees, rocks and symmetrical lattices (terrain objects that have a mirror image bonded to their base).

When selected, any object in the scene displays a bounding box that allows control over resizing and orientation and gives access to the object editors. These include the *Object Attributes* panel, the *Terrain Editor* and the *Materials Lab*, where objects gain textures and values that affect their realism and appearance.

Boolean modelling also has a place in Bryce. Properties in the *Object Attributes* panel can be adjusted to make objects neutral, positive, negative or intersecting. Using these attributes, objects can be combined in various ways to make new shapes. In this way, a hole in a wall can be created using Boolean subtraction by grouping a positive wall object with a negative spherical object.

The *Terrain Editor* presents any selected terrain object in your scene as a 2D greyscale image and 3D preview. The 2D image on the *Terrain Canvas* is called a height map, its dark areas representing low altitudes and lighter areas the peaks. Bryce contains many tools to affect the look and structure of terrain, including those that erode, elevate, smooth and sharpen. There are also a number of special-effect and filter tools that act on the greyscale image to affect the height

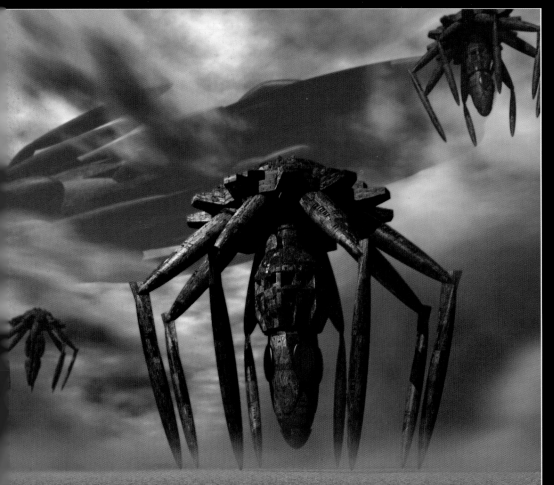

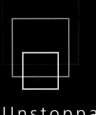

Unstoppable Legacy

artist: Adam Benton

map. Pictures can even be imported with their greyscale values blended with the terrain to create a new custom object.

Materials in Bryce can be applied to the surface as well as the interior of objects and are made up of fourteen channels arranged in sets of colour, value (such as specularity) and optics (such as transparency). New materials are created by adjusting the components of each channel. Each material can have up to three components, which can take the form of a colour, a numerical value (for intensity) or a texture. Textures can either be pictures or 3D procedural forms generated by Bryce, and they can be mapped, blended and transformed in several ways. In later sections, we'll explore how textures can be put to use, but for now, it is enough to know that this is an area that you will definitely want to experiment with.

One more aspect of Bryce is worth a mention in this brief overview. The *Sky&Fog* palette is where you adjust the natural lighting of a scene, adjust *Shadows*, *Cloud Height* and *Fog Level* and where you can choose from a selection of preset skies. The *Sky Lab* section has controls for the sun, moon and stars, position of the sun, and atmospheric controls to simulate hazy distance or the colour of the sky.

Bryce is a wonderful tool for creating a setting for the world of your imagination. If you are prepared to dig deep into its feature list, you'll find that you'll be rewarded with far more realistic images of your natural and unnatural subjects.

Terrain Editor
The main object here was created from a *Symmetrical Lattice*. A picture was prepared in Photoshop and imported into Bryce's *Terrain Editor*. Combined with a *Symmetrical Lattice* object, it was duplicated and rotated using the *Multi-Replicate* function. Then a texture was applied to the grouped objects.

Cloudy Skies
Bryce's *Sky&Fog* palette lets you create atmospheric effects. Here you can adjust the height and amount of cloud cover and use the *Deep Texture Editor* to apply texture to the clouds, like the combination shown here. The palette also contains controls for ambient light settings and the colour of the skies (using the *Sky Dome* setting).

Lights
Bryce has five types of direct lights: *Radial, Round Parallel, Spot, Square Spot* and *Parallel*. The sun was created from a flattened *Radial* light. Bryce allows you to set the intensity, cast shadows, set the colour and determine the rate of falloff. It gives you various render options for the lights in a scene.

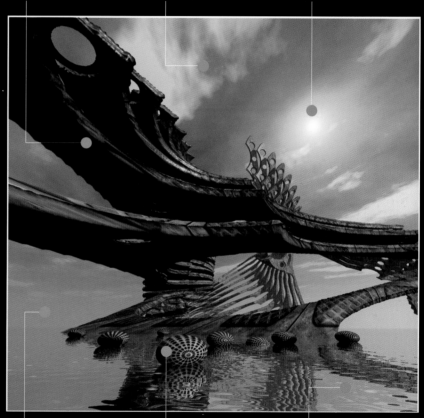

Haze
To make the picture more realistic, fog and haze can be added using *Sky Lab*. Good results can be achieved by experimenting with settings such as *Density* and *Thickness*. Additionally, *Color Perspective* can be set to give the effect of the colour saturation, lack of contrast and colour change that naturally occur when viewing distant objects.

Object Creation
The 'eggs' were made from flattened *Spheres*. Given a texture, they were then multireplicated. They were positioned on the water using the *2D Disperse* option of the *Randomize* tool. This is a great way of randomly dispersing objects throughout your scene without having to position each one manually.

Planes
Ground, water and cloud planes form the scene's basis. Water textures are selected from the *Waters & Liquids Preset Materials Library*. Here *Mercury Surface* has been applied.

Colony

artist: Mirek Drozd

Vue d'Esprit by e-on Software

Vue d'Esprit by e-on Software is a 3D scenery, texturing and rendering tool that is fast becoming a standard for creating ultrarealistic 3D images. It is available in two versions, the prosumer Vue d'Esprit and a new Vue Professional edition.

Easy to use, it features a high-quality renderer and support for all major import formats, plus integrated subpackages like SolidGrowth 2. This realistic tree-and-plant creation and rendering technology makes every plant and rock unique when dragged into a Vue scene. In a similar manner, the terrain editor uses a technology called Solid3D to give you real-time previews of your landscape as you model it.

One of Vue's main draws is its visual *Atmosphere Browser*. This offers a selection of predefined atmospheres that you can load into your scene at the beginning of the project, or any time thereafter. The standard atmosphere models are fairly basic, but the volumetric-atmosphere models feature complex algorithms to replicate the interaction of light and particles in the atmosphere. These are much more realistic, but they take up a lot of power. You can adjust settings for all such models at any time in the *Atmosphere Editor*.

In addition to sophisticated outdoor lighting algorithms, Vue produces 'natural'-looking pictures using some of the most advanced rendering techniques. Raytracing, volumetric effects, lens flares, glowing objects, motion blur, realistic 3D vegetation, soft shadows, blurred reflections and caustics are all available. The application ships with thirty SolidGrowth 2 trees and plants, more than a hundred atmospheres, a hundred different types of clouds, three hundred materials and two hundred and fifty high-quality, fully textured 3D objects. There are also extensive modelling features and export paths.

You don't need a hugely powerful computer to set up complicated scenes in Vue – the secret is scene optimization and subdivision into smaller parts. Vue features layers to organize objects in the scene, so you can make several separate scenes by copying objects into different layers. When your scene is full of objects, rendering time increases considerably, but you can work around this by temporarily switching off those layers that you don't need to see. Using this method, you gain on the screen-refresh rate, enabling you to concentrate on the subject you are working on. Once you've rendered the scene in draft mode to gain an overview, you can once again switch off all layers that are not in use and then render in normal or final mode, using the *Render Only Visible Layers* function.

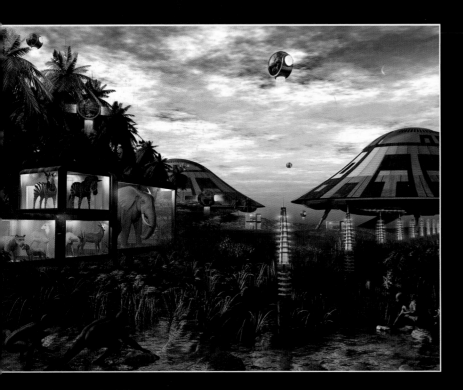

N.O.E.

artist: Robert Czarny

Terrain Editor
Vue's *Terrain Editor* is a powerful landscape tool that can also be used for quick modelling of very complicated objects. Simply edit the 8-bit grayscale 2D elevation map of your target object in an image editor (Photoshop, for example). Copy and paste it into Vue's *Terrain Editor*, and it will be generated in the scene. Make sure that the size of your image exactly matches the size of the terrain onto which you paste it.

Atmosphere Presets
Don't choose a *Volumetric Atmosphere* model if you don't really need it. The *Standard Atmosphere* model will give you more flexibility over atmosphere parameter settings, and rendering will be quicker.

Striders in the Sun

artist: Robert Czarny

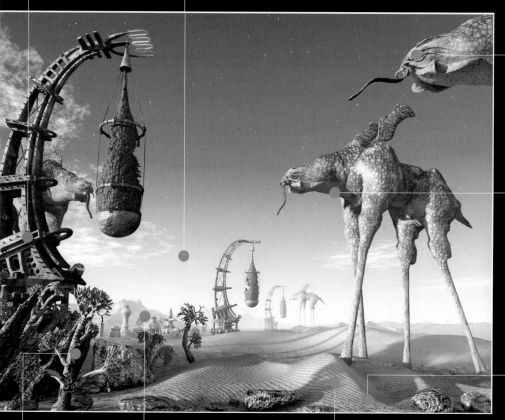

Poser Import
It's possible to import Poser characters into Vue directly with all textures applied intact. This is obviously a quicker method than exporting through a standard 3D file format such as the OBJ or 3DS formats and reworking textures.

Skin
You can obtain better lighting of animal or human skin exposed to the sun if you add *Backlight* to the one-sided skin material (*Material Editor > Other > Backlight*). Without backlighting, shadows on skin are rendered too dark. Vue also allows you to tune the character's skin material by using the *Luminous* setting, increasing the ambience and setting *Soft Shadows* to 0.

Materials
When working with a complex mix of similar materials, as in the ground here, it may be hard to distinguish between them, making it difficult to position them properly. You can use 'temporary' materials (e.g., simple blues and reds), then replace them with the final material; or you might modify one parameter of your material to give it a different look (e.g., set *Direct Light* to 0 or the *Luminous* setting to 100). After positioning, this can be easily reversed.

Vegetation
Vue offers a large library of plant and tree species that can be edited freely. You can easily change a species by modifying its trunk, branch and leaf shapes, applying different materials or combining it with a few different species. This strange alien plant is composed of modified cactus and coral.

Import Objects
Vue can maintain a large library of free and third-party 3D objects from the Internet. To speed up browsing, add a representative symbol, such as '@', to object thumbnails when you import them. If you search your catalogue by '.jpg' alone, you will also dredge up texture maps and other files.

Shadows and Lighting
The use of several additional lights is usually necessary to obtain realistic lighting conditions. Fifteen additional distant lights were used for this scene. Here, a 2% shadow blur has been added to the main sunlight. For a bigger sun or for light passing through clouds, a higher value would be used.

Planetside Terragen

Terragen by Planetside Software creates complex landscape images with ease, as shown here in the creation of *Bliss* by Kate Andersen. Using different settings, you can render a world that looks almost like Earth, or one that is most definitely in the realm of science fiction. One of Terragen's main attractions is its atmospheric settings, which allow you to change the colour, depth and form of cloudscapes, haze and fog.

1 When starting Terragen, I usually open the *Landscape* window to create a terrain. You can either let Terragen generate one for you or import a bitmap image. I imported a greyscale image, then used the *Sculpt* settings to create a basin with a distant mountain range. It's a question of testing the landscape as you go, to see how your erosion effects are changing the terrain. I prefer to do a small section first, look at the effect, and then do the rest of the terrain. For this image, I opened the camera window once the terrain was eroded, then chose a fixed height of 500 metres above the surface so I could see the distant mountains above the foreground.

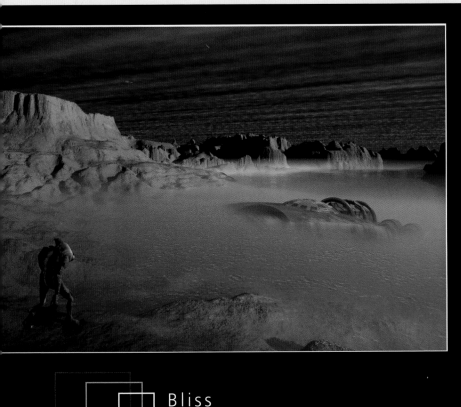

Bliss

artist: Kate Andersen

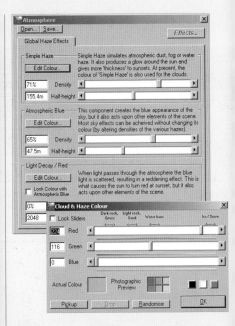

2 I opened the *Atmosphere* window and in the *Simple Haze* section set the *Density* to 71% and the *Half-Height* to 155.4m. I chose to edit the *Haze Color*, setting it at 224 for red, 116 for green and 0 for blue. I didn't want a blue sky, so I changed the *Atmospheric Blue* setting to a low *Half-Height* of 47.5m with a *Density* of 65% and the colour set to 54 for red, 138 for green and 232 for blue. For *Light, Decay/Red,* 0% *Density* and a high *Half-Height* of 2048m were set, then I changed the colours to 150 for red, 155 for green and 161 for blue. This created the lower haze/fog layer and when the sky was rendered, it produced a golden haze and golden clouds.

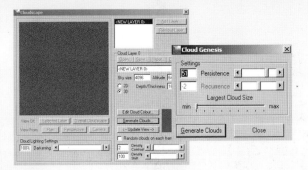

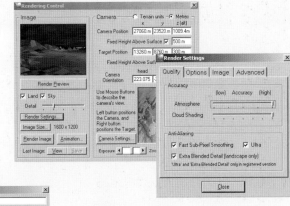

3 I opened the *Cloudscape* window next. With Terragen, the cloud and atmosphere colours are the same, so all I changed were the main window settings for *Depth/Thickness* to 16, *Density Contrast* to 2 and *Density Shift* to 100%. I checked the *3D* box for the clouds and then selected the generate clouds tab (*Generate*). In the resulting *Cloud Genesis* dialog box, I changed the *Persistence* to 51 and set the *Largest Cloud Size* at the minimum setting. This effect varies depending on the sun's position, so if the sun is behind clouds, for example, it can produce a sun-ray effect. For this image, however, I positioned the sun behind the camera, and no rays were produced.

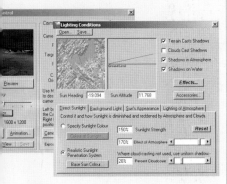

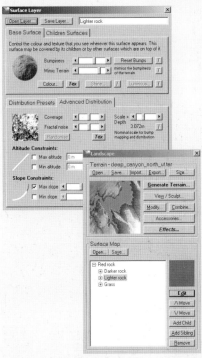

4 I opened the *Lighting Conditions* window to gain access to the sun settings. It's more realistic when the terrain casts a shadow, so I checked that box (*Terrain Casts Shadows*), as well as *Shadows in Atmosphere* and *Shadows on Water*. I checked the *Realistic Sunlight* option and set the base sun colour to 231 for red, 163 for green and 68 for blue. Next, I moved the sunlight around the terrain to see what suited the mood, changing the *Sun Heading* to 19.094 and setting a low *Sun Altitude* of 11.768. I also increased the *Sunlight Strength* to 150% and the *Effect of Atmosphere* to 170%. On the *Background Light* tab, I set the *Color of Shadows* to 102 for red, 120 for green and 192 for blue, while *Lightness* was set at 0% in the *Shadow Settings*. The only other settings I changed from the defaults in *Atmospheric Lighting* were *Glow Amount* and *Glow Power*, increased to 300% and 150%. When the terrain casts shadows, the image can turn out too dark, so I check the effects when cloud and terrain shadows are changed. On this image, the cloud shadows are turned off.

5 Next on the list were the terrain textures, so I reopened the *Landscape* window. This texture was to be nothing complicated, just a few layers with reds, yellows and brown highlights. Entering the *Surface Layer Editor*, I changed the surface to a red earth layer, with an average *Bump* and with the *Mimic the Terrain Bumpiness* function selected. Red was set to 72, green was set to 32 and blue was set to 16. I added a dark rock layer with more red (80), green (40) and blue (24). To make this layer stand out, I added extra *Bump* and limited the *Distribution* to 30m. I then added a yellow rock layer, setting red to 88, green to 48 and blue to 32. For each rock layer in the terrain, I added a slightly varied *Child Layer*, with slightly more bump or fractal depth for more variation.

6 In the *Water* window, I made the *Wave Properties* fairly rough, with *Roughness* set to 56, *Wave Size* set to 176 and the *Visibility Effect* set to 91. I didn't vary the default setting much, but I changed the *Patch Size* to 3,159 and the *Distort* setting to 119. On the *Subsurface* tab, I increased the *Subsurface Distance* to 770m and changed the colour again, with red set to 16, green set to 16 and blue set to 16. I also changed the *Transparency Color* to red at 87, green at 64 and blue at 80. This made the water transparent in the 'basin', while the colour of the terrain showed through along the shoreline. I then rendered the image at high quality.

7 I took the render into Photoshop. Here I added a simple spaceship with dull metal textures and a few lights as well as an alien, both rendered and textured in Bryce and set on a separate layer. I also duplicated the ship on several more layers, used the *Smudge* and *Blur* tools on a few and decreased the *Opacity* for each. I made final adjustments along the ship lines and blended the layers in *Hard Light* mode. I then changed the overall colour, adding more red to the scene by using the *Variations* option, and finally cropped the image to make it look more balanced.

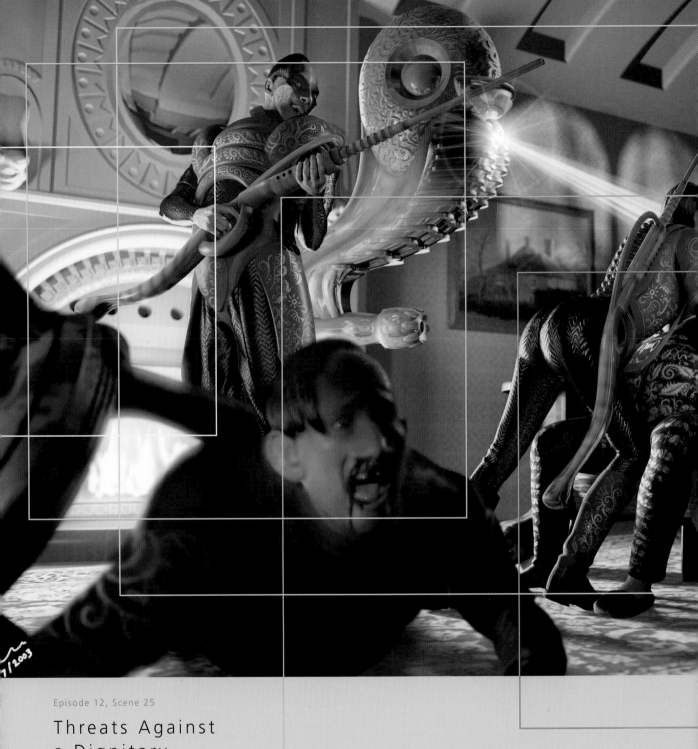

Episode 12, Scene 25

Threats Against
a Dignitary

artist: James Lee

Light Sabres at the Ready

Software is just a tool. Like a chisel or a paintbrush, it needs a human hand to wield it and create something artistic. The following pages will demonstrate some of the techniques used by digital artists in creating great science-fiction artwork. This section starts with 2D techniques and the use of layers and creative effects. It then moves into 3D, and finishes by bringing both 2D and 3D together in the area of postproduction techniques (known simply as postwork).

For most walk-throughs, you'll need just a simple understanding of packages like Adobe Photoshop, Poser by Curious Labs and Corel Bryce. For others, a basic knowledge of 3D packages should be all you require. Most of these techniques can be transferred with little effort to other packages, since many graphics applications share common toolsets and working methods.

If you are inspired to try some new applications after reading about these techniques, visit the websites of the software manufacturers listed in the Sources section. Most of the applications in this book are available for download in demo or time-limited form, so be sure to try them out.

Fine-Art Photoshop

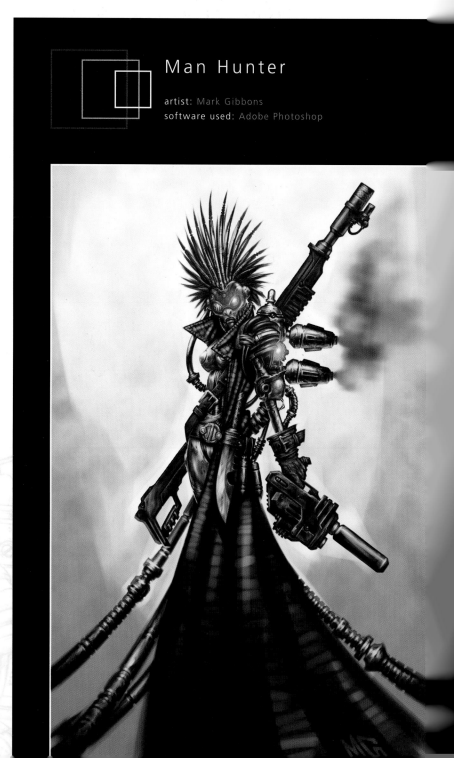

Man Hunter

artist: Mark Gibbons
software used: Adobe Photoshop

Mark Gibbons comes from a traditional illustration background and was more than a little reluctant to move into the digital age. Once he began working for Sony Computer Entertainment as a concept artist, however, he was 'encouraged' by the studio to take an introductory Photoshop course. After learning the basics, his first priority was to understand how to re-create his traditional style in digital form. For Gibbons and many artists like him, Photoshop offers a speed and versatility that's unachievable with traditional media. The use of layers, in particular, gives an artist fantastic opportunities to be creative and experimental. With the creation of *Man Hunter*, Gibbons demonstrates some of the layers techniques he relies on when creating a typical digital painting.

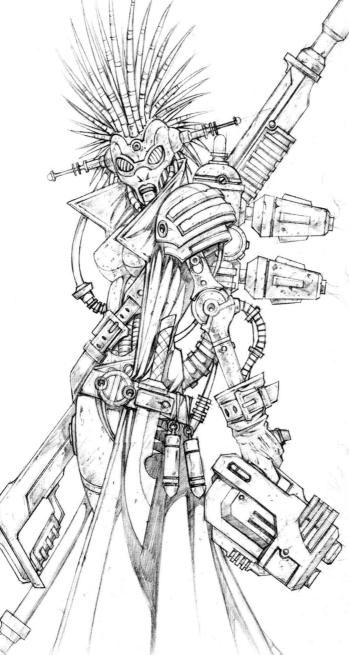

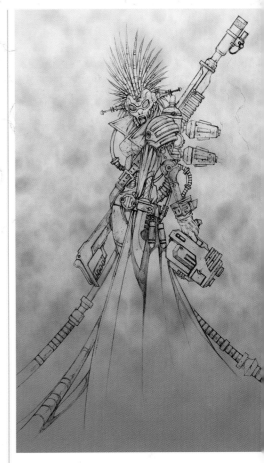

1 I need to be able to scribble and scratch with real pencils, so I always begin with a physical illustration. I usually add a degree of shadowing in my pencil sketches, because it helps to create depth and definition in the final image.

I scanned the sketch into Photoshop as a greyscale image at 300 dpi, using *Image > Adjustments > **Auto Levels*** to increase contrast and brightness in the drawing. Occasionally I'll also adjust the brightness and contrast when I need to remove any surplus noise from the scan. In most cases, however, I prefer to do this by hand with the *Eraser* tool, since that gives me greater control.

I converted the greyscale image to RGB colour via the *Image > **Mode*** menu, then copied the *Background Layer* and set its blend mode to *Multiply*. I always make a point of naming all the layers, as this saves precious time that would otherwise be spent clicking between them to work out what's been painted where. I named the newly copied *Multiply Layer* 'Blackline', because it was a key layer that would remain at the top of my layer stack for most of the painting process. By changing the layer's blend mode to *Multiply*, I ensured that my original drawing would always be visible.

2 I usually work with an extremely limited brushes palette because I want a painting tool that closely re-creates the feel and qualities of a traditional paintbrush. So apart from the odd filter or effect, most of my Photoshop work begins and ends with the *Airbrush* tool set to *Normal* blend mode and with 80% pressure.

I returned to the background layer to add some basic colour. I could have filled (*Edit > **Fill***) the layer with flat colour, but instead I applied the *Gradient* tool, which helped to define a basic lighting direction and colour palette. I then duplicated the graduated background layer and played around with different blend modes and *Layer Opacities*. I also applied some filters to these background layers. *Clouds* or *Difference Clouds* (*Filter > Render > **Clouds***) add an interesting chaos to backgrounds, but I always transform these cloud layers since they tend to look rather busy by default. Selecting *Edit >**Transform*** gives a range of options for manipulating what should end up looking like a smoky, smudged backdrop for the character. Again, the key is to experiment.

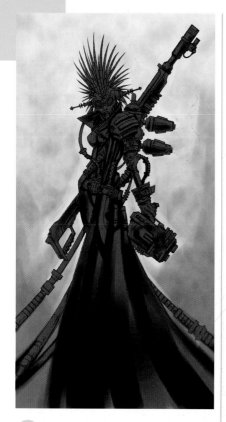

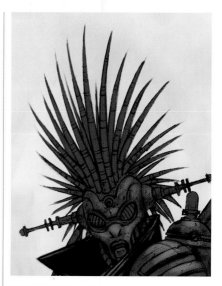

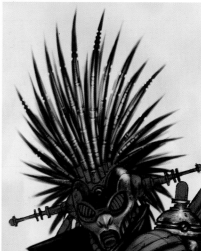

3 Starting on the figure, I usually either block in a flat colour on a new layer or, as here, use *Quick Mask* to paint a mask of the figure area from the background gradient, then copy to a new layer. I call this my 'Underpaint' layer.

At this point, I was trying to get a quick feel for the light and shade on the figure, so I created two new layers above Underpaint. I named one 'Shadows' and set blend mode to *Multiply*. The other I named 'Highlights' and set to *Screen*. Using these two layers, I was able to paint quick shadows and highlights to the figure without ever having to change the colour on my brush. I was trying to add form to the figure, not final colours. Using *Multiply* and *Screen* layers like this doesn't add variety to the colour range.

Using *Layer > New > **Adjustment Layers**, I set up a number of permanently adjustable *Sliders* between layers in the image. I usually set up a *Hue & Saturation* or *Color Balance* layer and group it with the previous layer when I have an area of a painting I'm unsure about. Doing so means I can always tweak the values of that specific portion of my painting.

4 Once I had a solid idea about tone and shape, I focused on a specific point in the illustration, adding new layers and painting this area to a finished quality. This gave me a little snapshot of the final illustration to keep me heading in the right direction. The benefit of working in layers is that it was easy to adjust colour values or saturation in a particular section of the work as I went along. So I selected the pipes that run into the Man Hunter's coat as my first area of focus – you can see that I kept the painting quite loose, the original tight pencil lines disappearing beneath broad *Airbrush* strokes.

5 Although the Blackline layer was vital and provided the fundamental structure of the figure, its hard black edges needed to be painted over in some areas to make the character sit convincingly against her background. I created a 'Backlight' layer to sit above the Blackline and added details like extreme highlights and rim lighting to it. Essentially, this was a normal layer used to obscure pencil lines below, and it should really have been used only for adding these specific effects. Unfortunately and inevitably, when I work like this I always end up painting areas on this layer that I shouldn't.

6 Layers allow you to experiment without the risk of spoiling areas of the image that you are already happy with. I created a 'Try-Out' layer when I decided I didn't like the elbow and shoulder areas of my original design. Once I'd blocked in a shape I liked in flat colour, I checked the *Preserve Transparency* box in the *Layers* window. This allowed me to slap the paint around inside this new shape without the need to keep cleaning up any 'spills' onto areas of the painting I was already happy with. Some of the other layers in this image have been hidden to illustrate the technique.

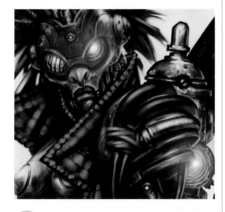

7 I wanted to give the Hunter's backpack and eyes a soft green glow. I could probably have done the job with a careful hand and a soft *Airbrush*, but there's a much simpler way: *Lens Flare*. Used 'neat', the *Lens Flare* filter is a rather crass, blunt instrument, but it can give beautiful, delicate results if applied carefully.

I created a separate layer for each glow since I wanted to ensure maximum flexibility. Setting the blend mode to *Screen*, I filled each layer with black. The image wasn't affected at all until I created a lens flare (*Filter > Render > **Lens Flare***). With the flare on a separate layer, I could reposition it precisely and alter the *Opacity* and colour values as required. In this instance, I set the *Lens Flare* to 10% and lowered the *Layer Opacity* to 25% to produce suitably subtle results.

8 Having spent all this time carefully selecting and applying colours, shades and tones, I decided to adjust the basic colour balance of the final picture. After flattening the image to a single layer, I duplicated it and set this new layer's blend mode to *Overlay* with a 40% *Opacity*. This darkened the image and increased the tonal saturation. I then tweaked the *Color Balance* of this layer to boost the cyan and blue colouration until I felt the overall tone achieved the colder, more metallic quality I wanted. However, the overlay increased the contrast too much, and I was losing detail in the darker shadows, so I added a *Brightness/Contrast* adjustment layer and upped the brightness to compensate. All that was left to do was sign it.

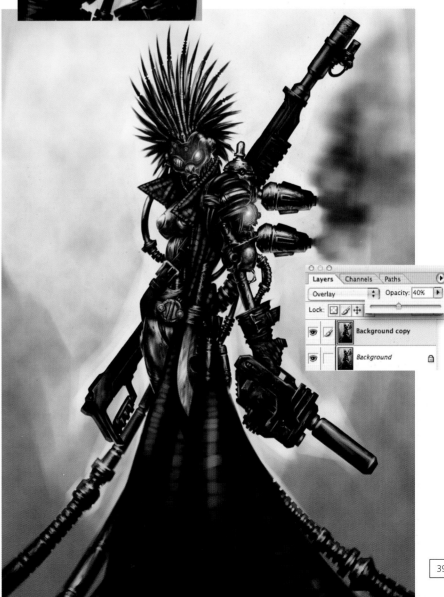

Channels and Layers

I f you made a change to a picture, in early versions of Photoshop, it was saved as an integral part of the image and remained there. If you wanted to go back a step or two, the only option available was to save several different versions of an image. This took up a lot of hard drive space at a time when storage was expensive. Then came layers, the *Undo* command, the *History* palette and inexpensive storage, and a whole new world of creativity opened. Now it is not unusual for artists to have images with twenty or thirty layers, which they can mix and match exactly to achieve the desired effect. This process is shown here in the creation of *Silence at the Wheel* by Byron Taylor.

1 I started with a figure – my own Shelly character texture on the Victoria 2 model – dressed in a catsuit in Poser with a custom bump map applied to it. I created a ship's wheel in 3ds max, saved it as a Wavefront.obj file and imported it into Poser, adding a reflection map to make it look metallic.

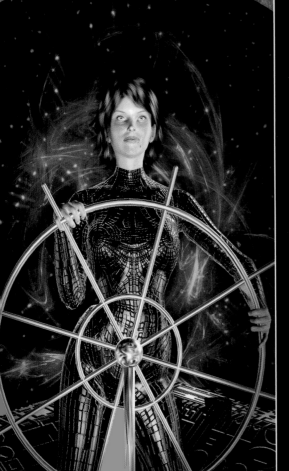

Silence at the Wheel

artist: Byron Taylor
software used: Adobe Photoshop, Poser Pro Pack by Curious labs,3ds max by discreet, Victoria 2 model by Daz Productions, KPT Effects by Corel

2 The lighting controls in Poser are not as sophisticated as those in some other programs, so because I wanted dramatic backlighting, I created two lighting setups. One image has general lighting, and the second has a single light source behind and to the right. I also rendered a 'sci-fi' console, which I'd found for free online, with a general lighting setup. Now I had two renders of Shelly and one of the console, which I then opened in Photoshop.

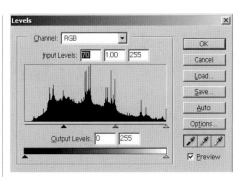

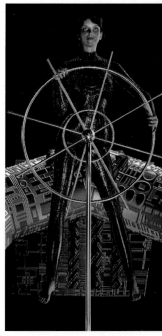

3 The *Channels* (*Red*, *Blue* and *Green*) in Photoshop display the elements that make up the actual image and are what you adjust when working with the *Color Balance* and other *Image Adjustment* commands. I looked through the channels in the second render until I found the one that would give me the lighting effect I was looking for, which turned out to be the red channel. By dragging this channel to the *Create New Layer* icon at the bottom of the *Layers* palette, I made a copy (Alpha) of the channel, then inverted it using *Channel Options* > **Color Indicates: Selected Areas**. Alpha channels are those that are outside the RGB or CMYK channels which create the image and can contain any greyscale image. I then made a selection from it by Control-clicking (Mac users should Command-click) on the channel. I went back to the *Layers* menu, created a new layer and filled the selection with a light blue.

5 I opened the rendered console image that I wanted to place behind Shelly, went into the *Channels* palette and repeated the previous steps. I duplicated the console layer onto the main layered image and moved the layer so that it was behind the main figure. Since the console was so bright, I adjusted the *Levels* (Ctrl or Cmd + L) and *Saturation* (Ctrl or Cmd + U) to bring it down in brightness and colour saturation.

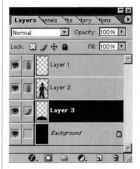

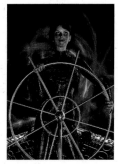

4 I then duplicated the new layer (*Layers* > **Duplicate Layer**) and set it to *Screen*, so that the detail beneath it would show through. Poser automatically generates an alpha channel when you save scenes as tiff files, which saves a lot of masking time, so I inverted the Shelley render's alpha channel and made a selection of it. Then I returned to the *Layers* menu and created a *New Layer* (Ctrl or Cmd + J) from this selection.

6 This was to be an illustration for the cover of a book, so I changed the canvas size from 945 x 1689 pixels to 763 x 1209 pixels. After linking the floating images (by clicking on the links in the *Layers* palette) so that they would *Transform* (Ctrl or Cmd + T) together, I moved the image elements down, framing the picture the way I wanted. I then applied filters to the background layer, using *KPT FraxFlame*, *Noise*, *Gaussian Blur* and *Radial Blur* until I produced the effect I wanted.

7 Layers are essential to the creation of my artwork. With all the various selections, alpha-channel layers and duplications, I built more than twenty-four layers working on this image. The final image uses sixteen of those, flattened and converted to CMYK mode to be ready for printing.

41

Blending Multiple Renders

When he conceived the image *The Tiamat Experiment*, Eric Wadley had in mind the image of a cybernetic dragon whose skin was torn, revealing a metal, mechanoid skeleton underneath. Accomplishing this in a 3D-rendering program would be a difficult and time-consuming process, but Wadley achieved the same effect by blending more than one render together using Photoshop. This technique can save you a great deal of modelling time, especially if you are using programs like Bryce or Poser. The method uses Photoshop, but it can be adapted for almost any layer-based paint application.

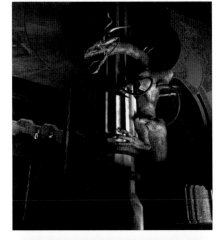

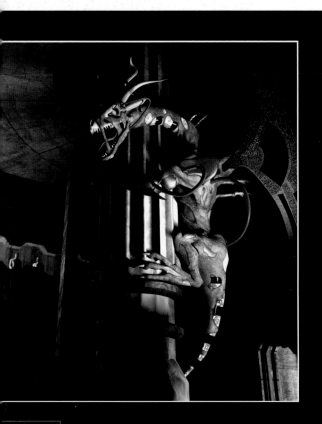

1 I began by designing and rendering three completely different versions of the cybernetic dragon using a dragon model exported from Poser. The first render in Bryce was completely organic and showed the dragon's skin. This would become the top layer, from which the basis of the dragon would be made.

2 This second render was the mechanical skeleton of the dragon. Only portions of the torn skin from the first render would reveal pieces of this metal frame underneath.

3 This third version was a render of the organic skin on a simple, flat surface. Portions of this skin would be used to fill in areas of the image where skin from the first render was not used.

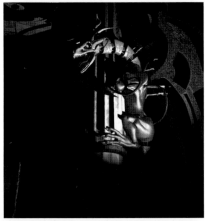

The Tiamat Experiment

artist: Eric Wadley
software used: Adobe Photoshop, Poser by Curious Labs, Corel Bryce

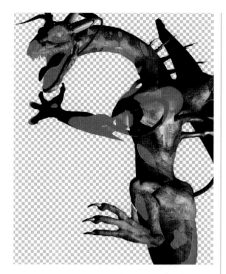

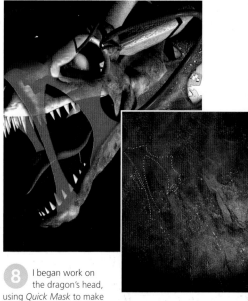

4 It was then time to put the whole scene together in Photoshop. Placing the organic and mechanical dragons on separate layers, I started to cut away portions of the organic dragon to reveal the mechanical dragon underneath. I found it was easiest to use Photoshop's *Quick Mask* mode to paint the areas I wanted to cut away first. That way, I could easily modify parts that didn't look quite right before actually erasing them from the organic dragon layer.

6 While the scene was starting to look interesting, the organic dragon skin still looked very flat against the metal skeleton. To add a little depth, I used the *Burn* tool to create some shadows on the skin. Choosing a small, soft brush, I began darkening the edges of the organic dragon layer. It's important to keep in mind where the lights in the scene are coming from when burning shadows like this. If done correctly, it will create the illusion that the skin has thickness and depth, instead of looking paper-thin.

8 I began work on the dragon's head, using *Quick Mask* to make a selection around the mouth. This would be used to create additional cheek flaps to accentuate the mouth and face further. Taking the skin render I made in step three, I moved the 'cheek flap selection' into the initial skin render, then repositioned it to include a clean section of skin. I copied the section of skin and pasted it into the main image on a new layer.

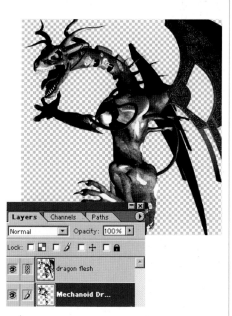

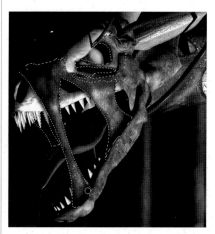

5 Once I was satisfied with the ripped and torn sections, I deleted them from the organic dragon layer. This revealed the general look of the dragon and how much of the metallic skeleton would ultimately show in the scene.

7 To add more reality to the depth of the skin, I used a medium-sized soft brush to burn some shadows into the metal dragon layer. This added to the illusion of depth, since it now appears that the skin is casting shadows across the metal skeleton.

9 I repositioned the flaps of skin onto the dragon's face and began using the *Burn* and *Dodge* tools to create highlights and shadows. This process took quite a bit of work because the lighting on the skin flaps was a little off.

Using the same techniques, I did some additional work on the image, including adding more skin to the dragon's shoulder, eye socket and tail, as well as some work on the leg joint and the points where the wing and skin connect.

Using Curves in Photoshop

One of the most useful tools in Photoshop is the *Curves* dialog box (*Image > Adjustments > Curves*). Merely by changing the shape of the curve, you alter the tone and colour of an image: by bowing it upwards you can lighten an image; by bowing it downwards you darken it. The sections of the curve represent contrast values. The steeper the section, the higher the contrast.

In *DuckStar*, L.W. Perkins used *Curves* to lighten the mood of a commissioned piece. Completed on a tight four-day deadline, the image was destined for certificate artwork to be used at the 2003 World Science Fiction and Fantasy Convention, held in Toronto. The brief requested 'something either Canadian or science fiction, that can be printed on a home laser-printer if necessary'.

After a futile attempt to do something with a maple leaf, Perkins hit upon the idea of a duck ship. Although this is a humorous take on science fiction, purists can rest assured that this technique still works on their more serious images.

Duck-star
The inspiration for the ship was not metal, nor could it fly.

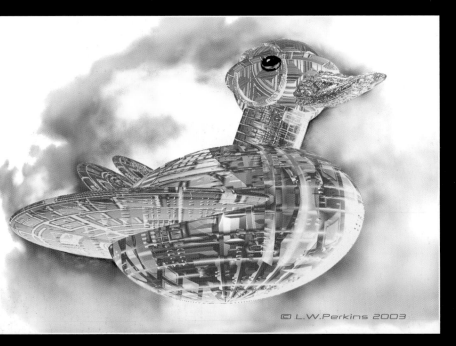

© L.W.Perkins 2003

DuckStar

artist: L.W. Perkins
software used: Adobe Photoshop, Corel Bryce

1 I assembled the duck in Bryce 5, using some spheres, a cylinder, a shaped lattice for the beak and a small sphere for the eye. Then I applied a 'techno' texture from Bryce's internal library.

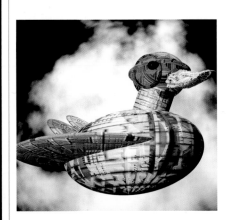

2 Unfortunately, the final render was too dark for the light mood I was looking for. Also, the background needed to be white, since it was going to be used as a spot illustration and I didn't want a black frame around the image. This is where Photoshop's *Curves* adjustment came in handy. The *Curves* interface looks intimidating at first, but it is actually a lot of fun to use.

3 Once you select *Curves*, you can make the dialog box larger by clicking the icon at the lower right-hand corner (the icon looks like a box with a tiny arrow). You will also see a grid box with a diagonal line. The grid represents the values of your image from dark to bright, as well as the image's hues. The diagonal line across the grid is the gamma line, representing your image as it is now. The darkest parts of the image are at the lower left on the line, and the brightest parts are at upper right on the line.

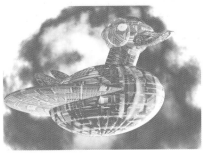

5 Taking a duplicate of the original darkduck render (*Image > **Duplicate***), I once again opened up the *Curves* dialog, put my cursor over the lower left-hand corner and dragged the gamma line to the top of the box. The image turned white. Then I dragged the upper right-hand corner of the line down to the lower right-hand corner. I now had a negative of my original image, which I saved for later use, naming it 'negduck'.

7 The next step was to composite the adjusted original with the new negative image. I did this using the layer blending options (*Layer > Layer style > **Blending options***), making the upper negative layer an *Exclusion* layer and then flattening the image. Although it was going in the right direction, the duck still needed a darker eye and slightly more contrast. It also needed to be separated from the background a little more.

4 Here's the same render with more detail in the lights and shadows. To get this, I clicked on the gamma line about two-thirds of the way down, creating a point, and then clicked again halfway between my last point and the top. This gave me two handles, with which I dragged the curve into a gentle S shape. You will see that the dark areas on the duck have lightened up slightly, while the light areas have darkened slightly. I saved this version of the duck as 'darkduck' so that I could use it again as a separate layer without accidentally overwriting the file.

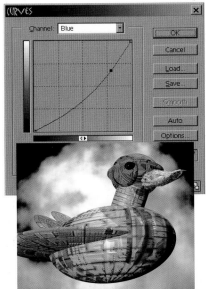

6 One of the most useful functions of *Curves* is its ability to adjust each colour channel separately. This can be accessed at the top of the dialog box, where the RGB drop-down list will show each colour channel. I wanted more yellow in my darkduck render, so I opened the *Blue* channel and dragged down the gamma line slightly to achieve a golden effect.

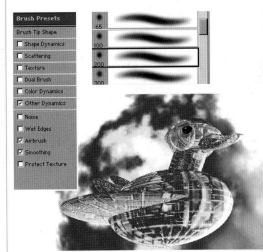

8 Once again, *Curves* came to the rescue, helping me to increase the contrast a little (you can also use the *Image > Adjustments > **Contrast/Brightness*** dialog for a quick, if less controlled, change). I used a black airbrush for the duck's beady eye and did some airbrushing in white to soften the background, which made the duck stand out.

Distorting Reality

Filters are an excellent way to add a bit of unreality to an image, but they're controversial in the digital-art community. Some say they're just tools; others say they shouldn't be used at all. The lens flare, a prime example, was one of the most overused filters in early digital sci-fi images, yet it was essential in the deadline-frenzied world of commercial illustration.

Filters are useful, but they shouldn't be used as a quick fix. Try to use them in conjunction with other tools to create your own technique, or apply them in original ways. Above all, people should not be able to recognize which filter you've used.

Phillip James uses filters with other Photoshop tools to great effect. In *Origins*, an A.I. machine has discovered its humble computer origins. James created the original version of this piece as a mixed-media illustration many years ago in art school and had been itching to resurrect it as a digital piece. Here he gets his wish, in the process displaying some distortion tricks with the *Liquify* filter.

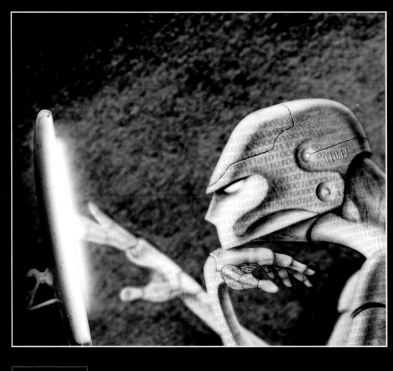

Origins

artist: Phillip James
software used: Adobe Photoshop

1 I usually work from quick thumbnail sketches and very rarely start with finished drawings. I mostly work in greyscale and duotone images, adding colour later with *Hue & Saturation*, using masks as I did here.

I began preparing the ground for applying filters by clicking onto the image with the *Type* tool from the *Toolbox*. A new layer was created automatically. I didn't worry whether the font style or size was quite right; I was just concerned with having the text in the right general position and size. As the text remains fully editable in its layer, I knew I could play around with it later. Using the *Transform* menu commands, I rotated and aligned the text to the side of the flat-screen monitor and adjusted it until it filled the desired area. I created a copy of the layer, then chose the *Liquify* filter from the *Filter* menu. When this filter is used, the type layer must be rasterized before proceeding, after which it is no longer editable, so it's wise to keep a backup just in case.

2 In *View Options* in the *Liquify* filter controls, I selected the *Image* and *Backdrop* boxes and chose the base layer over which the type would be distorted. This allowed me to see the image almost as a trace layer over which I could distort the text. I also had the ability to adjust the layer *Opacity*. If you have multiple layers, they can be switched on and off using the layer controls to the right of *Backdrop*. You can also choose *Mesh Size*, *Mesh Color* and the *Freeze* options. The *Freeze Mask* tool lets you mask areas that you don't want to liquify, giving you greater control over the area of distortion.

4 In the *Freeze Area* box, I clicked *Invert* to freeze areas outside my previous mask automatically. Using the *Warp* tool and a large brush with *Brush Pressure* set low to reduce the amount of warp, I dragged the text from left to right to stretch it. If you make a mistake doing this, use *Reconstruct* in *Revert* mode (under *Reconstruct Options*) to undo any errors. *Restore All* takes you back to your original instantly, while *Reconstruct* takes you back slowly, in stages. The *Reconstruct* tool in the *Filter* toolbar is even more intuitive, since it allows you to paint over specific distorted areas to reconstruct them. You can also use Ctrl-Z (PC) or Cmd-Z (Mac) to take you back a step.

3 I zoomed in and started playing with the different tools, experimenting with the various effects that could be achieved. Most of the tools in this filter are self-explanatory (*Mirror*, *Turbulence* and so on), but their effects can be increased or decreased by adjusting *Brush Size* and *Brush Pressure*. At the front of the robot head, I used the *Pucker* tool to pull the text in, thereby reducing its size. On the cheek area of the robot, I used *Twirl Clockwise* to twist the text, leaving the red, 'frozen' area undisturbed. I could experiment by adjusting the *Brush Pressure* to increase and decrease the speed of the twirl effect.

5 For the hands and shoulder, I used techniques similar to those described earlier. The *Thaw* tool allowed me to thaw certain areas that were previously frozen, almost like painting away a mask. *Thaw All* removes all masked areas, allowing you to view your distortions clearly. I chose *OK* when I was happy with everything, and the *Liquify* filter rendered the distortions. Back in normal mode in Photoshop, I removed any text from areas that wouldn't be visible using the *Eraser*. I blurred the text slightly with *Gaussian Blur* and by reducing *Opacity*. I then flattened the image (*Layer* > **Flatten Image**), and changed the image mode from greyscale to RGB (*Image* > *Mode* > **RGB Color**). Finally, I added colour using the editing controls in *Hue & Saturation* (*Image* > *Adjustments* > **Hue & Saturation**).

The Art of Noise

N oise in Photoshop can be a powerful creative tool or a powerful destructive tool, depending on how you use it. It's good for achieving a random but even pattern for textures, stars and so on. In *Alieana's Gift*, Byron Taylor explores some of the possibilities of using noise for creating alien skin on a previously modelled Poser figure.

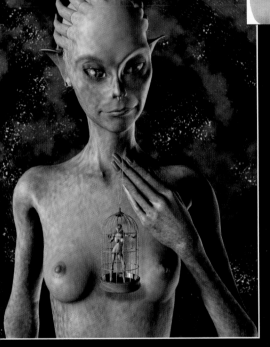

Alieana's Gift

artist: Byron Taylor
software used: Adobe Photoshop, Poser Pro Packby Curious Labs, 3ds max by discreet, Victoria 3 model by Daz Productions

1 I built a female alien in Poser, using the Victoria 3 model and the face and body injections available for her. I created a pair of horns in 3ds max and imported them into Poser as a Wavefront Object (.obj) file. I then switched to Photoshop to bring it all together.

2 I opened my favourite Poser texture, Shelly for Victoria, which I had previously developed in Photoshop from several photographs. This is a fairly complex operation, but one that's well worth trying. There are tutorials on the Web and elsewhere that cover the process.

3 Opening the texture in Photoshop, I set it as the background. I then created a solid colour layer (*Layer > New Fill Layer > **Solid Color***) to colour the texture, and another solid layer of colour to which I added noise (*Filters > Noise > **Add Noise***). There is no set formula for doing this – after doing it a few times, you'll learn to achieve the amount of noise and distortion that you want.

Since *Noise* is a pixel-by-pixel operation, and I wanted a larger pattern, I selected an area of the layer and used *Free Transform* on it (Ctrl or Cmd + T) until the pattern was about the size I wanted. Enlarging will blur it somewhat, but I used *Gaussian Blur* (*Filters > Blur > **Gaussian Blur***) on it some more to achieve the effect I was looking for.

4 After playing around for a while with different blending styles, I settled on an *Overlay* style of blending – this allowed both the original background texture and the new noise-based one to be shown together.

After a few test renders, I decided that it was turning too cool, and that there needed to be more flesh colour in the mix. So I added a flesh-toned *Multiply* layer. This is very important in achieving realistic characters – nothing is all blue or all flesh tone. You'd be surprised at how much blue is in a 'flesh-coloured' character.

5 I then opened the Shelly Head texture file. This was developed from photographs in the same fashion as the body texture.

6 I took similar steps with the face texture: adding, transforming and blurring *Noise*. It's important here to make sure that the level of *Noise* between the head and the body matches in the render, since the face template is in a different scale from the body.

7 Using the new textures saved to new files, I converted them to greyscale, reversed them, added more *Noise* and touched them up to function as *Bump maps*. Remember that in *Bump maps*, the lighter the colour, the higher the surface will be. There were areas I wanted to smooth out, so I went in with the *Airbrush* tool and a 50% grey to take out some of the bump.

8 After rendering the alien and the woman in the birdcage (who is wearing the original Shelly texture), I opened them both in Photoshop and composited them. The background is created with more *Noise* for the stars and rendered clouds for the nebulas. I finished off with a little *Radial Blur*, just for effect.

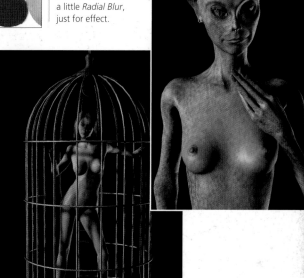

Anatomy of a Sci-Fi Image

reating artwork in 2D digital applications can be a complex and rewarding process. However, many artists choose to create a whole scene from scratch, using a combination of 3D modelling, arrangement and rendering, followed by postproduction work in a 2D package like Photoshop. What follows is a detailed overview of the stages in the creation of a digital illustration, the cover for a science-fiction novel. You'll see how Dariusz Jasiczak created *Wreck*, the digital version of a sketch he painted some years ago for the Andre Norton book *Sargasso of Space*.

Jasiczak uses trueSpace for modelling objects, Bryce for creating landscapes and Photoshop for final retouching and all post- and prepress work.

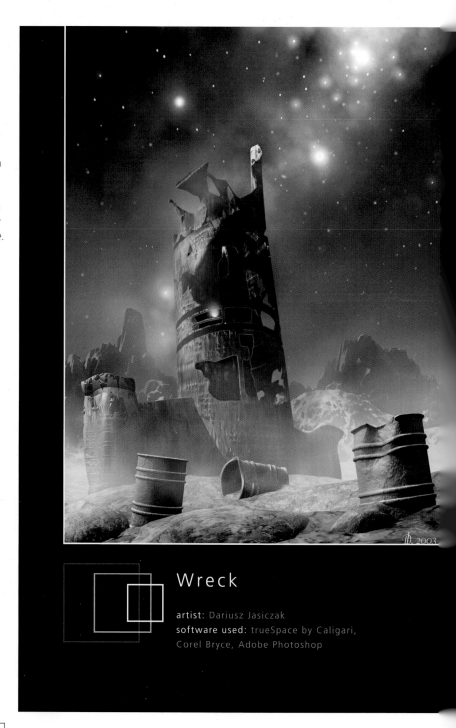

Wreck

artist: Dariusz Jasiczak
software used: trueSpace by Caligari, Corel Bryce, Adobe Photoshop

MODELLING THE WRECK AND DEBRIS IN TRUESPACE

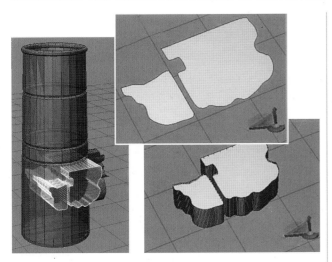

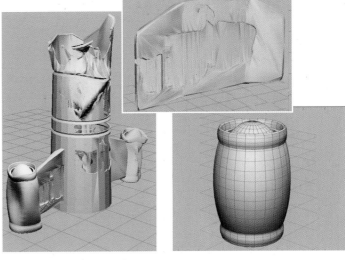

1 In a new scene in trueSpace, I created the main body of the wreck from a basic polygonal cylinder. This was then manipulated with the *Polygon Slice* tool to form three more concentric cylinders, each smaller than the last. These were scaled up and hollowed out to form a central stack with an open top. I placed a torus on top of the open cylinder stack and used the *Object Union* tool to join the two. I then used the *Spline Polygon* tool to create some new irregular shapes. These were extruded into blocks by using the *Sweep* tool and merged into the lower body of the central cylinder stack.

3 I formed engines from two elongated spheres. One was hollowed out, with the top and bottom subtracted and replaced by tori, which I then merged. I inserted a solid spindle-shaped sphere in the hollow and used the *Object Union* tool to join the two. This was then copied to form two engines.

I added a cube to the scene and extended it from one of its axes. The polygons on its sides were extruded and manipulated further to form a trapezium. I then changed this shape – which was to form the main body of the wings – into a NURBS structure. I applied one of the extruded irregular blocks, using the Boolean subtraction method to give the wings an uneven surface. I positioned the wings in the centre of the bottom segment of the tube and placed the engines at the sides of the wings. I further deformed the wings and engines, then the whole object was merged together using the *Glue as Sibling* tool to form the wreck (saved as wreck.dxf).

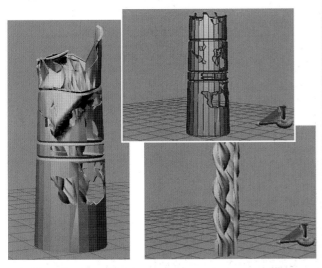

2 Using the *Object Subtraction* tool, I cut the irregular blocks out from the main tube, thereby creating corrosion holes. Moving to *Perspective View*, I selected the *Deform Object* tool to give the highest segment of the rocket wreck a jagged edge. The number of profile curves (visible on the object when using this tool) can be freely decreased or increased using the mouse before starting the deformation. I then used the *Deform Object* tool as well as *Sculpt Surface* to manipulate the control vertices of the top segment of the object to warp the edge. I created another object forming the 'spine' of the ship and placed it inside the hollow. I created more irregular blocks and used them to cut out chunks from the wreck's surface using Boolean subtraction.

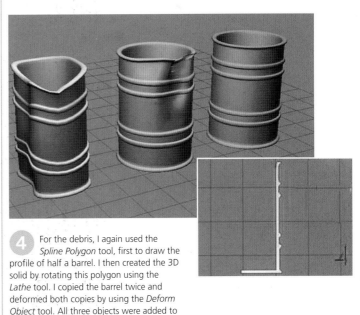

4 For the debris, I again used the *Spline Polygon* tool, first to draw the profile of half a barrel. I then created the 3D solid by rotating this polygon using the *Lathe* tool. I copied the barrel twice and deformed both copies by using the *Deform Object* tool. All three objects were added to the wreck scene and saved.

Anatomy of a Sci-Fi Image

ARRANGING THE SCENE IN BRYCE

6 Clicking the E icon for each separate wreck and barrel element opened the window *Edit Mesh*. I applied the *Smooth* function to each, then selected all imported objects. From the *Materials* window, I chose the Bryce blue-green material from the *Simple&Fast* group to texture the objects. I then eliminated the *Ground Plane* object from the scene.

7 I placed five terrain objects on the back plane of the scene to create a mountainous background for the picture. I sculpted their surfaces in the *Edit Object* window and chose the flat grey material from the group *Simple&Fast* in the *Materials* window.

From the *Create > **Rocks&Trees*** section, I added a Stone #5 object to the scene and copied it twice. I scaled the copies and placed all three in the first plane between the camera and the barrels. I assigned them a chocolate brown material from the *Simple&Fast* group and saved the scene as a composition.

5 I opened a new document in Bryce and turned off the view of the sky (*Sky&Fog > SkyOptions > **Atmosphere Off***). Then I imported the trueSpace model (*wreck.dxf*) and adjusted its size using the control mesh. I set the view to *From Top*, selected a camera and clicked the A icon to open the *Camera & 2D Projection* window. The position of the camera was set at X = 125, Y = 30, Z = 131; the rotation at X = 0, Z = 0, Y = 214; and the value of parameters at Pan V = 239 and Pan H = -15. I then set the view to *Camera View* and imported the barrel objects into the scene and positioned them.

LIGHTING THE SCENE AND TEXTURING OBJECTS IN BRYCE

8 I chose a custom sky view from the *Sky&Fog* options. In *Sky Lab,* I gave the sky the following parameters: *Stars* were set to *Intensity* = 80 and *Amount* = 4500; *Sun/Moon Shadows* were set to 90. In *Sun Controls,* the *Azimuth* was 290, the *Altitude* was 45 and the colour of the light was set to blue. *Stratus* and *Cumulus* were turned off in the *Cloud Cover* section, and I set *Haze* (to the parameters 6, 50, 0) in the *Atmosphere*

10 I copied the undistorted barrel and added a cylinder to the scene. I scaled it down, placed it inside the copied barrel and applied a *Light Glass* material (*Materials > Glasses > Light Glass II*). Next, I added more radial lights and placed them inside the barrel. I grouped all the objects together, scaled them down and placed them high inside the wreck. I applied the black material (*Materials > Simple&Fast > Full Black*) to the wreck's spine and raised the *Specularity* value to maximum.

9 Two spotlights (*Create > Spotlight*) were added to the scene to illuminate the left side of the wreck's top segment and the left engine structure. I placed a radial light (*Create > Radial Light*) between the camera and the wreck, placed a second one near the right wing and shone a third out from the wreck.

11 I mapped the terrain objects forming the mountains in *Parametric* mode with a custom sandstone texture (using *Materials Composer*) based on *Cliffy* sand. I mixed the *Greystone* rock texture with colour in the *Deep Texture Editor*, then mapped it in *World Space* mode onto the ground terrain. I scaled it up in *Object Space* and applied the material to the stone objects.

53

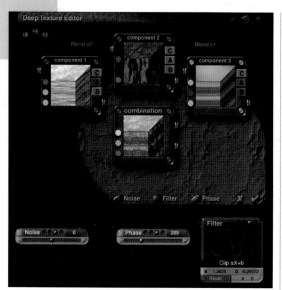

12 I used two textures – *Bump* > **techno city 2** mapped in *World Space* mode and *Basic* > **techno 2** mapped in *Parametric* mode – as materials for the central element of the wreck. For the engines and wings, the material consisted of two textures: *Psychedelic* > **Citylights** and *Rocks* > **Graystone**. Both were mapped in *World Space* mode. Material for the barrels came from the *Clouds* > **Cloudbump 3** texture, also mapped in *World Space*.

I added a sphere to the scene and mapped it in *World Space* with a *Clouds* > **Lowsmog** texture. Using *Materials Options*, I changed this to fog by setting it to *Fuzzy* mode and clicking the *Additive* parameter, then placed it at the right side of the scene. I then saved the scene with the file name 'texture'.

14 I mapped the barrels in *World Space* with a *Rocks* > **Purplerock** texture. A new material formed from two modified textures, *Basic* > **Techno basic** and *Clouds* > **Stormy**, was mapped to the whole wreck (apart from the spine) in *World Space* mode. I scaled down the fog sphere and altered its colour and brightness. I then saved the scene with the file name 'texture_1'.

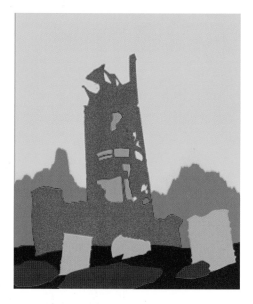

13 I assigned a bright blue-green tint to the sky in *Sky Lab*, changed the position of the sun (*Azimuth* = 275, *Altitude* = 45), reset the stars (*Intensity* = 30, *Amount* = 4500) and chose a pink colour for *Sky Dome*. Using two textures, *Rocky Gray* and *More low smog*, mapped in *World Space*, I created a new material for the stones. I changed the mapping for the second texture to *Object Space* mode, and applied this material to the ground.

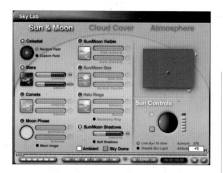

15 I opened the file 'texture' again and removed all its lights. I turned off the view of the sky in *Sky&Fog* and chose a yellow colour from the palette. I turned off all parameters in each section of *Sky Lab*, then set *Ambient* to white, set *Sky Dome* to black and selected *Disable Sun Light*. All the *Stone* objects were selected and the *Materials Lab* editor had all parameters and modes turned off or scaled down to zero values. *Ambient* was then set to brown and the parameter scaled up to 100. In the same way, I selected navy blue for the ground, pink for the barrels, green for the mountains, blue for the spine and red for the wreck. I saved the scene with the file name 'mask'.

I selected the *Anti-Aliasing* option in the *Document Setup* and rendered the scene to disk as a 300 dpi file called 'mask.psd'. Similarly, I rendered the files 'texture' and 'texture_1' as 'scene. psd' and 'scene_1.psd', respectively.

WORKING IN PHOTOSHOP

17 The file scene_1.psd was copied and pasted into the open mask.psd file as the top layer. All colour layers were switched off in the *Layers* palette and *Layer 7* (scene_1) selected. I adjusted brightness and contrast (*Image > Adjustments > **Brightness & Contrast***). I repeated this with the *background* layer (*Scene*). The main colour areas of the image (from the *Background*) were selected in turn (using *Select > **Load Selection***), then I copied and pasted it again in the same place, changing all the selections into layers. After this process, I deleted the green layer and repeated the whole operation for *Layer 7* (scene_1). All colour layers were then eliminated from the file. This left twelve layers, which I sorted into display order and saved as wreck.psd.

19 In *Layer 1* (the body of the ship), I erased the bottom fragment of the wreck to show the layer lying below. Both layers were linked. I repeated this process for each pair of layers, showing the same elements to create depth. For the barrel layer, I took an additional step by increasing the cyan level in *Variations* (*Image > Adjustments > **Variations***). The pairs of layers were then merged in order and I added a new empty layer on top. Using the *Airbrush* tool in the new layer, I painted fog around the wreck as well as faint light from some stars and reflections inside the wreck. I softened the two top segments in the wreck layer by using the *Eraser* and the *Feather* tool on a low setting. I linked all layers and placed some flares (*Filter > Render > **Lens Flare***), then saved all changes to the file.

18 Selecting *Set Foreground Color*, I chose a pink colour and a sample of the sky colour (using the *Eyedropper* tool) from *Layer 7* (the layer without the mountain range) taken for *Set Background Color*. I duplicated this layer and applied a cloud filter (*Filter >Render > **Clouds***). I used the *Eraser* tool set in *Color Dodge* mode to cut out extraneous detail. I duplicated the layer and used the *Eraser* again, this time in *Screen* mode. I linked both layers with *Layer 7*. I used the *Eraser* again to delete the bottom half of *Layer 7* to display the *background* layer underneath, and then I linked the layers.

16 I opened the rendered mask.psd file in Photoshop and made a selection from the red area (the wreck) by using the *Color Range* tool (*Select > **Color Range***). I copied and pasted the selection in again as a new layer. This operation was repeated for all the other colours – except the yellow (the sky) – resulting in a file with six layers and a background. The file scene.psd was copied and pasted into the open mask.psd file.

20 I converted the image first to greyscale and then back to RGB. Using *Variations* (*Image > Adjustments >**Variations***), I gave the image *More Yellow* twice and then *More Red* twice. I copied the resulting image and then closed it without saving it. I opened the original and pasted the variations image on top with the layer in *Soft Light* mode. I erased the fragment of the sky in the upper right-hand corner of the new layer, merged the layers and finally saved all changes.

Creating Clothing

Many of the techniques in this book are concerned with showing you how to build up elements of your artwork from scratch, or how to apply painstaking effects over several hours, even days. There are shortcuts, though. If you don't have proper costumes for your models or don't have time to model in the first place, for example, help is at hand in the shape of third-party objects created by other artists. And not everything in digital art is as complex as it seems. With the power of the tools at your disposal, you'll often find there are simple solutions behind what look like very accomplished techniques.

For *Energize!*, Daniel Murray used a combination of free objects, Poser models and his own method for making quick clothing for sci-fi renders. Using this process, it took the artist just ninety minutes to create the finished scene.

1 Using Poser, I rendered a male figure in the pose and lighting I desired. The model is Daz Production's Michael 2.0. The props for a Kirk-type hero are available online for free at Excalibur Productions (www.xcalpro.com).

There are many sites on the Web offering downloads of costumes and props for applications like Poser and 3ds max. Some of these are on commercial sites, others are offered freely. More information can be found in the Sources pages at the back of this book.

2 I rendered the figure three times: once with a dark grey body, once with a gold body and once with a skin-texture map. I then output the images as tiff files. Tiff files that are output from Poser contain an alpha (or mask) channel which allows for precise figure masking. This comes in very handy for cutting figures from backgrounds.

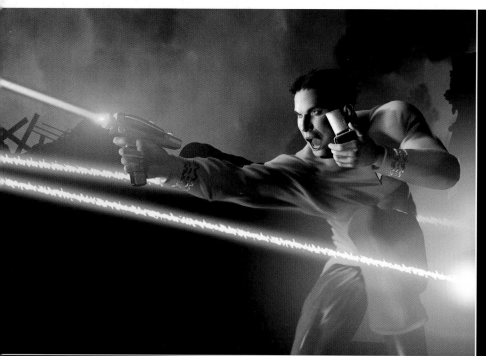

Energize!

artist: Daniel Murray
software used: Poser by Curious Labs, Adobe Photoshop, Michael 2.0 by Daz Productions

3 I imported each image into Photoshop. Using the *New Layer* command, I assigned each image to an individual layer, stacking them from bottom to top: first skin, then dark, then gold. Then, in reverse order, I selected the *Eraser* tool and erased the parts I didn't need. The gold layer was for the tunic, so I erased the gold legs on the dark (trouser) layer underneath. Next I erased the hands, and suddenly I had the beginnings of a costume. I set the *Eraser* to a hard edge and trimmed the parts I needed into their respective shapes. At this point, the image was still pretty rough, but the basics were in shape.

4 Now that the rough parts were in place, I selected the handy *Smudge* tool and began 'pulling' colour to where it needed to go. For digitally painted clothing, the *Smudge* tool is invaluable. While settings are dependent on the image size, usually I use a 20 – 60-pixel brush with a pull value (*Strength*) of between 40% and 85%. This is where a digital pen tool like a Wacom tablet comes in handy, as *Smudging* with a mouse can be a very clumsy procedure. I also used a number of pictures of clothing references to get the basic look and feel of the cloth. There is no better teacher than experience, so I've found that the more I practice with this technique, the more lifelike the effects become.

5 I started to bring the clothing out gradually from the mix of colour layers. All the colours present in the final scene were there in the beginning, just in different amounts and placements. Once the basic *Smudging* was over and the clothing started to take its basic shape, I used the *Dodge* (brighten) and *Burn* (darken) tools to add highlights and shadows to the existing colour information. From there, I applied more *Smudge* work, and the clothing came into its own.

6 I created a simple background for the image, a basic stock forest-fire image with a solid black blob. I kept it simple for two reasons: to give the feeling of a destroyed area, and to avoid distracting the viewer from the main figure, a common problem in 3D work. Simple shapes work best here, and this background additionally evokes the feeling of destroyed buildings.

7 With the proper elements now ready, I dropped the figure onto the background. The phaser (blue) beam and the alien energy beams were easy to accomplish. First, I used a *Line* tool to create a solid-colour line (blue) from the end of the gun to the edge of the picture. Then I created two thin lines of a darker blue on each side of the beam, running parallel on a separate layer. On the thin lines, I applied *Gaussian Blur* (*Filter > Blur > **Gaussian Blur***), just enough to take away the hard edge. At the phaser emitter, I added just a touch of white for the energy release. I used the same technique for the alien beams, with just a bit of a *Ripple* filter (*Filter > Distort > **Ripple***) applied for the jagged effect. Creating the yellow laser strike at the right edge was simply a case of applying white and yellow on separate layers with the airbrush.

Texturing in Bryce and Poser

L. W. Perkins put together *Utopia/Dystopia* to compare procedural textures (textures generated from mathematical formulas) with image-based textures. Bryce has a wide variety of procedural textures that you can apply with a single mouse-click, and these work for glass, metal and water surfaces. The buildings on the right (*Utopia*) are all textured with procedurals, and even the windows and 'knobs' are created with these textures. The problem is that procedural textures look wrong when you use them on organic objects like plants and grass. Their patterns are too regular, and their colours are too flat. This look is better for a cartoon style than for a photorealistic style, but if you are doing animation or game designs, procedurals take less memory than image-based textures.

Utopia/ Dystopia

artist: L.W. Perkins
software used: Corel Bryce, Poser by Curious Labs, UV Mapper by Steve Cox, Adobe Photoshop, Victoria 3 model by Daz Productions, Ember skin for Victoria 3 created by Keith Young and Michele Chang (Spanki and Fatale at www.renderosity.com)

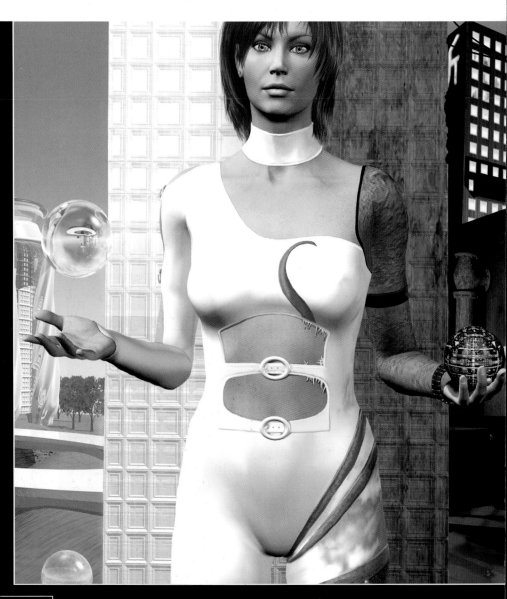

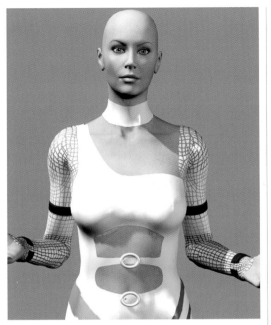

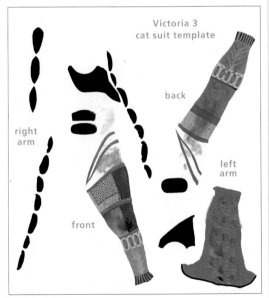

Victoria 3
cat suit template

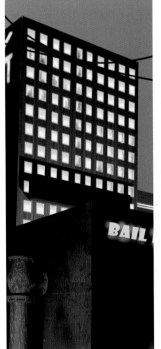

2 This latest texture map was loaded into Poser into the *Render > **Materials*** screen under *Transparency*, with the minimum and maximum sliders set to 100%. The black areas tell Poser what is invisible, and the white areas render normally. It's important to use full black at 100% for Poser if you want to make the area completely transparent. Finally, I painted a bump map (or heightfield, as it's sometimes called) to give the flat map the illusion of a slight 3D texture.

Victoria 3
cat suit template

back

right arm

left arm

front

3 I used textures to make my rectangular boxes look like buildings. Because they were Poser primitives without maps, I first needed to assign texture coordinates (UVs) to the models so I could create a template and paint custom maps for them. I used Steve Cox's free UVMapper for this, because it works great for simple models like spheres, cylinders and boxes. My first step was to export the model out of Poser as a Wavefront.obj file, then I loaded the model into UV Mapper (*File > **Load Model***), which produced a screen showing some statistics about the model.

1 Human 3D models need image maps for their skins, unless you are making a stone statue with a repeated pattern. Here, the human Poser model Victoria 3 is wearing the purchased skin, Ember. A procedural texture might work on her suit, but I wanted clean white on the *Utopia* side and a much grungier, grittier look on the *Dystopia* side. I applied the texture template for the catsuit directly to the catsuit model and rendered it so I could see where the seams on the map came together. Rendering the texture-map grid on a model also makes your task easier when you come to paint the texture map in Photoshop. After doing this, I also painted a map that was just black and white.

Load Model...	Ctrl+L
New Model	▶
Import UVs...	Ctrl+I
Save Model...	Ctrl+S
Save Texture Map...	Ctrl+T
Export UVs...	Ctrl+E
Exit	Alt+F4

building 1
ambience

(4) I wanted a map that used the cubic mapping option, so I selected *Edit > **New UV Map***. I selected *Box* and clicked *OK* to the default mapping size offered me. (You can always size it up later in Photoshop as long as you constrain proportions.) I checked *Save Model*, renamed it to keep it distinct from my old .obj file and then checked *Save Texture Map*. It's important to save a new file and map together with new names because the old model is still ignorant of its coordinates and won't accept a new map. Also, UV Mapper generates a template that is in index colour, so when you open it up in your paint program, convert it to RGB. It will still work fine, and you can paint with the full range of colours for your colour map.

top

side front side back

bottom

(5) You don't always have to map simple shapes. In Bryce, a square image map will be pasted to all sides of a cube, so if only one side shows, you can slap a square texture over the front of it. The Egypt Warehouse was just a cube, so it was easy to put together a texture by using some free resources I had found on the Internet.

6 To give it a bit of bump, I created a greyscale copy of the colour map, and for an 'ambience' map, I also made one that was all black except for the window, so the window would look like it was lit while the rest of the building remained dark.

The screen shows the settings in the *Materials Lab* with each map driving the colour, the bump and the ambient settings.

However, image maps take a toll on Bryce's memory as much as huge polygonal models do. That's why it becomes necessary to use them where they will have maximum effect. I usually use them in the foreground and use procedural textures everywhere else.

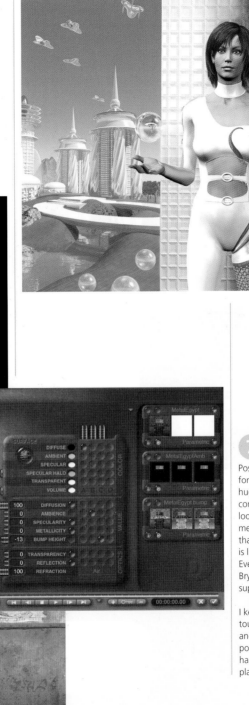

7 Finally, I pieced together the two Bryce renders of *Utopia* and *Dystopia* with the Poser render. I didn't render it as one file in Bryce for two reasons: my PC isn't capable of handling huge files; and by rendering in chunks, I have more control over the process. I can save out pieces that look good, so a small crash here and there will set me back only a few minutes. I also use the software that does the best job for the work at hand. Poser is lightning-fast at putting out a reasonable render. Even taking time for some postwork, it beats Bryce's snail-like progress. However, Bryce has superior lighting and environment capabilities.

To preserve the textures in this particular image, I kept the Photoshop postwork to a minimum, only touching up the Poser render (especially the hair) and fixing composited edges. If you dislike postwork and have a powerful computer that can handle multiple image textures, these can take the place of much manual work and look spectacular.

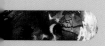

3D Textures in Bryce

The *Materials Editor* in Bryce is a powerful tool that can be used to create distinctive or unique textures for your artwork.

As we have seen in other examples in this book, textures define the colour, pattern or bumps within a material. A material can contain up to four textures, and the *Deep Texture Editor* provides a palette for mixing, altering and creating textures in Bryce. You can dramatically alter the appearance of a material with the custom textures you create in the *Deep Texture Editor*, but be aware that very complex textures can add considerably to your rendering time.

By combining 2D images manipulated in Photoshop with the functions and elements of the *Deep Texture Editor*, Eric Wadley was able to create many of the textures in his image, *Celestial Graveyard*. Here he demonstrates how he made textures for the planet that looms ominously in the background.

1 The skeleton and props were first set up in Poser, then imported into Bryce. After working on the lighting and cloud and fog settings, I was ready to begin working on the textures.

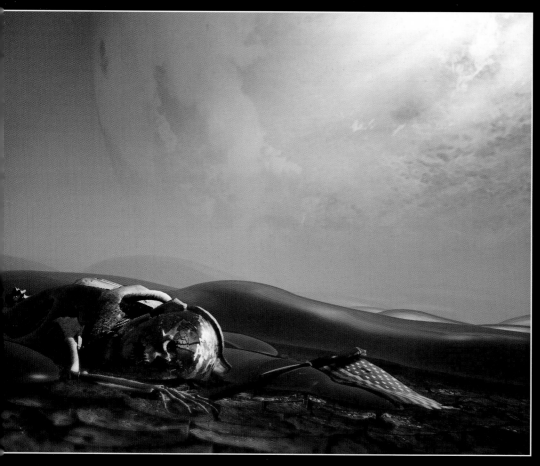

Celestial Graveyard

artist: Eric Wadley
software used: Poser by Curious Labs, Corel Bryce, Adobe Photoshop

2 I found a stock image of an electron-microscope scan of bone texture and opened it in Photoshop. My goal here was to make a texture that was both contiguous and seamless (meaning there are no apparent seams or repeating patterns if I tile the image). To this end, I selected the *Offset* filter (*Filter > Other > **Offset***).

3 To get rid of the obvious seams that appeared after applying the *Offset* filter, I used the *Clone* tool with a large, soft brush and copied other parts of the bone texture over the seams and large dark spots. I was left with a texture that could be tiled without making it obvious where the tiles really are.

4 It was then time to go into Bryce and spice up the seamless texture I'd made in Photoshop. I entered the *Materials Editor* and began with the default *Swirling Water* Bryce texture (under *Waters & Liquids*). I added the 2D seamless bone texture, and after a great deal of experimenting, I came up with a usable texture.

5 I rendered my new texture at 4000 x 4000 pixels. Keep in mind that if you wish to make a large final image, the textures should also be large to avoid pixelation.

6 Going back into Photoshop, I created another 2D texture using an electron-microscope scan of chicken bones. I used the same technique as before (in steps 2 and 3) to make this texture seamless as well.

7 Back in the *Materials Lab* in Bryce, I imported two textures: the rendered version of the bone texture created in step 5, and the new chicken-bone texture made in step 6. I worked on scaling each of the textures in the *Edit* screen, keeping in mind that the pattern had to be small enough to imply that a very large planet was looming in the background of the image. I also played with the rotation and position of the textures so that the right part of the texture would be showing where I wanted it to.

8 Once I completed the texture for the planet, I was ready to apply it to the planet sphere in the scene. At first, the texture looked a little too uniform, but I fixed that by creating a couple of larger spheres with cloud textures on them.

I then used similar methods to create all the other textures in the scene, including using the same 2D bone textures for the ground. After some more lighting and postwork in Photoshop, I had a complete image.

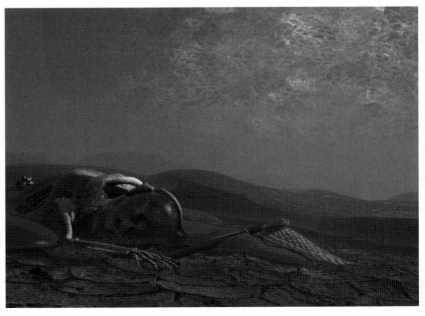

Realistic Lighting

Natural ambient light doesn't come from a direct light source but rather is the reflection of light from all the surfaces in the environment. Certain high-end 3D applications use radiosity algorithms to calculate and simulate ambient light effects, but this is a processor- and memory-hungry operation. Most rendering engines, like those used in Vue d'Esprit, Vue Professional or Bryce, simply provide an ambient-lighting value that illuminates all objects equally in the scene. If used excessively, however, this type of ambient lighting can be responsible for giving an artificial, flat look to shadows. Simply deleting the ambient light source is not a good solution because it causes another problem, that of unrealistic, pitch-black shadows, so here Robert Czarny demonstrates an alternative method to obtain realistic shadows and lighting.

It's possible to effectively simulate ambient light reflected from clouds, sky and ground by adding a few distant weak light sources with very diffuse (25–50%) shadows. Additional lights cast realistic shadows, and less ambient light (*Atmosphere > Atmosphere Editor > Light > **Light Balance***) makes shadows darker.

The best solution would be to cover your sky with lots of these lights to simulate proper light from the sky, but rendering time would increase considerably. Usually three to six dark blue-grey lights will be enough, but you can use more lights for more complicated scene geometry.

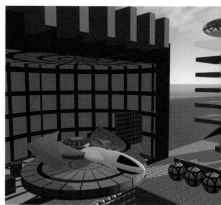

1 You can also add a brown light simulating light reflected by clouds near the sun (for realistic sunsets, for example), or a green light placed under the ground plane to simulate light reflected from the grass. In this case, you should turn off *Cast Shadows* for the ground material; otherwise it will block the underground light (*Material Editor > Effects > **Cast Shadows***).

2 There is no one rule for settings, and you have to experiment each time to obtain best results. For general purpose additional lights, however, you could set *Softness* to 30, set *Enable Shadows* to 95%, and deselect *Lens Flare*, *Gel Material* and *Volumetric Lighting* for each one. Very soft and dark colours should be applied in the *Set Color* dialog: Set *Hue* between 130 and 170 (for blue sky), *Luminosity* to 25–40 and *Saturation* to 30. For realism, additional lights should be similar in colour to the sky in the scene. If you imagine an alien planet with a red sky, additional lights should therefore have a reddish tint. You can also vary colours slightly for different lights.

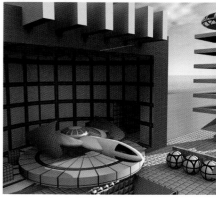

3 To gain precision in setting your lights, it may be useful to temporarily delete all your textures and replace them with flat white materials, but save your scene beforehand to avoid losing the originals. Tune the lighting for the 'white' scene, then select all lights and copy them, load your original scene and paste the lights from the clipboard. If you get satisfying results with the lighting on the flat white material, the setup will be just as good for final textures. Shown here are examples of the scene with textures. The top image is without additional lights – shadows are flat, there is too much ambient. On the bottom is the result with additional lights and realistic shadows.

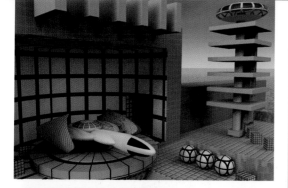

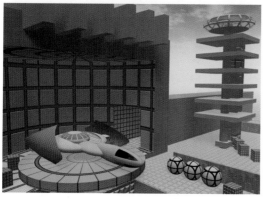

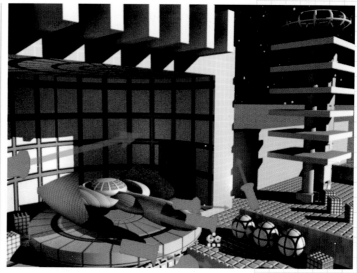

4 When there is no direct sunlight (a cloudy sky, for example), it's impossible to get satisfying results with only one light source. Sunny scenes typically have a high amount of direct light, a low amount of ambient light and pronounced (high-contrast) shadows, while cloudy scenes have a low amount of direct light, a high amount of ambient light and absent or very weak (low-contrast) shadows. Shown here (*above*) is a scene with weak sunlight and soft shadows (*Light Shadow Editor > Shadow Density >* **40%**) plus a lot of ambient light. The result is that there's no shadow under the space ship, too much light in the corridor and so on. The top image has a few additional lights. The main light is attenuated and has soft shadows, so there is no single main sun light and all additional lights have similar settings (low power and soft shadows).

5 Lighting space scenes is even more challenging than cloudy skies. In Vue scenes based on Earth, the main outdoor light source after *Sun* is *Sky Dome*. In Vue's outer-space atmosphere, or on moons or planets without atmosphere, the sky is pitch black, so the shadow contrast is very sharp. Only the light reflected from surfaces and objects can affect the dark shadows. In such a case, light should radiate from below the ground (don't forget to turn off *Cast Shadows* for the ground material), with additional spotlights simulating reflected light. When setting these spotlights, give them soft shadows (less than 40%). They should also emit the colour of the reflecting object. I used cyan to simulate light reflected from the platform of the same colour.

Finally, you should always render your final scenes in *Ultra* mode (*Picture > Render Options >* **Preset Render Quality**), since lower modes produce jagged shadows that can look very bad. Sometimes rendering final scenes with several lights can take a long time, but be patient: the high-resolution results will be worth it.

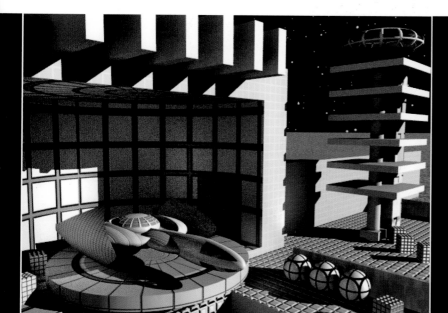

Space Dock

artist: Robert Czarny
software used: Vue d'Esprit
by e-on Software

Surface Modelling

Surface modelling involves creating a set of surfaces to define the boundary faces of a 3D object. There are many surface modelling techniques available in a NURBS-based application like Rhinoceros, including lofting, extruding and revolving curves. Taking his image *Racer* as an example, James Lee demonstrates the technique of building surfaces from edge curves to create a spaceship, using Rhinoceros. Using edge curves to build surfaces not only lets you create free-form shapes easily, but it is a good way to build your model in incremental steps – one surface at a time. This gives you complete control and flexibility over the final design. Combining this with other modelling techniques, you can build terrific 3D models for your sci-fi illustrations.

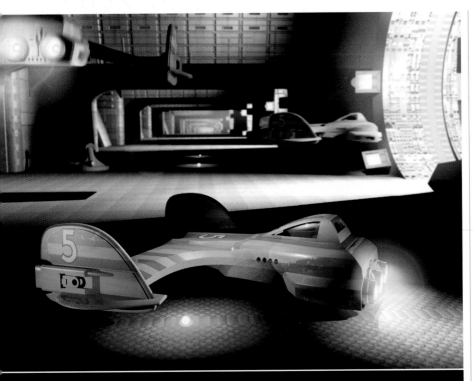

Racer

artist: James Lee
software used: Rhinoceros by Robert McNeel & Associates

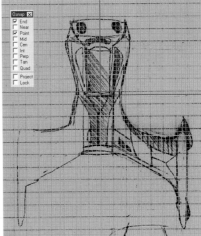

1 I started with rough pencil sketches to develop the general concept for the futuristic racer. These sketches served as good references for building the shapes and establishing dimensions of the craft. Typically, I don't spend too much effort preconceptualizing the model, instead relying on good old-fashioned experimentation during the modelling process to arrive at the final design. I then scanned the top view image of the racer and saved it as a jpeg file. In Rhino, with the *Top Viewport* active, I selected the image to bring it into the viewport (*View > Background Bitmap > Place*). I then scaled the image so that it was large enough to fill the viewport.

2 A surface can be defined by a set of curves that establish its boundaries. To create a set of curves, you will need to make use of all of the viewports to gauge the curves' position and orientation in a 3D space. I recommend starting with one plane (the top view, for example) to draw your surface-edge curves.

In the top viewport, using the sketch as a guide, I carefully drew the curves that defined the basic shapes of the wing as seen from above, including the edges where the surfaces meet. I used a combination of line and free-form curves and manipulated their control points to make adjustments. Sometimes it helped to toggle off the background so I could more easily check the curves I had created. When a curve connected with another curve, I used the *End Object Snap*, which locks the cursor to a specific part of an existing object (such as the end of a curve).

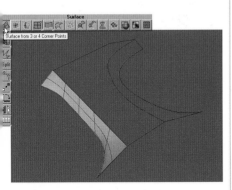

3 To create the first surface, I selected the curves which defined the edges of that surface, then selected *Surface* > **Edge Curves**. This command requires the selection of two, three or four curves. When you come to do this, depending on how you constructed the curves, you may find you have more than four curves that define the surface edges. In that case, you will need to select adjacent curves and join them into a single curve in order to reduce the total number of edge curves. This command also lets you use the edge of an existing surface as an edge curve for creating an adjacent surface. This ensures that the resulting surfaces are using common edges, which makes it easier to join them.

4 I repeated this process until all of the wing surfaces were created. On some surfaces, I had to flip the *Mesh Normals* in order to preview them properly. I used the same techniques to finish the bottom surfaces of the wing. I then selected all the surfaces and joined them into a single surface by using the *Join* command.

5 I then began work on the main body of the racer. Using the top-view sketch as a guide, I created curves to define the general shape of the main fuselage, as well as the outline for the placement of the canopy. A simple rectangle was used to create the hood of the spacecraft. With *Object Snap* on, I made sure that adjacent curves were connected to each other at their end points, and that the fuselage curves terminated at an end point on the wing so that surfaces could be created to connect the wing to the body.

6 Again switching views and turning on the *Ortho* command to restrict the object movement to one axis, I positioned and rotated the curves to establish their 3D orientation. With the *End Object Snap* turned on, I joined the curves with straight lines or other curves to define the remaining edges of surfaces.

7 I built the surfaces from the edge curves by using the *Surface* > **Edge Curves** command. To speed up the process and to ensure the surfaces on both sides were equal, I used the *Mirror* function (*Transform* > **Mirror**), which copies the selected object facing the opposite direction. Once all of the surfaces were completed, I joined them together using the *Join* command.

Using these simple techniques, I created the basic shapes for the ship. To complete the other details and components of the racer (e.g., engines, canopy, rudders), I used the other modelling techniques within Rhino, such as Boolean operations with solids or extruding surfaces and curves. After the model was complete, I exported it as a Wavefront polygon mesh, which could then be used in Bryce to render as part of an image.

Special Effects

Plain images can often be given an otherwordly look with the judicious use of filters in Photoshop. At other times, the clever use of lighting and material effects in 3D applications can achieve a much more startling result. For *Transmission* (inspired by a song by Canadian band The Tea Party), L.W. Perkins assembled a variety of digital elements and textures in Poser, Bryce and Photoshop before using Bryce's *Materials Editor* to apply special surface effects to the mix.

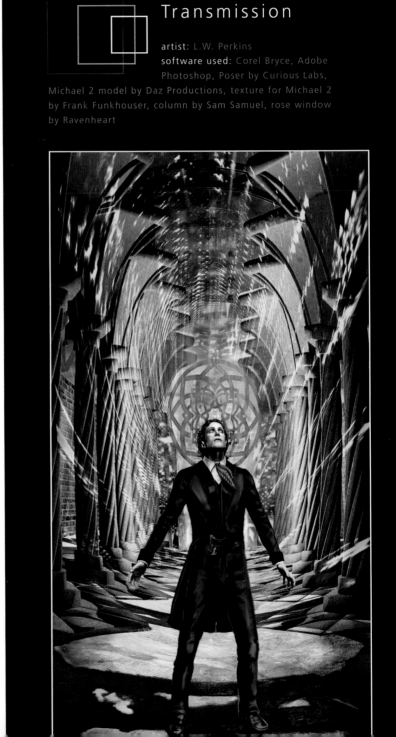

Transmission

artist: L.W. Perkins

software used: Corel Bryce, Adobe Photoshop, Poser by Curious Labs, Michael 2 model by Daz Productions, texture for Michael 2 by Frank Funkhouser, column by Sam Samuel, rose window by Ravenheart

1 I wanted to use a new special-effects technique that I had found while playing around in Bryce, so I set up the image as three layers in order to make use of a separate special-effects layer.

When working on the base background for the image, I wasn't too concerned with perfection. I just wanted to establish a lighting scheme and a mood, and to block out the general shape of the columns and the roof. I knew I would be spending most of my time using Photoshop to paint details because it gives me more precise control, and Bryce's long render times on my PC make it inefficient for detail work. I also find Bryce's *Nano Preview* insufficient and use the *Spray Can* constantly to check my work as I assemble things.

2 I then rendered the Poser figure, being careful to light the face from above to match the light in the background render. Again, I wasn't too concerned with details at this point, needing just the general pose. I layered the background and figure together in Photoshop, painted the clothes and fixed up various small gaps and flaws with digital paint. I also repainted the hands and feet.

3 It took three easy steps to set up the special effects. First I opened a new scene in Bryce and created a torus from the *Create* menu. Next I clicked on the *E* in the *Attributes* bar to edit the torus, and changed it from a fat doughnut to a thin ring. Then I switched to the *Edit* menu and changed the workspace from the default *World Space* to *Object Space* in order to make stretching the torus easier. Then I simply dragged the control handle on the y-axis until I had a long tube.

4 Before I textured the torus, I wanted to clear away the atmosphere, so I went to the *Sky&Fog* editor and used the drop-down menu to turn the atmosphere off. I could have left it the default blue, but for this image, I chose to change it to black. Either works fine; it's a matter of taste. Finally, I deleted the ground plane as well.

5 I opened the *Materials* editor by clicking on the *M* in the torus *Attributes* bar. I then browsed the *Volume* menu, finally chose a material (.mat) file called *Wispy Flames* and applied it. Many surface materials can make great volume materials. Some materials won't convert – and Bryce indicates this by turning off the view of the model in the material preview – but others work great. Clouds are particularly adept at being either surface or volume materials. For the purposes of creating science-fiction effects, the best materials have both ambience and transparency.

The appearance of the .mat can be altered by moving the slider between the tortoise and hare icons. A setting more in favour of the hare will make a less dense, more noisy material with banding. Meanwhile a tortoise setting will produce a smoother, denser material, but it will take much longer to render. For this reason, it's a good idea to do a small test render before committing your computer to a full-sized volume render. For the light streaks in *Transmission*, I had to leave Bryce rendering overnight.

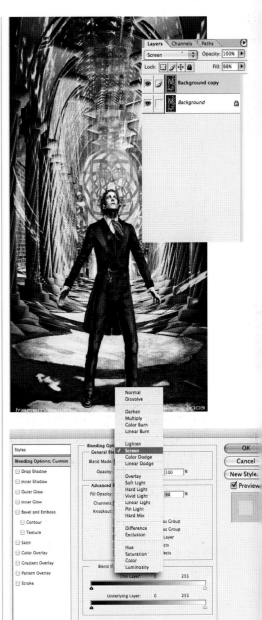

6 Once the render was complete, I opened Photoshop again and put the render above the finished background layer, and experimented with different layer styles to see which ones fitted the look I wanted. Generally I find that the best results come from using a *Normal* layer with a *Screen* layer set above it, with the *Opacity* reduced on the latter. This way you get both the shine from the screen layer and the colour from the normal layer underneath. By experimenting with the different styles and opacities, you can further enhance your special effects.

Setting the Scene

C omposition is key to a successful picture. Whether the scene is simple or complex, the careful positioning of visual elements is essential. In *The Caretaker* by Andy Simmons, an alien gardener tends the very few organic plants still surviving on Allbriea Prime. The scene was largely composed in Bryce with terrain objects laid out in a standard perspective order: foreground left, middle-distance right and distant left and right. According to Simmons, this order produces a good viewing pane, leading the eye into the picture. Then, once the focal objects (created in Poser and Amapi) were put in place, it gave a balanced composition to the image.

The Caretaker

artist: Andy Simmons

software used: Corel Bryce, Poser by Curious Labs, Amapi by Eovia, Adobe Photoshop

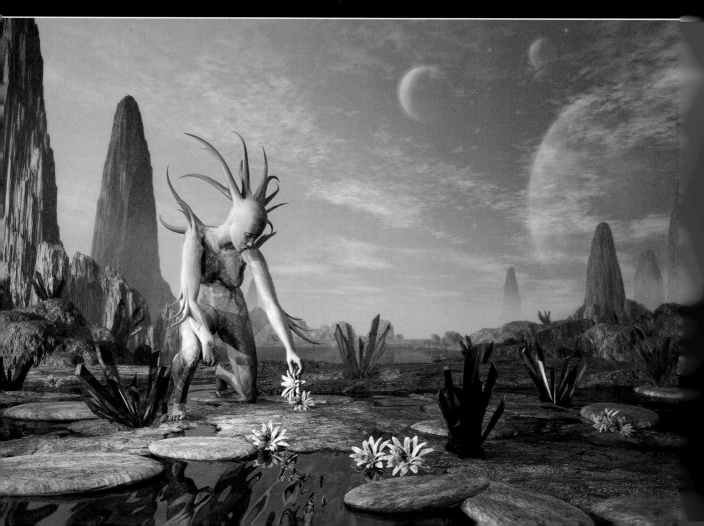

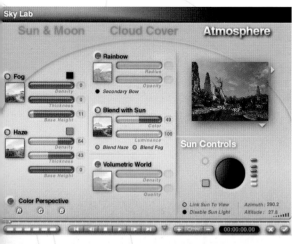

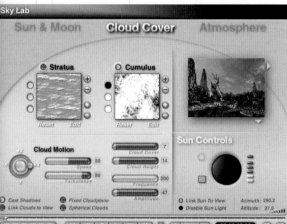

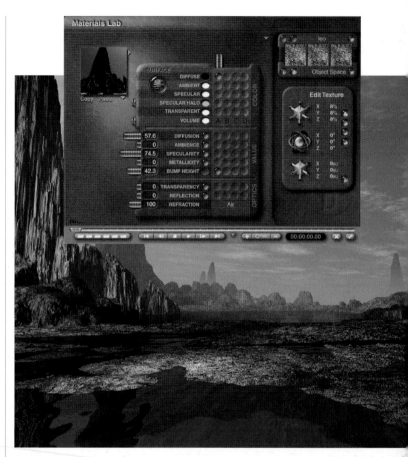

1 Before I started the scene, I needed to create the mood for the landscape. First I selected a preset sky and adjusted it accordingly in the *Sky Lab*. I wanted to use wispy broken clouds to give the scene lots of depth. Manipulating the *Fog & Haze*, *Clouds*, *Sun* and *Ambient* settings produced the sky as shown here.

2 I created the basic terrain using the applications built in landscaping tool, the *Terrain Editor*. I used a 512 x 512 *Terrain Canvas*, since this yields a higher-resolution object when rendered. The shape was created from scratch by using the *Mounds* and *Gaussian Edges* editing tools in the *Elevations* tab, and when complete, it was replicated throughout the scene.

3 The terrains were laid out in a standard perspective order, with a water plain added to add some reflective elements to the final image. With the terrains now in place, a rocky texture was added. Regarding ambience settings in the materials editor, I never use the material ambience in any of my Bryce renders, with the exception of metal/glass-type materials. It tends to wash out the texture unrealistically and not give a true representation of ambient light. I prefer to add lighting and keep the texture high in contrast.

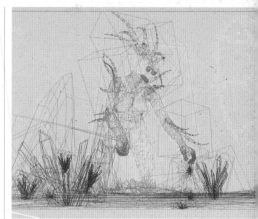

4 With the basic landscape arranged, I added the central figure, crystal shapes and flowers. The tendrils were imported and replicated and placed around the figure's head and arms. This can be tricky in Bryce, since there is only one XYZ viewing pane – most 3D programs offer a standard four-window setup, which makes manoeuvring and placing objects a lot easier.

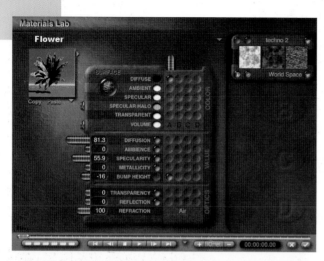

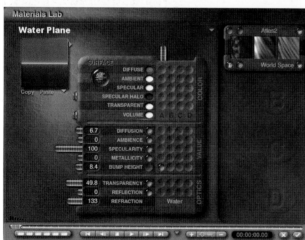

5 A water texture (based on Atlas2) was applied in *World Space* mode to the water plane, and a simple (custom-built) blue patterned bump texture was assigned to the figure in *Parametric* mode with a degree of reflection added. Varied coloured glass textures were added to the crystals and simple coloured textures (based on Techno 2) applied in *World Space* mode to the flower shapes.

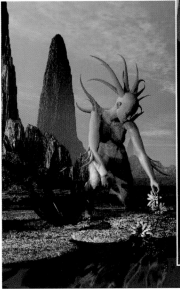

6 Achieving the desired colour for the sky meant sacrificing the strength of the sunlight. I used *Radial* and *Spot* lights to bring light in from the left, focusing each spot onto a different object. The strength of the lights was adjusted to produce a subtle effect around the focal alien and foreground. These images show the light before (*right*) and after (*left*) the additional lighting.

7 More *Spot* and *Radial* lights were placed throughout the scene. Spotlights were focused on the left edge of the high terrain to give the impression of sunlight striking the rock faces. Lights were placed close to the figure, some set as ambient (reflective) light and some to highlight the focal point (the alien) of the image.

With everything in place, the image was rendered to disk with *Normal Anti-Aliasing* selected, *Gamma Correction* off and *48-bit Dithering* on.

8 The rendered image was then taken into Adobe Photoshop for postwork, an essential part of the process. Apart from colour adjustments and correction, I like to touch up and add more elements that would be painstaking to produce in 3D. In this image, I decided to add a distant moon and planets to fill the sky. I created a new layer, then, using the *Circle Marquee* tool, made three circles of varying size and filled them using the *Gradient Fill*. The gradient colours were selected from light and dark sky tones. The *Opacity* of the layer was bought down to 50%, and the dark sides of the moons were blended away more, using the *Erase* tool with a large soft brush.

9 I wanted to blend the tendrils into the alien form by removing the hard edges where the object meshes met. This was done with the *Smudge* tool set with a medium/soft brush and 50% *Opacity*. I used a graphic tablet and pen for brush control, but a mouse would be adequate for this task. I also added a distance-blur effect. This was achieved by duplicating the main layers, applying a 1.3 level *Gaussian Blur* and then using a large soft brush to erase the foreground elements on the layer. This process also had the effect of enhancing the foreground focal detail. The last stage was to apply colour adjustments in hue and tone to finalize the picture.

Postwork: Motion Blurs

Postproduction work is a critical part of creating good 3D images. Whether you are making fixes to your rendered image, adding effects (engine glows, lens flares and so on), or adding details that were not modelled, postproduction can be the most time-consuming yet satisfying phase of the creative process. One useful part of this process is using blurs to add action to your artwork.

In *Flight to the City* by James Lee, a group of ships is racing through an alien cityscape towards a set of large buildings in the distance. To make the image more dynamic, Lee wanted to add a blur effect to convey a sense of speed and motion. While the blur could have been added at the rendering stage, it made sense to incorporate it during postproduction. Doing so gives the artist more flexibility to make minor tweaks to the effect without having to rerender the whole image – a process that might take many hours.

Flight to the City

artist: James Lee

software used: Corel PhotoPaint, Corel Bryce, Poser by Curious Labs, Rhinoceros by Robert McNeel & Associates

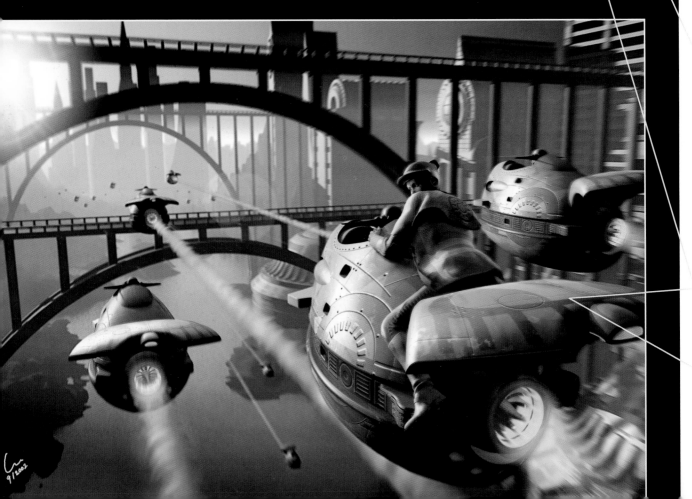

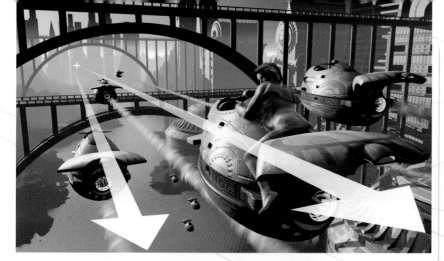

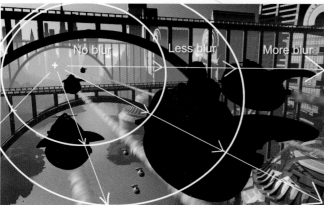

No blur Less blur More blur

2 I created a copy of the image and pasted it as a separate object. I named this object Copy of Background. Making a copy of the image allows you to make corrections in later steps. It also allows you to back out of a mistake easily.

Since the ships will appear stationary, I needed to mask them from the blur effect. Again, I started by creating a copy of the ships. Within Bryce, I created an object mask for the three ships based on the original 3D models, and saved it as a jpeg file. I then loaded the object mask into PhotoPaint by selecting *Mask > Load > Load Mask from Disk* and then selecting the file. I inverted the mask, selected the background layer, and copied and pasted the spaceships as a separate object layer, naming the new layer Ships. I now had three object layers: Background, Copy of Background and Ships.

1 In planning the use of blurs, you should first identify the scene elements that are in motion. Here I could have designed the scene in such a way that the camera is stationary and the ships are racing into the horizon. The ships would be the objects in motion, moving away from the camera. However, I chose a different approach: to have the camera 'flying' with the ships, in which case the surrounding buildings are in motion while the other ships would appear stationary. This allowed me to highlight some of the details present on the ship models, which would have otherwise been lost in the blur.

In this image, I decided the ships would follow a straight path to the centre of the group of buildings in the distance (indicated by the plus sign). The arrows show the direction of movement of background objects.

It's also important to understand that the objects will display varying degrees of motion, depending on their relative distance from the camera. Objects closer to the camera will appear to be moving faster than those further away. For example, those buildings that are on the horizon will exhibit less motion than the set of buildings rushing past the camera to the right of the image. In the second picture, you can see roughly identified zones that illustrate the direction and intensity of the motion.

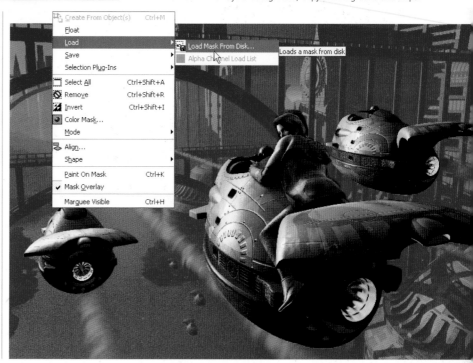

Create From Object(s)	Ctrl+M	
Float		
Load	▶	Load Mask From Disk...
Save	▶	Alpha Channel Load List
Selection Plug-Ins	▶	
Select All	Ctrl+Shift+A	
Remove	Ctrl+Shift+R	
Invert	Ctrl+Shift+I	
Color Mask...		
Mode	▶	
Align...		
Shape	▶	
Paint On Mask	Ctrl+K	
✓ Mask Overlay		
Marquee Visible	Ctrl+H	

Loads a mask from disk

Postwork: Motion Blurs

4 The postproduction motion blur will not be as accurate as what's achievable in a 3D program render. For that reason, you may have to tweak the blur manually to make corrections. For example, the building beyond the first bridge overpass (highlighted) has the same amount of blur as the section of bridge in front of it, even though that building is further from the camera. To reduce the amount of blur selectively, I used the *Eraser* tool to remove areas of the blurred 'Copy of Background' object layer to reveal more of the background object, which had no blur effect. I use an eraser setting with high transparency (85+) and high value (90) for the *Shape Soft Edge* to make subtle adjustments. I then removed the mask created in step 2. I also used the *Eraser* to remove blurs that may have occurred around the edges of the ships due to stray pixels which were not masked.

3 To create the illusion of motion, I wanted to use the *Zoom* effect, which blurs image pixels outwards from a centre point. The pixels closest to the centre point are the least affected, so I wanted the centre point to be the group of buildings in the distance (as identified by the focal point in step 1). I selected the 'Copy of Background' object, inverted the mask so that the ships were masked and then applied the *Zoom* blur (*Effects > Blur > Zoom*). A button to the right of the *Zoom* slider allows you to select a centre point. I placed the crosshair in the image on the distant group of buildings. I clicked on the *Preview* button to see the changes dynamically, then adjusted the *Amount* setting until I achieved the correct blur effect. By increasing the amount of blur, I achieved the illusion of more speed.

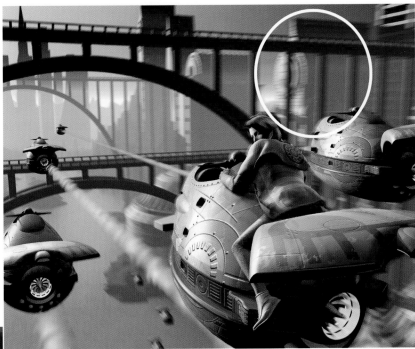

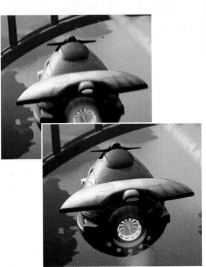

⑤ I wanted to add a subtle motion blur to some of the ships to add more action to the scene. I made a copy of the Ships object layer, which I named Copy of Ships. Selecting the object, I used the *Zoom* blur, placed the centre point in the same place as before, and adjusted the amount of the blur. I was careful not to apply too much blur, because I wanted some sense of motion to come primarily from the buildings whizzing past the camera. Again using the *Eraser*, I made some adjustments to remove the blur on the leading edge and in front of the ships so that the blur created a trailing end. This helped create the sense of forward motion.

⑥ You can also use *Motion* (*Effects > Blur > **Motion Blur***) and *Radial* (*Effects > Blur > **Radial Blur***) *Blurs* to create other motion effects. For example, I applied *Radial Blur* to the ship engines to create a sense of rotating turbines. With a few more finishing touches and other effects, like lens flare and engine glows, I had a completed image that was more visually exciting than before.

Postwork: Light Rays

L ight rays are an efficient way to enhance the atmosphere in an image. The possibilities are endless – just the sun shining through a window or coming from a gap in the roof can really lift an image and add that certain something.

You can achieve the effect in most 3D software applications with the help of volumetric lighting, of course, but sometimes this can be a tricky procedure.

Some applications also increase render time considerably when using volumetric lighting effects.

As shown in this image by Rudolf Herczog, you can instead achieve great results in just a few minutes with the help of Photoshop. Herczog, also known to the digital art community as Rochr, claims this method can be a lot easier when it comes to positioning and controlling the overall look of the beams.

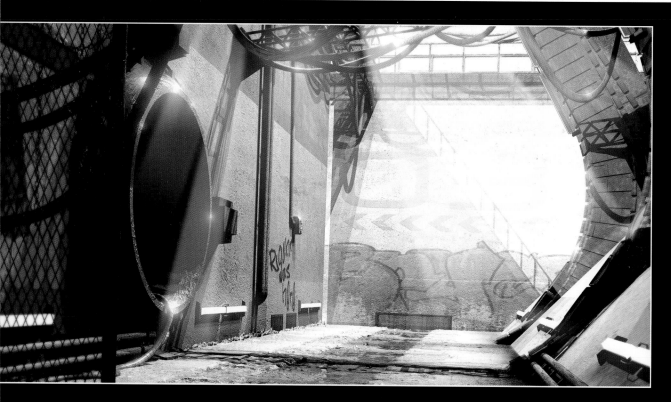

Slum

artist: Rudolf Herczog
software used: Corel Bryce, Adobe Photoshop, Universe Image Creator by Diard Software

1 As you can see, this image lacks atmosphere, and some extra lighting is just what it needs. I started off by opening the final render from Bryce in Photoshop and creating a new layer (*Layer > New > **Layer***). I turned to the *Custom Shape Tool* in the *Toolbox* palette and selected a triangle shape from the top tool submenu (you may have to go into Photoshop's *Preset Editor* to find the shapes you need). Triangles are ideal to use when you're looking for the effect of the light coming through small gaps and cracks. Sometimes you will need some wider rays, and for that you could also use stretched-out rectangles. Both work equally well, so experiment and see which one suits you best.

2 I set the foreground colour using the palette in the *Toolbox*. I made sure to choose a colour that goes with the colour scheme in the render – usually it works best with white or a very light yellow. Naturally enough, rays like these can be used for creating spotlights of all kinds, although spotlights for a stage or a concert, for example, would require stronger colours. For this image, I chose a faint yellow colour. I wanted the image to have a warm atmosphere rather than a cold one with bright white lighting. I created the triangle and stretched it out. The size of the ray cone is entirely arbitrary. I usually let the sides 'hit' a spot with strong reflections, or in some places let the ray slide past it.

3 It was time to set the atmosphere by making the rays slightly transparent and to give the image a hazy look. In the *Layers* palette, I changed the *Opacity* of the ray to 41% to make the beam semi-transparent. As with the rest of this walk-through, this is just a value that suited this image and ray in particular, and thus it should be taken only as a guideline. I always change the transparency of a ray to suit the right spot in a scene. Sometimes I use a wide beam with an *Opacity* of 15–20% in the back, and add stronger, thinner ones set at 35–50% in front.

4 Now I had to soften up the light ray, so in the *Filter* menu, I selected *Blur > **Gaussian Blur*** and applied it to the ray layer.

This action takes the sharp edges off the ray. The amount of blur applied is highly individual. I like to mix strong rays with softer ones to get that hazy look. Very soft rays can also be used as fog, mist and so on. Keep in mind that if something is in the way of the ray – for example, a pipe – there should be a small gap in the ray. I then added another, slightly stronger ray to mark the edge.

5 Once the light ray was positioned, I had to get rid of the sharp ending at the bottom. To make it smoother, I created a layer mask (*Layer > **Add Layer Mask***) and selected the *Gradient Tool* in the *Toolbox*. I selected *Radial Gradient* from the top tool submenu and then clicked and dragged the mouse along the broken line. Sometimes you will need to change the blend mode (*Layer > Layer Style > **Blending Options***) to get the right blending effect. When doing this, make sure that the layer mask is selected first. In *Normal* mode, when you blend the left side and try to blend the right as well, the left will pop back to its original state. By choosing *Multiply*, you will be able to blend freely from all sides.

6 I repeated this procedure for the rest of the rays. Usually one of my images contains anything from five to twenty light rays, depending on how many objects there are in the way of the beams.

I suggest you experiment with *Opacity*, but also with the width of the rays. Be careful not to add too many thin ones, because this will only make the image too crowded and give the scene an unnatural look. Also remember that even though a ray is nearly invisible, it can still add a lot of atmosphere. Often it's the things that are barely noticeable that create the mood of an image.

Postwork: Head-Up Display

Many digital artists enjoy the challenge of conceptualizing and modelling all the elements of a scene down to the smallest details. Whether it's a control panel for a door or a futuristic display screen, the time you spend on these details will help add greater realism to your virtual scene. In *Crush* by James Lee, an alien navigator seated in front of a console is being attacked by the daring heroine. Here, Lee demonstrates an easy way to create the futuristic head-up display (HUD) he created for this dynamic image. According to the artist, there's no better way to complement the console than with a 3D display showing planetary maps and communication screens.

2 Using the *End Object Snap* and a straight line, I connected the ends of the two curves. I created a surface from these curves with the *Sweep 2 Rails* function. Selecting the two curves the two rail curves andthe straight line for a cross-section curve, I hit Enter and clicked *OK*. Finally, I selected the new surface and exported it as a Wavefront (.obj) file (*File > **Export selected***).

3 Before I could paint a texture map for the HUD, I needed to create a 2D map template based on the 3D object. I loaded the HUD .obj model into UV Mapper, a freeware program that lets you easily create texture-map templates from Wavefront .obj models. These templates can be used in any 2D paint program to make texture maps, bump maps or transparency maps for your renders. I saved the model with a different name in order to preserve the original (just in case), then saved the texture map (*File > **Save Texture Map***). In the *BMP Export Options* dialog box, I changed the dimensions of the bitmap size to provide the appropriate resolution. For the HUD – a flat rectangle that wraps around a circular console – I used 1280 and 200 for the width and height. If you want a lot of detail, choose a larger bitmap size, at the expense of a slower render.

4 I opened PhotoPaint, and because the bitmap is an 8-bit image, I converted it to a 24-bit RGB file (*Image > Mode > **RGB Color** [24-bit]*). I made a copy of the background image and pasted it as a separate object, then renamed this object layer as Guide. I then applied the *Fill* tool to make the background layer black, since the texture map would also serve as a transparency map, where black represents transparent areas. I changed the *Transparency Mode* of the Guide object to *Divide* so that the black lines became white, which made it easier to view against the black background.

1 For this scene, I wanted a simple HUD that encircles the control console. Opening a new scene in Rhinoceros, I created a curve in the *Top* viewport to represent the basic shape of the HUD. I used the *Curve Offset* command on the curve to create a larger one with the same curvature, which would form the top of the HUD. From the *Front* viewport, I moved the top curve above the bottom curve to represent the height of the HUD.

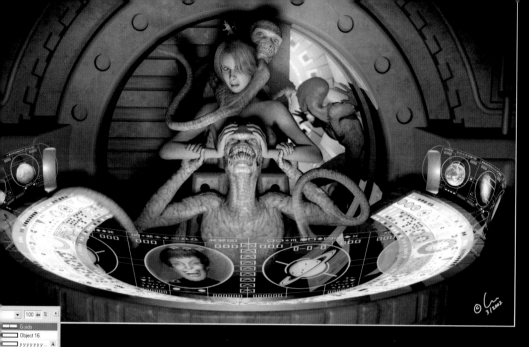

Crush

artist: James Lee
software used: Corel
PhotoPaint, Corel Bryce,
Poser by Curious Labs,
Rhinoceros by Robert
McNeel & Associates,
UV Mapper by Steve Cox

5 I kept the Guide layer on top as I created subsequent object layers for grids, indicators and other screen elements, using paint, line, shape and text tools. I created planetary maps and communications screens by copying and pasting images and adding a layer of 'digital' indicators to make the screens look functional. Fonts like WingDings or WP BoxDrawing were used to create alien text. Since objects that are black will appear transparent in the rendered image while white objects will be more opaque, I tried to select vibrant colours for the display elements so that they would be visible in the render. Before saving the texture map as a .bmp file, I removed the Guide layer by deleting the object, and then I flattened the object layers.

6 I imported the .obj file into Bryce and positioned it over the console, then clicked on the M next to the newly imported object to access the Bryce *Materials Lab*. I clicked on column A for *Diffuse* and *Transparency*, then set the *Diffusion* and *Ambient* amount to 100. I clicked on the P button in *Texture A* to make it a bitmap texture. Then, clicking on the *Texture Source Editor* button, I loaded my HUD texture-map file as both the *Pict Image* and the *Alpha Image*. (Note: Bryce converts the texture file as a greyscale image.) Returning to the *Materials Lab*, I made sure that *Blend Transparency* was selected under the *Material Options* so the transparency would work properly. I also changed the texture's X-rotation in the *Edit Texture* settings to 180 to correct its orientation.

7 Finally, I added lights to illuminate the head-up display properly. However, to limit the amount of light hitting the other scene objects, I adjusted the *Intensity*, *Edge Softness* and *Falloff* settings in the *Lighting Lab* (accessed by clicking the E button next to the light's bounding box). With proper light settings, the HUD appeared to be glowing internally.

Postwork: Warfare

Scenes containing large numbers of elements and characters usually take a long time to render. One such image is *Last Stand* by Soheil Khaghani, inspired by characters from the game StarCraft, by Blizzard Entertainment, and films such as *Aliens* and *Starship Troopers*.

After using 3ds max to create this massive image, which contains more than 2000 characters as well as meshes, skins and textures, Khaghani decided to finish

as much as possible of the picture using Photoshop, in an effort to keep rendering time to a minimum.

When researching ideas for his scene – a large battle between two deadly enemies – the first thing Khaghani noticed was that something the games and films of this genre had in common was that the majority of weapons used by humans were projectile weapons, like machine guns, rifles, rockets and missiles. There were also some laser weapons, but they

were mainly used by fighters and tanks. These, then, were the effects that Khaghani wanted to develop as postwork in Photoshop instead of 3ds max – a combination of motion blur, smoke, fire, bright lights and lens flares.

These effects could have been created in 3ds max, but using Photoshop to create and composite postwork in this way allows the artist to use a larger variety of effects than a standalone 3D program could provide.

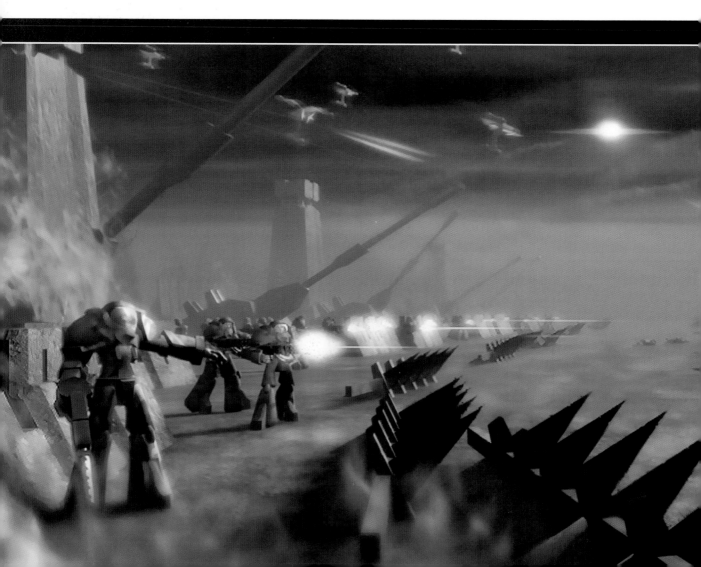

1 To create the smoke trails in the background, I began by creating a new layer for the scene in Photoshop, then selecting the *Brush* tool (I made a custom brush from a selection of the background). I selected the *Brushes* tab, then under *Shape Dynamics*, I set the *Size Jitter* to 50% and set the *Control* pop-up menu below to *Fade* with 300 as the value. Selecting *Other Dynamics*, I set both *Opacity* and *Flow Jitter* to 100%. Now when I used the brush it drew elongated streams of smoke. To add lighting, I double-clicked on the smoke-trail layer to bring up the *Layer Style* menu. Here I selected *Bevel* and *Emboss* and set *Depth* to 50%, *Size* to 15 and the *Soften* value to 0. Below *Shading,* I set the *Angle* to 40, the *Altitude* to 15, then the *Shadow Mode Opacity* to 50%.

Last Stand

artist: Soheil Khaghani
software used: 3ds max by discreet and Adobe Photoshop

2 There are a few ways to create the flare at the end of the smoke trail. The *Lens Flare* filter is one method, but the image has to be flattened down to a single layer for this to be applied. Another way is to create a new layer on top of the smoke-trail layer and then use brushes to make the flare. I used this method because I appreciate originality in an image as well as having more control over the outcome. So to do this, I selected a round brush and set the *Roundness* to about 80%, then clicked at the end of the smoke trail to create the flare itself. Now, to create a light streak, I just reselected the *Brushes* tab, reduced the *Roundness* in *Shape Dynamics* to 4% and increased the *Diameter* so that the brush head became about five times as big. I then placed the light streak in the middle of the flare, as shown in the image here.

Postwork: Warfare

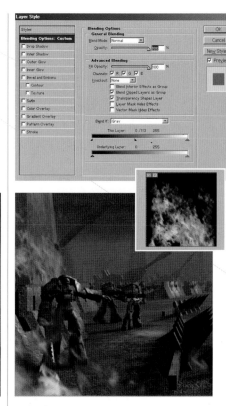

3 Now it was time for the motion blur. I started by duplicating the background image to create a new layer on top of it (we'll call this Layer 1, to make things easier). I made Layer 1 invisible by clicking on the eye beside it in the *Layers* window. Clicking on the background, I selected *Filter > Blur > **Motion Blur*** with an *Angle* of 0 and a *Distance* of 15.

I made Layer 1 visible again and selected it for use. I picked the *Eraser* tool with a *Round Brush* and *Hardness* set to 0, then set *Opacity* to 50%. Now I could simply erase the parts of the image that I wanted to be blurred. I used the brush sparingly, since I still wanted some details to be seen.

4 There are several ways to give the impression of a burst of flame coming from the muzzle of a gun, and I'll show three here, but they all share a common beginning.

I created a new layer and cycled through the *Brush* tool to the *Pen* by holding down the left mouse button on the *Brush* tool icon (you can also do this by pressing Shift + B). I zoomed in to draw the outlines of the flames from each barrel with a white colour, then filled them in with the *Paint Bucket*. For some, I applied *Filter > Blur > **Gaussian Blur***. For others, I used *Filter > Blur > **Radial Blur***, placing the blur centre to the far left and a bit down. I changed the *Radial Blur* method to *Zoom* and set the *Quality* as *Draft*. This gave the blur a grainy look. The third way I applied flame bursts was to use the *Smudge* tool to blur out the sharp edges. After each of these methods, I double-clicked on the layer and selected *Outer Glow* from the *Layer Styles*.

5 I wanted to add some flames to the foreground to fill up the empty space at the bottom left of the picture. To do this, I opened a stock image of flames in a new window, then copied it to the main picture. Pasting the flames automatically created a new layer. Since the dark parts closer to the edge of the flames were more transparent than the flames' core, I had to double-click on the layer to customize the *Blending Options*. In the *Blend If* section, I dragged the right side of the black *This Layer* slider towards the white side while holding down the Alt key. This gradually made the darker colours transparent. Then, to fit the flames into the scene, I selected *Edit > Transform > **Skew*** and resized them.

6 The glass on the space-marine helmets could easily have been created using 3ds max, but I wanted facial expressions to be clearly visible through the glass and also wanted the light to be reflected in a certain way. It also took a fraction of the time to create the glass using Photoshop. Again I began by creating a new layer. I zoomed in and selected the *Polygonal Lasso* tool to mark the area for the glass on each marine helmet. I then used the *Paint Bucket* at a low *Opacity* of 35% and no *Hardness* to paint the area.

7 To create the laser sights on the tower sniper's rifles, I used the *Line* tool at *Weight* 1 to draw six lines, on separate layers. Using *Merge Visible*, I then merged the six layers down to three by putting the lines emanating from the same tower together. The layer with the lines furthest back in the image should be faintest, so I just lowered *Opacity* to 10% and set the one in the front to 20%. To give the laser light a more realistic look, I applied *Outer Glow* in the *Layer Styles* window, then used the *Eraser* tool set at 50% *Opacity* to erase certain parts of the line.

Finally, to give the image a softer look, I flattened it down to a single layer and duplicated it to create a copy of the background on a new layer. I reduced the *Opacity* of the new layer to 50%, then selected the background and applied some Gaussian blur (*Filter > Blur > **Gaussian Blur***).

To finish off the lights and colouring, I selected *Image > Adjustments > **Color Balance***, then worked mainly with the shadows and highlights. I was still not satisfied with the flares, so I used the *Dodge Tool* with the *Range* set to *Highlights* to touch them up.

Playing God

The walk-throughs in the following pages are organized according to subject matter rather than by technique. This section covers a diversity of topics, from alien ships to alien plants; mad scientists to mechanoids; inner space to the outer rim of the solar system. As such, these pages should provide inspiration for the majority of science-fiction scenes you have in mind and provoke ideas for some that never occurred to you before.

The techniques demonstrated here are intended to be adapted to your work, not followed to the letter. So take the plunge and start creating your own universe.

The Summoning

artist: Michele Chang

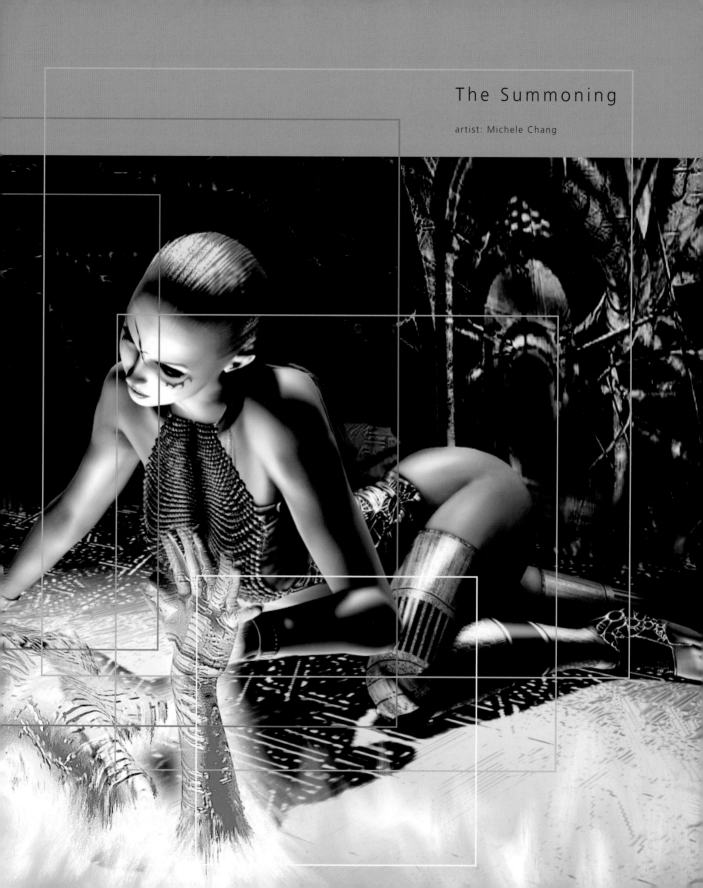

Mad Scientist

The classic depiction of the mad scientist is of a crazed individual working on some kind of high-tech gadgetry in his lab, sparks and electricity flying all around. A good example is *Mad Scientist* by Roberto Campus, part of a series of fourteen images made by the artist for a trading-card game. Campus decided to go for a cyborg as the subject of the scientist's experiment, since it allowed the artist to put a modern twist on an image reminiscent of 1940s and 1950s pulp magazine covers as well as adding a touch of gore to the picture.

Mad Scientist

artist: Roberto Campus
software used: Adobe Photoshop and Corel Painter

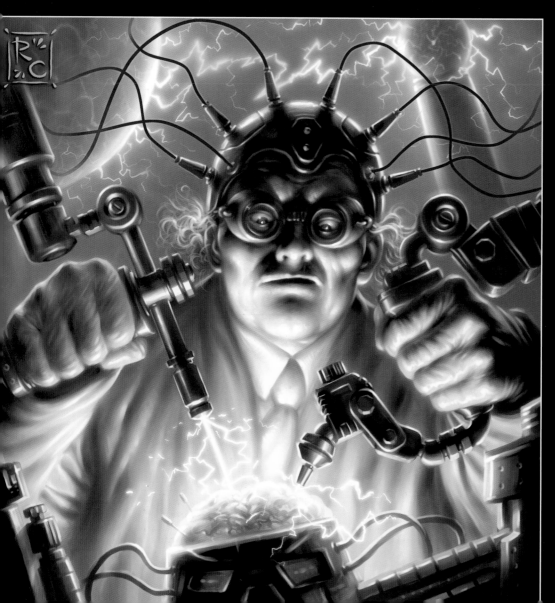

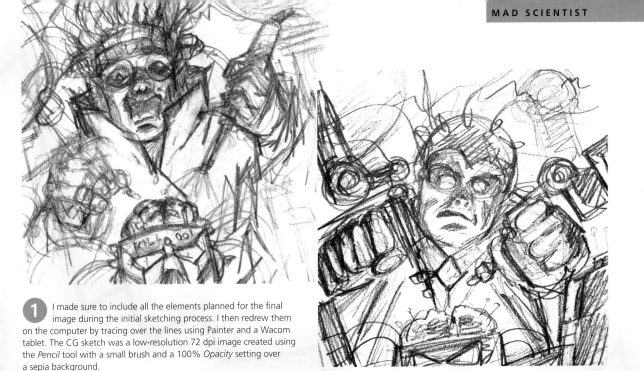

1 I made sure to include all the elements planned for the final image during the initial sketching process. I then redrew them on the computer by tracing over the lines using Painter and a Wacom tablet. The CG sketch was a low-resolution 72 dpi image created using the *Pencil* tool with a small brush and a 100% *Opacity* setting over a sepia background.

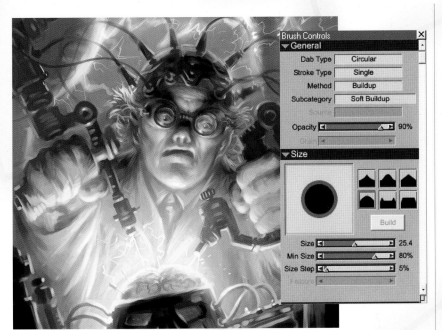

2 I continued using Painter for the main blocking phase. I resized the image to 300 dpi, then switched to the *Airbrush* tool with a medium-sized brush and medium *Opacity* setting. I picked a few base colours, put them in a corner of the image for later reference, then started filling up all the various areas, right over the original traced sketch (on a single-layer flat image). I don't add fine details in the blocking process and usually force myself to use the same brush size at all times. Then, by using the colour wheel to pick a lighter or darker colour than the base, I painted highlights and shadows. Throughout this stage, I used the Alt key to pick colours while I moved from area to area.

3 Next up was the main painting stage, when I refined shapes and added details to the foreground elements. Here I concentrated on reshaping all the forms to their final position and dimensions. I switched to the Painter *Brushes* tool and a medium *Opacity* setting, then I used varying brush sizes, but with regular, small and more carefully positioned strokes.

Mad Scientist

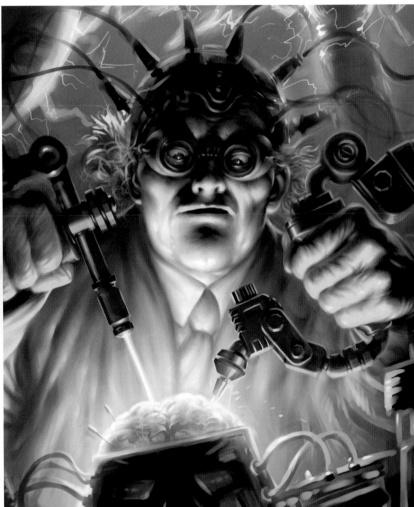

4 I soon realized that in order to achieve a higher level of realism for the face and hands of the main character, I had to rely on some reference material. Using a cheap digital camera (an invaluable tool for the digital artist), I snapped a few pictures of my face and hands illuminated by a light source coming from below. I imported the low-res photos into Painter, desaturated them and kept them handy (to the left of the actual illustration) while I was finalizing the face and head elements. Using a photo reference makes it easier and less time-consuming to achieve a higher level of realism.

5 The rest of the elements were created completely from scratch. As they mostly consisted of simple shapes, it wasn't too difficult to imagine how the light sources would play on them. The background and some of the foreground (the cables coming out of the scientist's helmet) were to be refined later in Photoshop.

6 I imported the image into Photoshop, copied the canvas layer and cut the foreground elements from the background, using the *Eraser* tool. Now I had the foreground elements (scientist and gadgets) separated on a layer called FG. I turned off this layer and proceeded to paint over the background on the canvas layer (which I then renamed BG). Using a large, simple, round brush set on *Normal* mode, I fixed up the background colours, then refined the shape of the Tesla coils.

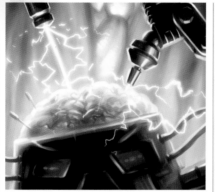

9 Using the *Dodge* tool set on *Highlights*, I went over all the spots that I felt needed to be brightened up and brought to prominence. I flattened the image to a single layer called Art, then duplicated that layer and called the new one Glow. I then applied a *Gaussian Blur* with a large radius effect to the Glow layer, obtaining a very blurred image. I set the *Blending Options* on Glow to *Lighten* and lowered its *Opacity* to 10%. Now, with the original layer showing through, the image highlights looked softer and more natural. Finally, after flattening the whole image, I applied a few adjustments to its contrast and colour balancing by using the *Curves* and *Color Balance* tools.

8 I added sparks coming out of the tools held by the scientist, using the same technique as before – but this time I used a light yellow colour. I flattened the whole image into a new layer. It was at this point that I noticed that the painted highlights were not bright enough.

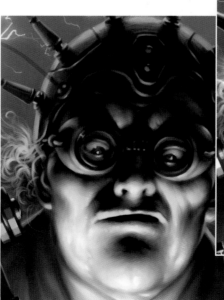

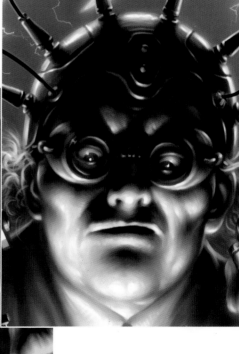

7 I added a new layer on top of the BG layer and called it Sparks. Here, I painted the electric sparks using a brush with a pink/bluish colour and 100% *Hardness*. To add a glow to the sparks, I added an *Outer Glow* effect in the *Blending Options*. I then merged the BG and Sparks layers. I turned the FG layer back on and added a new layer on top. I painted the cables coming out of the helmet, then added a soft *Outer Glow* effect to them in turn.

Cyborgs: People of the Future

Besides genetically modified humans and supermen, a common theme in science fiction is the mechanically augmented human, or cyborg. Such combinations of man and machine are often terrifying – but sometimes they are tragic, as seen in this composition, *Being Human*, by Ian and Dominic Higgins, a partnership also known as Eon.

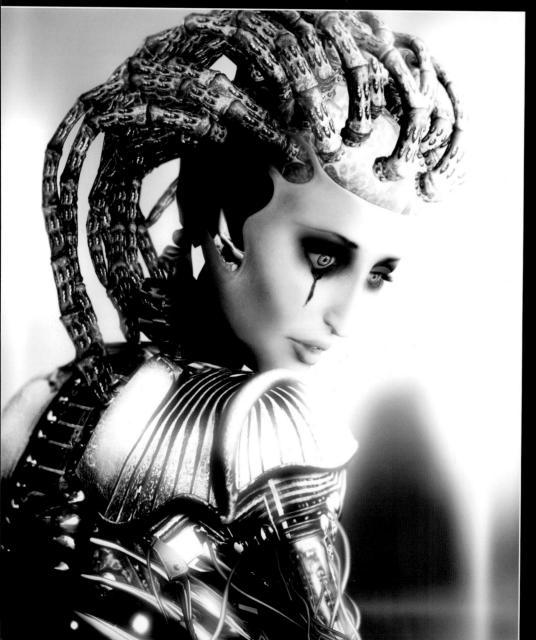

Being Human

artists: Ian and Dominic Higgins
software used: Poser by Curious Labs, Adobe Photoshop

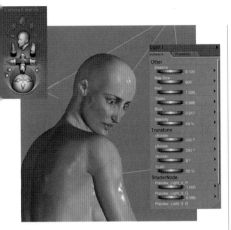

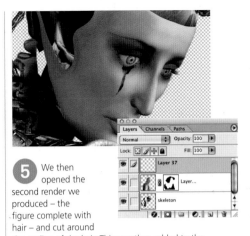

1 The character was created and rendered in Poser. Our starting point for the cyborg was the Victoria figure from Daz Productions. Using a combination of *Morph Dials* and *Magnet*s, we reshaped her features. With the modelling work done, we positioned her and selected the camera angle. We then set up the lighting. Be prepared to spend a lot of time on the lighting of your scene, since it determines the whole mood of the piece. We used high-key lighting on the face to soften its features. All shadow maps were increased to their maximum settings.

3 In Photoshop, we created a new canvas and named it Being Human. We opened up the first render we did and made an alpha channel selection of the figure. We then copied and pasted the figure into our new canvas and named this layer Render 1. Next we opened the skeleton render and again, using the alpha channel as a selection, we copied and pasted the figure into the new canvas. This layer was named Render 2.

With Render 1 as the top layer, we carefully began to mask away parts of the image to reveal the skeleton beneath.

5 We then opened the second render we produced – the figure complete with hair – and cut around the outline of the hair. This was then added to the Being Human composition.

Using the *Masking* tools, we blended the hair to the skull. We then began to paint in the details, such as the wires and the tearstain. We masked away the area around the ear to expose the metal skull beneath.

Using the *Burn* and *Dodge* tools, we enhanced the shadows and highlights. Once we were finally happy with everything, we blended all the layers together.

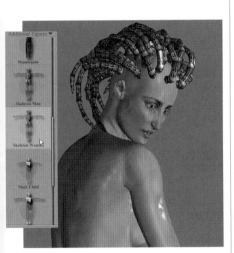

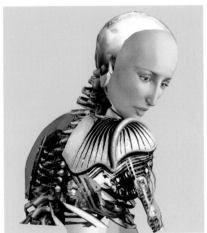

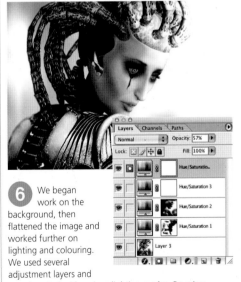

2 We produced a second render of the character complete with 'hair' piece. Next we opened the *Figures* library, selected the female skeleton from the *Additional Figure Library* and chose *Replace Current Figure*. We made sure to click all the options like *Replace Figure*, *Maintain Figure Height* and *Pose*. We now had a skeleton posed in our character's place. A little adjustment of the camera angle was necessary, however, as the new figure's height was dramatically less than that of the higher-resolution model we'd used for the character. The skeleton was then rendered out.

4 Next we worked on the figure's mechanical elements. After searching, we found some interesting images and textures of such things as old circuit boards and rusting metal. Cutting and pasting sections of these images, we began building up the torso area gradually, using the *Distort* filters and the *Liquify* tool to shape them. When using *Liquify*, we chose a light pressure setting so as to not blur the image too much. We also paid attention to the direction of the different elements' shadows and highlights to make sure they all matched the 3D render.

6 We began work on the background, then flattened the image and worked further on lighting and colouring. We used several adjustment layers and experimented with various lighting modes. By using the *Masking* tool on these layers, we could quite literally paint on lighting effects. When the lighting and colouring work was done, we flattened the image once more. We duplicated the layer and applied the *Gaussian Blur* filter, set to 40 pixels diameter. We faded this layer to 15% *Opacity* to soften the shadows and highlights a little. Finally, we flattened the image and saved the composition.

Building a Robot

Robots are, of course, a very important part of sci-fi art. Mostly they exist in the realms of pure science fiction, but some artists are able to design realistic mechanoids based on common occupations and tasks of the present day.

Henrik Boettger, Max Zimmerman and their team at FiftyEight 3D GmbH wanted to create such a robot, so they had a brainstorming session about its style, how it would move and what kinds of behaviour and characteristics it would display. The resulting robot was Cody-58, an eight-foot-tall robot designed to take care of small children.

After those first sessions, FiftyEight 3D GmbH began designing the style of Cody-58 in detail, as well as the main elements of its body.

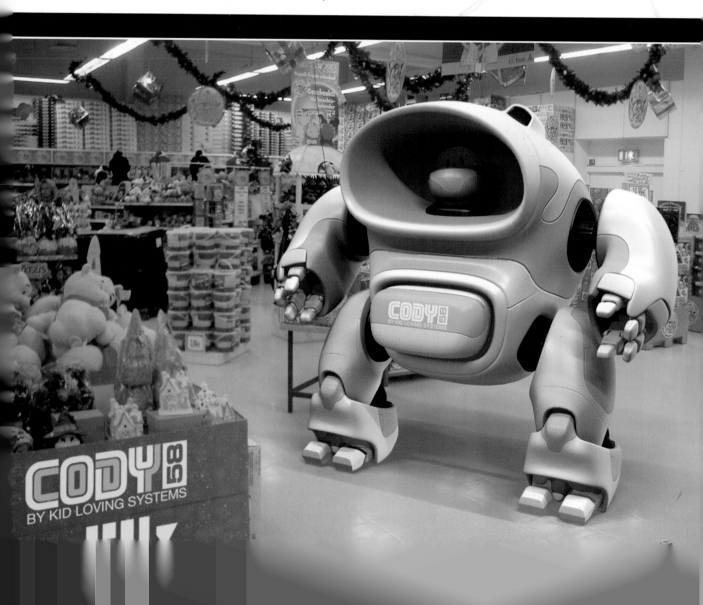

1 First we created several concept drawings and different sketches of the mechanical hardware. This is a fun stage because you can design whatever you want, bring up lots of ideas and create your own look. As a result of this process, we created a very unique 'toon' character. From these concepts, we went on to define the details of every element, as well as the function of movable elements like arms and legs and how they interacted. We also thought about the way the robot moves and the materials to use for its construction.

Cody-58

artists: Henrik Boettger and Max Zimmerman at FiftyEight 3D GmbH

software used: SOFTIMAGE| XSI, Adobe Photoshop

2 Further sketches went into even more detail. Finally we drew highly detailed concept sketches with the robot and elements in position. These clean drawings were the blueprints for the next step, the modelling. The concept sketches were put in the background of the different viewports as a reference from which to build the various parts of the model.

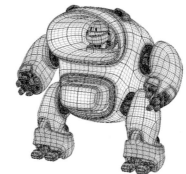

3 From simple primitives like cubes and spheres, we extruded and split polygons and edges to create a rough model. It is very important to keep the geometrical symmetry in the object while you are working – it makes it easier and cleaner to build up the rough parts. Everything was modelled with polygons, except the screws, which are NURBS objects.

After we had assembled the whole robot out of PolyMesh primitives in this way, we started to clean up the shape. During the whole process, we tried on one hand to add enough detail to define the shape of the robot, while on the other we tried to avoid having too many faces and edges, as this would not only reduce real-time feedback but also would have made later changes more difficult. We also tried to concentrate on the topology of the robot, so that the object had a clean and even mesh surface.

It was important not to smooth the surface too much, however. We tried to build everything in the rough as much as possible, but we knew we could, at any time, take advantage of the flexible resolution of XSI, which allows you to smooth the surface quickly by pressing the + (plus) key.

Building a Robot

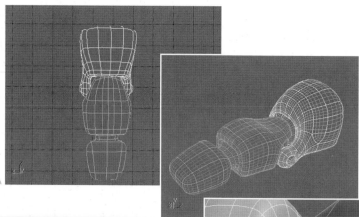

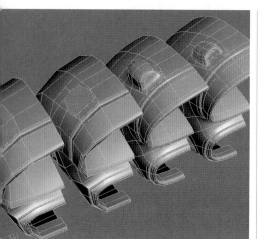

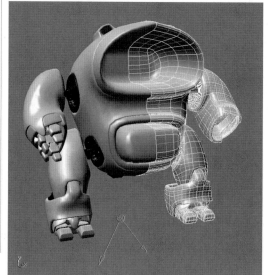

5 To specify the scale of the robot, details like the edge radius of each element and their relative proportions were very important. For example, we first defined the edge radius of the arm itself (*A*), then defined the fingers to make sure that they didn't just look scaled down (*B*).

To define the radius, we simply selected edges and used the *Bevel Components* function (*Modify > Poly.Mesh > **Bevel Components***), made sure that the model scaling was frozen and then chose relative values in the *Bevel* operator (*C*). Another very useful function was the *Set Edge Crease Value* (*Modify > Component > **Set Edge/Vertex Crease Value***), which helped to avoid making the surface edges too hard (*D*).

4 We added details like cables and air vents. The shots of the body shown here display the different steps of the procedure. We tried to give the air vents a distinctive 1950s look.

This detailed modelling helps to make the robot much more real and believable and is therefore a very important part of the process. During the concept stage, we decided that a few parts of Cody should be made out of plastic (its fingers, for example), and between these we wanted to have electronic elements, covered with a rubber material that would deform itself during rotation. The plastic parts were to remain stiff. The fingers had been modelled in one size only: this is something we always do if the object is symmetrical, even down to the smallest detail, like fingers.

6 After every detail was added, we went on to the final step of modelling: we mirrored the modelled half of the robot vertically and merged the two elements to create one whole robot. For this, it was necessary to align all the tags on the edges that were connected along one axis, then we duplicated the object, froze the new merged object, and deleted the two old single parts. Now the object possessed a symmetry map, so when we moved the left side, the right side responded accordingly.

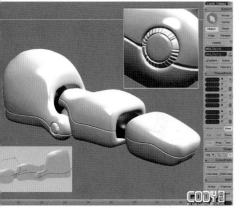

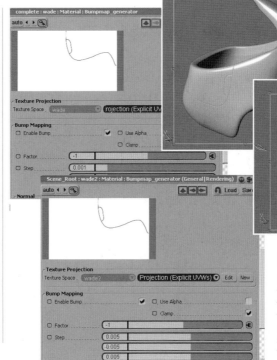

7 Moving on to the materials and textures stage, we first needed to define a colour scheme and surface behaviour – how light would reflect off the surface, for example.

We defined which elements were glossy or dull, or whether they should look like metal or plastic. We applied textures like logos and icons to some parts, while to other parts we added scratches to make Cody look worn out and older. This helped us make the robot look more convincing, so we used bump maps to create details on the surfaces.

9 As a rule of thumb, the textures used should be at least at the same resolution as the final rendered image. In this case, we needed only a black-and-white image, since it was to be used only for bump mapping. We started to map the bump texture with a planar projection (*I*, *J*), then dragged the UV coordinates in the *Texture Editor* until the texture fitted perfectly. For this, we grabbed the UV points, then rotated, scaled and moved them (*K*, *L*).

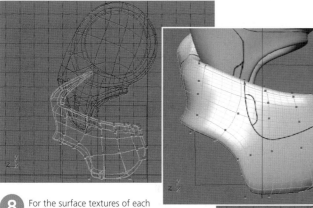

8 For the surface textures of each element, we took a screenshot of every object in the right viewport (*E*, *G*), then opened the screen grab in Photoshop and drew paths on top, using a new layer; then we used the *Stroke Path* command to fill the path with pixels (*F*, *H*). This way, the image isn't restricted to any specific resolution, and you can easily scale the path without the edge pixels going jagged. An image created in this manner can be exported to any file format, but it's important that it be in high resolution.

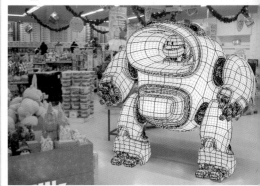

10 We took a high-resolution picture of a real shop environment and imported it into XSI. We then built the same light setup and atmosphere as the picture and matched the ambient light of the picture with the ambience value of the 3D scene, to create a similar contrast in the 3D image.

We then added several exclusive lights to bring out interesting parts of the robot and achieve particular light reflections or shadows. When everything was complete, we rendered out the object along with its materials, textures, lights and shadows for the final image.

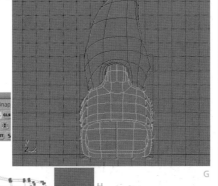

Creating a Mechanoid

Often, a digital art project starts with a desire to experiment with new techniques in software. Glen Southern wanted to take a 2D pencil-sketch concept of a robot and model it in 3D, using a skeleton for posing the model and perhaps for some animation later. Because Lightwave 3D has a very capable modeller that can produce sharp-edged mechanical meshes and smooth, subdivided organic shapes, it seemed perfect for the job.

Southern wanted to create a character that had the look and feel of a mechanical creature, but one that would also display a bit of personality. He soon settled on this Charathian Minder, a mechanized bodyguard for a human drug lord of the future. Before he starts on a character, he always thinks about the character's background, a method he says helps with the creation process.

According to Southern, this class of 'minder droid' is mass-produced and very versatile, being able to change its own hand attachments for a number of utensils and devices. The base AI can be used in a number of task-specific shells, but its main function is to provide personal protection. It stands very still and quietly, almost statue-like, until called into action. When provoked, it responds quickly and uses deadly tactics. Its head has a snakelike movement because it is attached to the body with flexible metal pipes and wires. Designed primarily for flat terrain, the Minder can cope with most environments, including water, low and high gravity and severe winds.

In life, the minder's dimensions would be height 7.5 feet; width 4.3 feet at the shoulders; weight 360 pounds. It is composed of a light alloy substructure with reinforced carbon plates.

1 When doing concept sketches, I tend to use pencils on a sketch pad, then I scan the results into Corel's Painter 8. Using a gel layer mode (*Layers > Gel*), I can then use a set of marker brushes to colour the sketch underneath the lines.

Painter has such a versatile set of brushes and 2D tools that it is possible to build and mimic almost any real artists' medium. I have a set of pencils, ink pens and markers that I always use for this type of image. Once you have gathered together your favourites, you can save them as a library. This is just a grab of the pencil sketch scanned and then inked in 3D.

2 I always hide parts of the model that I'm not currently using, so that there's less chance of messing them up. Also, keeping major body sets (e.g., the left thigh and all its pipes and rings) on a separate layer until the end of modelling helps in selecting parts for weight mapping.

The head is supported by a series of flexible pipes, and my intention was to make its movement very fluid and snakelike. To create the pipes, I used an eight-sided cylinder cut into segments. I started at one end and selected groups of points and moved them, then moved along to another group and adjusted them, and so on. I could have used lots of other techniques, but I found that this was like modelling in the real world, and I could bend the pipes however I liked. I always tweaked them with the *DragNet* tool set really high and moved them point by point.

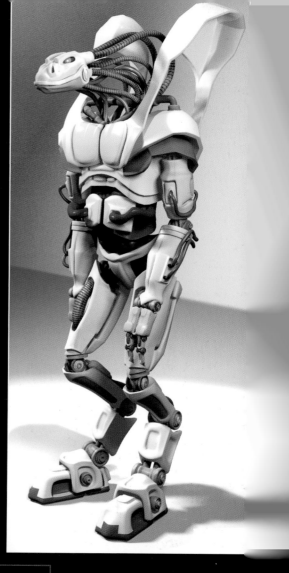

Polygon Statistics

		Name	Num
+	-	Total	3758
+	-	Faces	3758
+	-	Curves	0
+	-	SubPatches	0
+	-	Skelegons	0
+	-	Metaballs	0
+	-	1 Vertex	0
+	-	2 Vertices	0
+	-	3 Vertices	42
+	-	4 Vertices	3716
+	-	>4 Vertices	0
+	-	Non-planar	1937
+	-	Surf: (none) ▼	0
+	-	Part: (none) ▼	3758
+	-	Col: (none) ▼	3758

3 Most of the Minder model is made up of subpatched polygons – that is to say, a polygon cage that defines the overall shape but is then smoothed using the software's subdivision algorithms. I started to model from the head and worked my way down the body. One way to reduce the workload when modelling in 3D is to create just one side of a model and mirror that across a centre axis. When mirroring anything to make a symmetrical object, make sure the shared points are lined up on the X axis (*Set Value X=0*), or you will be in a world of polygon pain. Name every little part of the model as you go, and use a hierarchy. For example, a pipe of the arm would be left.arm.forearm.pipe1. This is extremely important for modelling and texturing.

The Charathian Minder

artist: Glen Southern
software used: Lightwave 3D by NewTek, Corel Painter

4 When doing this type of polygon modelling, there are two main methods of work flow, and I used both in this project. The first is called box modelling and begins, logically enough, with a box. The idea is that you start with a primitive shape and add some detail (more polygons) by using the software's tools. In Lightwave 3D, I find the *Knife* and *Bandsaw* tools best for the job. With these tools, it is possible to cut new rows of polygons or areas of detail, either along an edge or in a localized area. After adding more detail, I moved the points that make up the model so that they reflected more of the shape I wanted. I repeated the process, cut more detail, moved points and so on. In this way, you can quickly define a model and keep the polygon count to a minimum.

Creating a Mechanoid

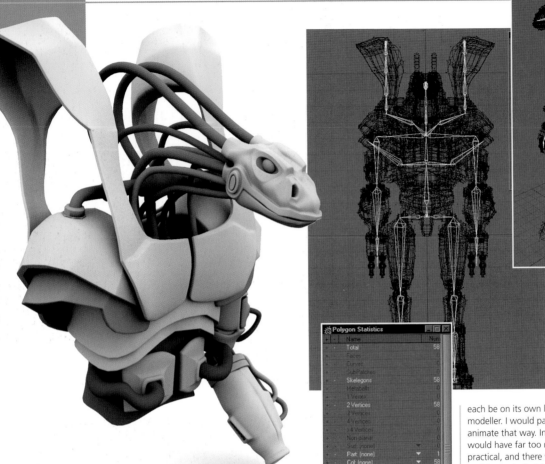

5 The second method involves stringing together a series of points (or vertices) and joining them up to make the polygons. I tended to use this subpatch weighting method for intricate parts of the model, where I wanted very fine control over the mesh. As with box modelling, once you have a basic shape defined, you can move the vertices one by one or as a selected group until you have the required shape.

In Lightwave 3D, you can define how smooth or sharp an edge on a model is by changing the subpatch weights that make it up. That is to say, you can take every point in the model and define how crisp or smooth the edges between them will be when rendered out. This is how, on a complex model like the Minder, you can see a mixture of mechanical and moulded organic components.

6 When I started this project, I was going to keep each major body part on a separate layer and then pose the Minder using pivot points and parenting the layer parts together. For example, the biceps, forearm and hand would each be on its own layer in Lightwave 3D's modeller. I would parent hand-forearm-bicep and animate that way. In practice, it turned out that I would have far too many layers for this to be practical, and there was no way I could animate the neck hoses in that fashion. Another way to 'rig' or a character in Lightwave 3D (or indeed most 3D packages) is to give the model some bones. These bones, like the skeletons they are based on, are strung together in a hierarchy that allows the animator to move and reposition parts of the model. I built a bones system for the Minder, then, using a system of weight maps, defined which bone would move which part of the mesh. Once inverse kinematics are applied to the model, if the thigh is moved, the calf, foot and toes all move with it. In this way, it is possible to create a fully posable model that can be moved in a realistic way.

One difficulty I had was how to animate the neck pipes as a group. This model didn't actually have a neck, so I couldn't simply add bones that followed up from the spine into the head. In the end, I settled on a very basic bones setup, but I made the weight maps from each pipe apply to the same bones – therefore, when I moved the neck setup, the entire set of pipes would move or bend in sync.

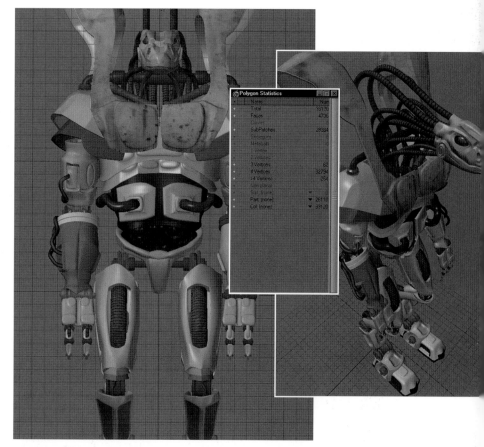

7 One common mistake when modelling a full character in 3D is getting the proportions wrong. It is so easy to get wrapped up in detailing one small portion of the mesh and forget the overall look of the model. There are a number of ways around this. One is to make a sketch of the model from the front and side views, then scan these into Photoshop. Save the resulting bitmap files, and Lightwave 3D can import them into the quad views in the modeller. With these references in place, it is possible to keep checking how well you are conforming to the overall concept as you create the individual parts.

Another way is to rough out a very low-polygon cage that represents the overall shape of the model. This can be placed in a background layer that effectively ghosts out the polygons but allows you to see the wireframe as a guide. I find that I'm constantly referring to my concept sketches, and although I don't use imported images much anymore, I find the whole process much easier with at least some type of reference material.

8 Lightwave 3D combines a good set of tools for creating UV maps with a powerful set of features for creating procedural textures. The test with this image was deciding which parts of the model would need what type of texturing. To texture-map the shoulder pads, I unwrapped the mesh and flattened them out to create a template for the UVs. I used that template in Photoshop to paint on some of the detail around the edges and to add some dirt and grime effects. Realism is important in 3D images, and attention to small details can make all the difference. In the Lightwave *Surface Panel*, you can combine different types of texturing to create the desired look. Once I had created textures for the shoulders, I added a few layers of procedural textures, including some fractal noise and a bump map to help emphasize the scratches and dents.

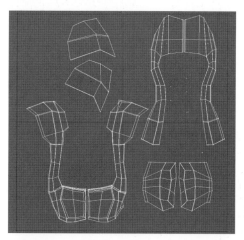

Inner Space

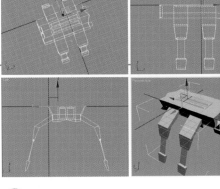

Not only do science-fiction artists get to realize their visions of outer space, but they can explore scientific themes in the microscopic and subatomic worlds of inner space as well, developing bizarre, speculative images of things that could conceivably come to pass soon.

Take nanobots, for example, theoretical machines constructed on a microscopic scale, which have been proposed as a possible future for medical and industrial science. This image, produced for the Science Photo Library (www.sciencephoto.com), presented a number of difficulties for Christian Darkin. The idea was to represent nanobots at work inside the human body, and the illustration had to represent the microscopic world not as it actually is, but as it appears when seen through an electron microscope. This meant throwing out all the rules about realistic rendering.

The lighting in images of electron microscope subjects is fake – it's not real light that's being used. Nor is the colour real. When modelling these subjects in 3D, you must fake the artificial lighting – creating materials that reflect light from their edges, and removing all shine and glossiness. Worse, you can't make microscopic surfaces look more realistic using bitmap textures taken from photos – as you would with normal-sized objects – or use lighting or atmospheric effects.

This image was created entirely in 3ds max. There was no postproduction work or image manipulation. Only one bitmap texture was used, and it came from the maps folder supplied with the application.

1 The modelling for this image was pretty simple. The cells are primitive capsules, and the background is just a couple of curved surfaces designed to hint at an organic shape. The only complex shape is the nanobot itself. For this, I began with a box in 3ds max and used subdivision, extruding legs with the *Extrude* function on the *Polygon* subobject level of the *Edit* mesh modifier. I added surface detail with the *Extrude* and *Bevel* tools, refining the shape by switching to the *Vertex* subobject level, and moving individual points. The idea was to hint at the possibility of articulation and intelligence, but keep the creature simple as befits its environment. In the end, the silicon chip was the inspiration, providing viewers with an added visual cue that the object they're looking at is tiny.

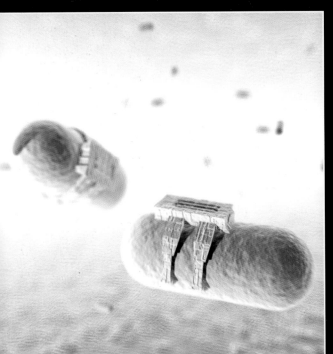

Nanobots

artist: Christian Darkin
software used:
3ds max by discreet

2 In the microscopic world, there's a lot going on. To underline the effect of scale, I wanted the image to contain vast emptiness, but also lots of tiny objects floating around. The particle system in 3ds max is well up to the job, so I used a particle cloud (selecting *Particle Systems* from the drop-down list on the *Create Geometry* tab) to produce copies of the capsule scattered around the background. By giving them random rotation and motion and a short period of rotation, I could scan through the timeline until the cells formed an arrangement I liked. Setting them in motion also added the possibility of easily introducing motion blur into the scene to give it movement if I wanted. In the end, I opted to turn off the blur.

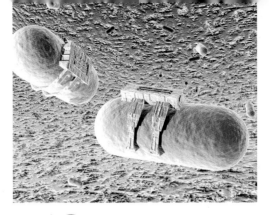

3 The really tricky thing about this scene was the materials. Electron microscopes don't use light when imaging objects, so they produce a very unusual set of effects. Objects tend to be ghostly and glowing in appearance, and colours are artificial (literally – they're added to the image to differentiate objects).

To reproduce this effect, I abandoned image texturing and instead created a material in which self-illumination was governed by a falloff map. Falloff maps are usually used on the *Opacity* channel to create glass or smoky objects. Used on the *Self Illumination* channel, they produce a glowing edge.

5 Lighting doesn't work quite the same on our constructed image as it does in ordinary rendering. Since all the materials in the scene have their own illumination, and nothing has gloss or shine, you can render the scene without any lighting at all. However, I wanted shadow and definition. A single bright light was added to the scene just off-centre from the camera. *Advanced Ray-Traced* shadows were selected to give a sharp, crisp shading that would provide some definition on top of the glowing edges.

4 Pale, washed out, but artificial-looking diffuse colours were combined with zero settings on the *Glossiness* and *Specular Level* controls to create ghostly but matte colours. Microscopic objects are rarely smooth. They're usually very rough and uneven. I found the best way to represent this was with a dent or noise bump map. The map needs to be large enough to create definite ridges and disturbances on the object. A more sophisticated look was needed for the nanobots themselves, which I textured with a 'mix' bump map. The mix was between a dent map and a geometric pattern designed to indicate electronic machinery.

6 I added a white fog to give the whole image some depth, although fog isn't really a factor in electron photomicrography, nor is extreme depth of field. However, they are definitely traits of standard microscope images, where shots lose focus within a fraction of a millimetre. This gives rise to the general impression that small images have a narrow depth of focus, so I used a little artistic licence here to produce a finished shot in which both drama and realism are enhanced. All we had to do was bend the laws of physics a little.

Creating Alien Forms

scape by Jerry Potts is one picture in a series by the artist telling the story of aliens visiting Earth for the first time. The scene depicted here is on board the alien ship that is orbiting Earth, just at the moment in which two escaped native earthlings are discovered.

According to Potts, the development of an alien character should contain logical controls balanced with the bizarre. His alien, based roughly on the earthly nautilus, was developed hand in hand with the concept of how such a creature could evolve into an intelligent tool-user. Having created the creature, he began the design of the spaceship's interior as he imagined the alien race would have designed it. Using forms of nature he proposed they would be familiar with, he designed an comfortable environment for the creatures.

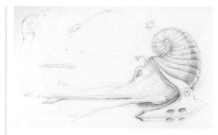

1 Often you don't see the evolution of the creator's original idea in a finished picture. *Escape* started as an alien invasion theme for which I made drawings in pencil and paper. I find it easier to create a model and scene in 3D software after first developing the idea with sketches. Here you see the original sketches for the alien and the huge ship in which it was able to reach Earth.

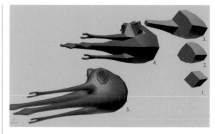

2 I divided the alien into two parts, the soft body and the shell. For construction purposes, this simplified things and aided in texturing, since two different textures would be used for each. I started with a box with two length, height and width segments. I then moulded the figure by pulling out points and extruding faces to create eye sockets and tentacles. I applied the texture at the end of this procedure and before the *Mesh Smooth Modifier* because it was easier to adjust to fit while the figure was in a low-poly state. The shell was made in a similar way, using a tapered cylinder instead of a box primitive. After the texture was applied, the figure could be posed by manipulating the points on the tentacles, and then a *Mesh Smooth Modifier* could be applied to smooth out the body.

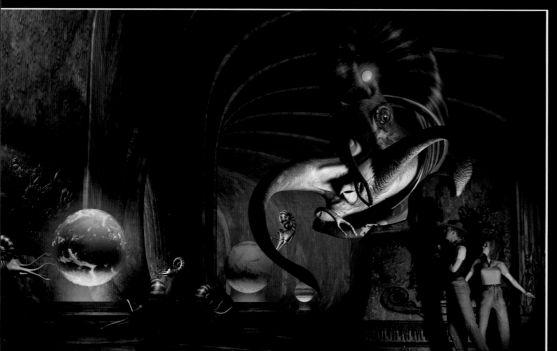

Escape

artist: Jerry Potts
software used:
3ds max by discreet,
Adobe Photoshop

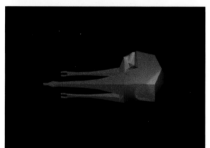

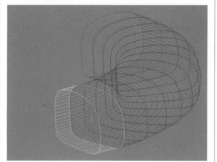

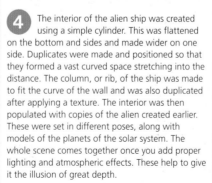

3 I made the textures for the alien in Photoshop. First a side view of the alien was rendered. This image was then loaded into Photoshop, where new layers were painted on top, creating different textured areas for the figure. I paid special attention to details around the eye area. Here again, I used designs from nature, such as a mottled skin, with darker colours on top and lighter ones on the bottom. These characteristics have evolved in nature to help hide animals from predators and prey alike, and they help make any creature you paint seem more natural. The creature's eye was a sphere inserted into the modelled eye socket.

4 The interior of the alien ship was created using a simple cylinder. This was flattened on the bottom and sides and made wider on one side. Duplicates were made and positioned so that they formed a vast curved space stretching into the distance. The column, or rib, of the ship was made to fit the curve of the wall and was also duplicated after applying a texture. The interior was then populated with copies of the alien created earlier. These were set in different poses, along with models of the planets of the solar system. The whole scene comes together once you add proper lighting and atmospheric effects. These help to give it the illusion of great depth.

5 I created the detailed bump or displacement textures for decorative elements such as the wall carvings by first creating the objects in 3D. For example, I loaded models of the alien into a new scene and arranged them into a decorative composition, – in this case, a depiction of an historical ancient alien battle. Then I applied a uniform texture colour (white is best) and installed a bright spotlight above and to one side with shadows turned on. I rendered the scene and imported it into Photoshop, converting the render to a greyscale image and then adding a border. The resulting map could then be used either as a bump map or as a displacement map on a high-polygon plane primitive in the scene.

Creating Alien Flora

The setting and background detail for sci-fi painting don't always have to consist of chrome, steel and glass, or desert planetscapes. There is plenty of scope for more organic surroundings. For *Music for the Muse*, Cris Palomino wanted to add a small field of flowers that, while reminiscent of terrestrial species, would look quite unearthly. According to Palomino, a rose by any other name could be alien if you were to use Xfrog from Greenworks Software to design your otherworldly flora, as she has here. Xfrog is a powerful plug-in for Maxon's Cinema 4D which makes great use of the spline capabilities of the host application while presenting advanced array and lofting possibilities in a truly organic manner. Its uses include modelling and animating trees, flowers, bushes, organic architecture and abstract organic structures.

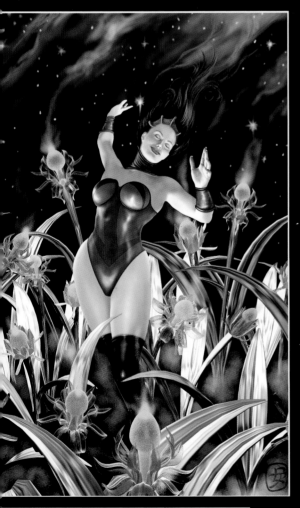

Music for the Muse

artist: Cris Palomino
software used: Xfrog by Greenworks Software, Cinema 4D by Maxon, Poser by Curious Labs, Adobe Photoshop, Corel Painter

1 The first step was to visualize my flower. Sometimes I will sketch things roughly, but I usually find with 3D that I just sculpt with the modelling tools and primitives or splines. Xfrog works with highly controlled 'Sweep NURBS'. Leaves and petals are shaped with splines and swept along a second spline for which Xfrog provides controls over the size, rotation and scale of the resultant shape. Then it's a matter of grouping the petals and leaves and adding other pieces that I modelled with C4D. My alien flower started looking like some kind of orchid at certain angles, and I was pretty pleased.

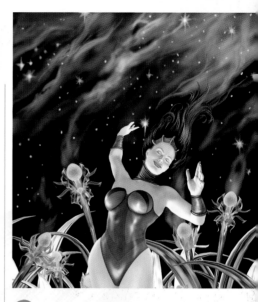

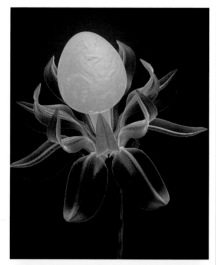

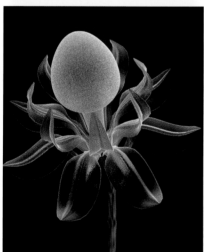

3 I then used the *Multi-Pass* settings to render the figure and plants with alpha channels to separate things out more. After I got it into Photoshop, I decided I wanted to render again with just the flowers in the foreground and the figure alone, because I wanted to paint fog around the ground and elements. The multi-pass allowed me to adjust individual aspects of the render, since all layers were preserved when I saved the file as a psd.

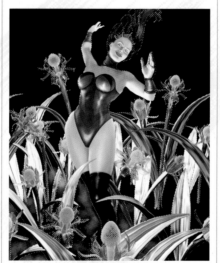

4 I created and adjusted alpha channels, switching the selections to paths and using the *Pen* tools for accuracy. Once the paths were created, I switched them back to selections and saved them as masks. It is good practice to create an overall mask, then break it down into smaller masks for individual parts. These can then be used in conjunction with the overall mask, employing the *Add*, *Subtract* or *Intersect* functions to isolate selections and match up areas further. By toggling *Invert Selection*, I can easily work areas next to each other. Alpha masks are preserved when going from Photoshop to Painter, and I used the flower and figure alphas combined to paint in the fog on the ground.

5 Once I had painted the fog, I had my grounding and now turned to the heavens above my Muse. I had some great NASA photos of nebulas and found one with wonderful pink and green swirls, so I painted the sky using that as a reference. The Muse's hair was given an ascending sweep as well, as I wanted the piece to evoke a feeling of mounting sensation, and wanted the elements in the piece to rise and swell like music. I also wanted the pollen from the alien flowers to rise and seem to mingle with the nebula.

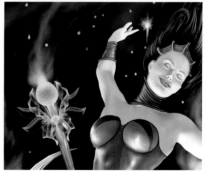

6 The final touch was to add some grainier pollen that was lighter in colour and closer to the substance that made up the flower's stamen. Using the *Pepper Spray* airbrush in Painter, I took a sample of the stamen's colour with the *Eyedropper* and lightened it ever so slightly. I trailed the pollen up, letting up on the pressure of the Wacom stylus with the upward movement, blending the pollen into the sky. I duplicated the figure's layers and compressed them. I then adjusted the hues and set the blending option to *Screen* to illuminate the figure, which enhanced the glow of the flowers as they made music for the Muse.

2 The plants had to look real, but also unearthly, so it was important to use materials normally not associated with earthbound flowers. I used some of Cinema 4D's shaders and an interesting SLA volume material called *Cheen*. I also wanted a palette of blues and purples for the entire plant to keep it distinct from the chlorophyll-green of Earth. I gave the centre stamen a bit of light within its bulb shape to make it glow slightly as it emitted its pollen and sent it towards the Muse and the nebula above. I had put a semi-transparent, matte glass material on the bulb, but it wasn't looking quite right. Changing to a different setting of *Cheen,* with a variation on the noise bump to make it more sugary-granular, worked better.

Future Weapons

Weaponry of all kinds often appears in sci-fi art, but we are concerned here with the handheld variety, which can be further divided into those that fire projectiles and those of the more fanciful laser type.

It is worth taking today's weapons into consideration when creating futuristic projectile weapons, since they are likely to retain some similarities, such as armrests, triggers and detachable magazines. When designing these weapons, it can therefore be useful to look at existing examples in books and films and take inspiration from them.

Laser weapons, however, are much more open to design. They usually have no recoil, and magazines are not necessary, so contemporary design limitations do not apply.

Using his image, *Escort*, Soheil Khaghani demonstrates here how to create handheld weaponry using discreet's 3ds max. This process features standard modelling techniques that can also be used for creating a wider range of weapons – such as flamethrowers, rocket launchers and handguns. These techniques should be helpful even when modelling other, less violent objects.

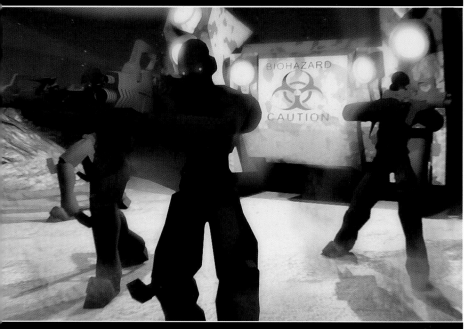

Escort

artist: Soheil Khaghani
software used: 3ds max by discreet,
Adobe Photoshop

1 To begin with, I made a preliminary sketch of the weapon, which I would use later to put in the background and base the rough modelling around. Just making it up as you go along is not a good idea because it is very hard to get the proportions right. I started out by creating a box using the *Front* view. I made sure that the box had a sufficient amount of segments for me to model with later on. Then I selected the faces as shown in the image here and deleted them to make the space next to the grip. I then clicked *Tools* > **Mirror** and changed the *Mirror Axis* to Y and the *Clone Options* to *Instance*. This created a mirror image of the box adjacent to where the space was

2 In the *Material Editor* window, I loaded my preliminary sketch and applied it to a plane that I positioned at the back. I then changed the *Opacity* of the box (this can also be done by selecting *Wire* from the *Shader Basic Parameters* menu). This made the mesh transparent, turning the plane with my sketch on it visible. Then, using *Edit Mesh*, I molded the box according to the dark grey areas of my sketch. I was careful to remember to align both the outer and middle segments with the sketch, because this would simplify the detailing process later on.

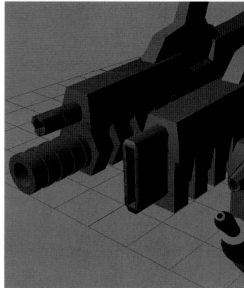

3 Now that the rough modelling was done, the final shape was beginning to appear. This stage in the process offers a good opportunity to turn back and redo anything you want – it will be harder to correct errors or to remodel the mesh if you wait until later.

I began relocating some of the polygons so that I could select the faces, and used *Edit Mesh > **Extrude*** to get the detailing I wanted. To add some additional detail to the mesh, I used the *Smooth* modifier, then selected the *Auto Smooth* box and gradually raised the threshold to smooth over some edges and leave others sharp.

5 After I had modelled the other components into place, I deleted the plane with my preliminary sketch since it would just be a hindrance from now on. It's important to keep in mind that the weapon has to be easily recognizable as an assault rifle (or whatever weapon you are making) from all angles but still look futuristic and different. I didn't think it looked convincing enough yet, so I added some features that I had seen in other contemporary and sci-fi weapons. These included grenades, sights and handle enhancements; these are highlighted here in the image in red wireframe.

7 Welding created a seamless join down the middle and made the whole thing look and act as if were a single mesh. This just left a choice of which muzzle to use, since this would more or less decide what kind of weapon this would turn out to be. I created three different muzzles for the various assault rifles used by the troopers.

4 The centre part of the rifle was more or less finished by now, so it was time to begin modelling other components such as the handle, magazine and trigger. I made a safety catch and some other small elements using boxes and *Edit Mesh* (shown in the image here in the red wireframe) to add more detail to the rifle and make it look more realistic. With that done, I started on the other components by placing boxes with appropriate numbers of segments in the *Front* view. I modelled the parts based on my sketch, using roughly the same method as before.

6 I had finished the main modelling of the rifle by this point, and the only thing that remained was to assemble it. I highlighted the editing mesh for the middle section of the rifle and attached all the different elements to it except for the magazine, since this was to remain detachable. I deleted the *Instance* mirror and created a new mirror, this time selecting *Copy* in the *Clone Options*. To join the two halves together, I once again selected *Edit Mesh* and attached the two parts. I then selected the points down the middle of the rifle where the two halves met, and selected *Weld*, as shown here.

The Future Warrior

A popular vision of future warfare is a battle being fought by mighty machines of destruction. However, there will no doubt still be a human element. The main inspiration for this piece, *Eve*, by Ian Grainger, came from the images of Luis Royo, whose scenes of postapocalyptic destruction always seem to include a beautiful girl.

Grainger uses Bryce and Poser as his main tools, but because he finds that Bryce renders can seem a little flat, he also uses Photoshop for postwork.

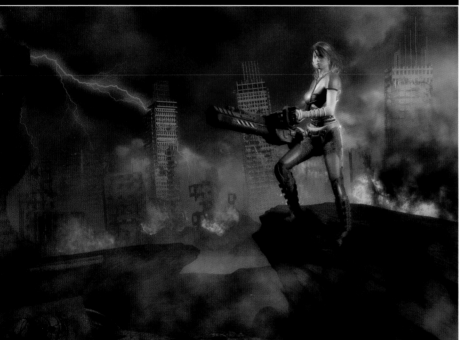

Eve

artist: Ian Grainger

software used: Poser by Curious Labs, Corel Bryce, Adobe Photoshop, Victoria 3 model from Daz Productions

1 The foreground elements were created in Bryce, mostly using terrains textured with photographic maps and applied in the *Deep Texture Editor*. The buildings were a combination of primitive constructs and lattices with Boolean subtractions to simulate damage, and cubes with transparencies applied (those in the far background). I created the fire and smoke using spheres and applied a water plane in the middle ground for interest. The clouds were 2D planes with photographs applied with transparency. I tweaked the lighting until I found what I was after, and then tilted the whole image slightly for dramatic effect.

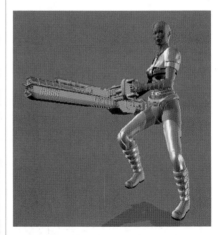

2 Moving to Poser, I imported Victoria 3 from Daz Productions. Leaving the body morphs at default, I played around with the facial morphs to get my character. I applied various items of clothing, mostly purchased from Daz and Renderosity (see Sources for both), and finally gave her a gun. I didn't bother with textures at this point since I would be applying those in Bryce. I posed her with the intention of placing her on the sloping rock in the foreground of the Bryce scene. This took a few attempts, as the angle of her feet in relation to the slope of the rock was a little hard to judge. I then exported her to Bryce as a Wavefront object.

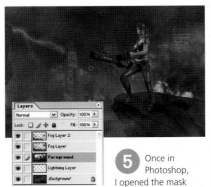

5 Once in Photoshop, I opened the mask render and adjusted its size to match that of the main render. I selected and cut the entire image, then closed the resized mask image. With the main image now open, I pasted in the new mask. I selected the black portion of the mask (*Select > **Color Range***) and then deleted the mask layer to avoid confusion. This left the foreground elements in the main scene selected. I cut and pasted again, which created a new layer with just the foreground in it. I created another new layer and placed it between the two existing layers, and using a specialist brush, I created the lightning in the background. In another layer, I created fog by using the *Clouds* filter, selecting contrasting colours from the existing smoke in the image. I reduced the *Opacity* to about 60% and erased those parts I didn't want.

7 I wanted more hair blowing in the breeze, so in a separate layer, I picked out a base colour from the existing hair and, using a small-pixel hard brush set at 50%, painted in more strands using a Wacom tablet. I created shadows by using a slightly darker colour in other layers at various opacities, then I did the same for the highlights until I got the effect I wanted. I blended the various layers by creating another layer, setting its mode to *Color*, setting the brush mode to the same and, using a soft brush and the base colour, painting over all the hair. This unified the different elements.

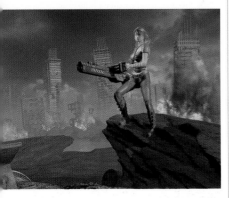

3 Once she was textured in Bryce and saved as a Bryce object, I merged her into the original scene, positioning her onto the sloping rock after some trial and error. I then rendered the image at a high resolution with premium antialiasing applied, and waited for five hours. (This scene was well over 300Mb, and Bryce doesn't have the quickest renderer in the world.)

8 Final touches were added using the *Clone* tool to fix the errors in the smoke from the various fires. I then flattened the image and created a duplicate of the background. I adjusted the *Hue* (+30), *Saturation* (+15), *Brightness* (+30) and *Contrast* (+15) of this layer, then applied a *Gaussian Blur* of 10. I then changed the mode of this layer to *Soft Light*, which completely altered the look of the picture, giving it richness and depth. I changed the layer *Opacity* slightly, then flattened the image. The last thing I did was to brighten the image a little, then tweak the colour balance until I was happy with the result.

6 I wanted to accentuate the highlights on her body where she was being backlit by the flames. For this, I created a new layer, selected the *Airbrush* tool with a soft brush of about twenty pixels and applied a pure white colour. Using a Wacom tablet, I painted over the areas already receiving highlights, using various levels of *Opacity* and changing the brush size where appropriate. I then applied a *Gaussian Blur* set to a strength of four pixels to the layer (*Filters > Blur > **Gaussian Blur***). Finally, I set the layer's blend mode to *Overlay* and adjusted its *Opacity* until I got the effect I was aiming for. The effect was subtle, but it helped to define the edge of the character and the intensity of the flames behind her.

4 Once the image was rendered, I saved it as a bitmap file. Still in the Bryce workspace, I selected all the scene elements except for the 2D planes in the background and took a mask render – at a smaller resolution to save time, since I wasn't going to use it for any fine detail work.

Futuristic Vehicles

I n the world of science fiction, planetary exploration often calls for imaginative utility vehicles and planetary rovers. One such vehicle is the mobile laboratory/exploration truck created by Christine Clavel and Pierre-Olivier Boidard, which roves through a rocky desert on a distant planet.

The idea for *Spacetruck* came to Clavel when she found high-quality photos of the surface of Mars and Venus on various NASA websites (notably Great Images in NASA at http://grin.hq.nasa.gov) and wanted to see what the true surface of a planet looked like when mapped onto virtual ground and rocks created in Bryce. The idea of a vehicle exploring this terrain naturally followed.

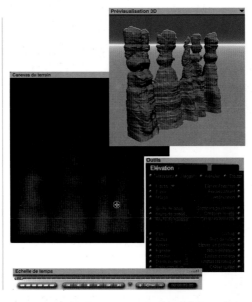

1 The set was modelled using Bryce rocks, terrains and symmetrical lattices, with a main terrain used for the flattest part and several smaller ones for the craters. I decided to show only a small part of the planet soil, in order to focus on both the vehicle and surface-relief details. The bright light, hard shadows and ground aspect indicate that the planet has a poor atmosphere, or it might even have no atmosphere at all. I added around fifty rocks of various sizes and shapes, implying evidence of intense meteoritic activity. Using Photoshop for greyscale painting and Bryce's terrain editor for the elevation, I made some strangely shaped rocks, like the 'hoodoos' that can be found in Arizona canyons.

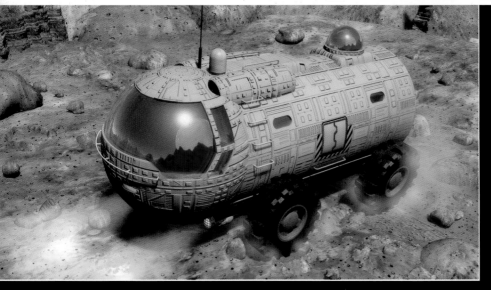

Spacetruck

artists: Christine Clavel and Pierre-Olivier Boidard
software used: Corel Bryce, Adobe Photoshop, Amapi 3D by Eovia, Adobe Illustrator

2 At this point, my intention was more to make a 'realistic' rock texture than to be geologically correct. I cut a large selection from an actual digital photo of the surface of Venus and applied it to the whole background using different parameters: *Object Space* for the main terrain and *World Space* for the pebbles and craters. The second image here shows a breakdown of (*from left to right*) the meshes, the flat shading and the textured views of the scene.

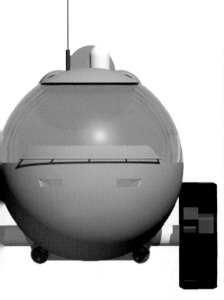

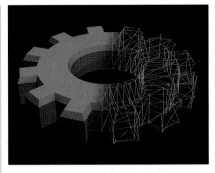

5 I wanted my truck to have big, all-terrain tyres, which are quite hard to model using terrains or primitives. It was easier to use a polygonal modeller and extrude the tyre shape from an Illustrator curve. For this, I like the power of the extrusion and sweep tools in Amapi 3D, as well as its considerable export capabilities.

I actually designed a half-tyre, then I had to duplicate the part, rotate it to make a symmetrical object and then once again rotate it 15° on the x-axis to create a double series of large grips on the tyre's tread. After saving it in .3ds format, I imported the tyre into Bryce.

7 After several render tests, I decided not to use the whole texture in the ambient channel but only on the small door detail, and chose a light-brown sand colour that gave the model a kind of military look. Once the initial scene setup was completed, it was time to add the environment and the atmosphere.

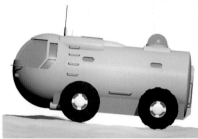

3 The general shape of the truck was simple to create, using Bryce's primitive-based modelling capabilities. I combined spherical and cylindrical forms with a few terrains for peculiar shapes like the base of the rear dome. Although I usually do much more intricate modelling, this is a relatively small scene (274 objects, and only about 280,000 polygons).

6 Instead of modelling some of the more detailed work in 3D, you can use good-quality textures, especially for small or distant objects. Painted textures, associated with bumps and transparencies, can be very important for achieving convincing objects and 'realism'.

I created the main texture – which I also used as a bump map on many parts of the truck – in Photoshop (at 1024 x 1024) from miscellaneous low-resolution pieces of hull-plate and other sci-fi textures I had downloaded from the Web. I designed it to fit the diameter and length of the main cylinder perfectly.

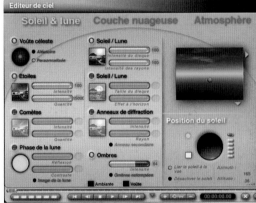

8 With such a large glass surface on the truck's cockpit, I had to consider the reflection of the surroundings. I added relief – hills and rocks – all around the virtual camera spot and tried to give the terrain an unusual shape on the lower part of the windshield. In the sky reflection, I added a celestial conjunction between the planet's sun and a huge moon. Setting the sun's position and elevation is easy: you just manipulate a virtual trackball and view the result in real time on a thumbnail of your scene.

In spite of the sunlight, the wheels were too dark. I wanted to make the details more visible with specular illumination on the tyre's bevels, so I positioned an invisible light source to the left of the vehicle. The result was satisfying enough, but the image lacked dynamism. Taking the rendered image into Photoshop, I used *Airbrush* to paint some dust clouds to add motion to the wheels. Using the same tool on another layer, I made large white beams for the headlights, then finished with some colours and slight hue adjustments.

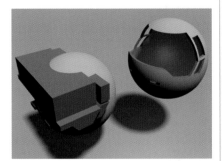

4 I used the power of Boolean operations – mainly subtractions – to cut out various apertures in the cabin, side and rear of the vehicle. The front sphere was combined with nine skewed cubes to remove the negative parts. I also added some previously made pieces from my Bryce object library, such as the side and ladder bars.

Spacecraft

The *Star Wars* films contain some of the greatest and grandest of space-vehicle designs, from the elegant, slick lines of the small Naboo Starfighter to the enormous, angular, arrowhead-shaped Star Destroyers of the Empire. The Correllian Cougar is a CG ship model designed by Adam Benton, created for a large-scale *Star Wars* fan film. The brief for this model was straightforward: a rugged, but fairly sleek, well-travelled smuggler's craft, capable of carrying a small crew and cargo, armed and capable of some fast moves. Here, Benton offers some insights into the various stages of design, modelling and texturing of the Cougar, along with some aspects of lighting.

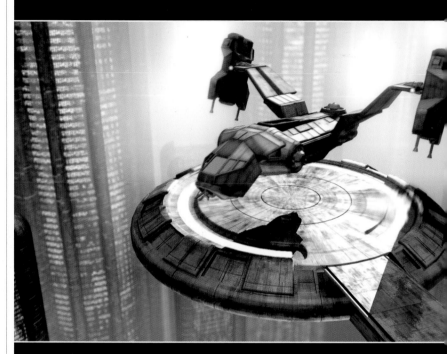

The Correllian Cougar

artist: Adam Benton
software used: Cinema 4D by Maxon, Adobe Photoshop, BodyPaint 3D by Maxon

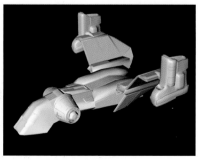

1 Basing my modelling on a 2D sketch, I opened Cinema 4D and started assembling various geometric primitives. These were made editable to allow for some basic extruding, deforming and scaling to get shapes similar to the sketch. I then added some details to the mesh. By using subdivisions and selecting various large groups of polygons, I was able to start creating some of the plate structure details with extrusions and bevels.

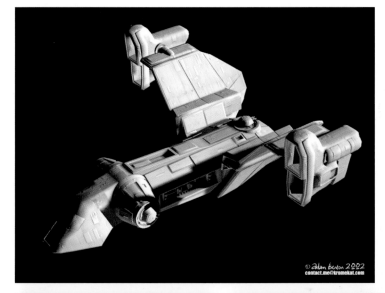

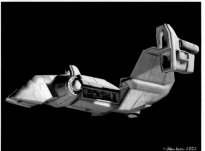

2 At this stage, some of the details and parts were working better than others. I began to feel that the ship's hull was looking too planelike and decided to rebuild it more efficiently, allowing me to make it more rectangular and accommodate some inset areas full of engineering-part details along the sides. As the modelling progressed, I found myself replacing more and more of the original parts with slightly redesigned and rebuilt geometry to get the look I wanted.

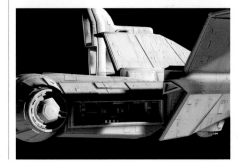

3 I then increased the detail of the mesh. As a temporary guide to tell me how much I needed to model and how much could be created with textures, I applied a simple tiling texture mapped cubically to add some details in the bump and diffusion channels. I enhanced this further by adding a couple of lights to simulate a kind of space lighting.

Just as it is important for a painter to step back from his canvas, it's essential that the digital artist keeps moving around his model and assessing its form and presence, so I did this regularly.

 # Spacecraft

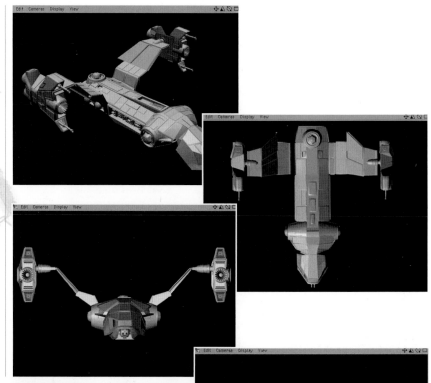

4 After replacing the hull, I turned my attention to the wing-mounted engines and gun mounts. I wanted to retain their oversized and heavyweight appearance, but I also wanted them to be a little more horizontally symmetrical than their previous form. Apart from the obvious cylinder-shaped forms, these and all the other angular parts were made from simple cube primitives by subdividing, extruding and pulling and scaling of different polygon faces. It's a very natural way of working – often it feels as though I'm working with geometric clay.

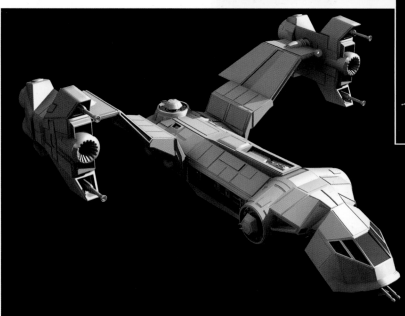

5 Finally, after some further modifications to the wings and a revised cockpit shape, the mesh was done and ready for mapping and texturing. Early on in the modelling process, I took advantage of the ship's symmetrical form and built only one side of the entire model – one wing and engine, half a cockpit and hull – and then by using one of Cinema 4D's *Symmetry* objects, I created a mirror image. Not only does this halve the amount of modelling requirements, it makes the whole texturing process simpler.

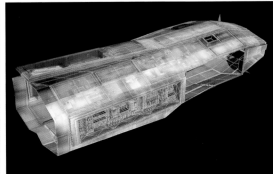

8 Once I finished painting the textures, I imported them back into Cinema 4D and applied them to their mesh parts. As you can see here, the texture is being applied to the existing half of the hull, and because this mesh is contained in a symmetry object, the texture is mirrored also. This process is not ideal if you want differing levels of grime or markings, but if your viewpoint isn't going to notice these things, it's a quicker method to double the texture.

6 Using BodyPaint 3D, I was able to dissect, arrange and lay out a map of the various parts of the mesh in a flattened form, like a tailor's pattern. With this process (known as UV mapping), the mesh remains the same, but the instructions to the application on how textures are to be applied to it are modified. Once I was happy with the layout, I exported the template to Photoshop for the painting to take place.

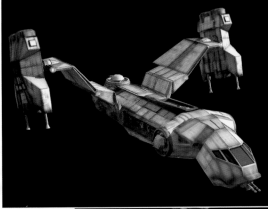

9 Once the model and its textures were completed, the Corellian Cougar was ready for duty in the film and any still promo renders.

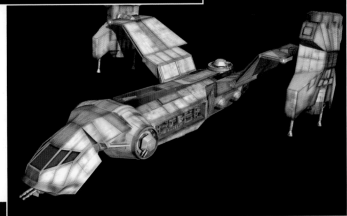

7 Using the UV template as a guide, I built up many layers of colour for the markings, dirt, base paint colour and plate details. After playing with the levels, I exported the colour map and then adjusted the intensities of the various elements to make other versions of the texture map. I used these to drive the diffusion and bump channels.

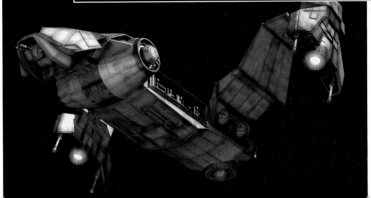

Creating Alien Landscapes

What makes a landscape an alien one? It could be the presence of extra moons or suns in the sky, strange lighting, large structures of extraterrestrial origin, alien plants and animals, or all of the above. The challenge for the artist is to make the landscape convincing and believable without getting too clichéd or corny.

In the case of *Swimmer* by Slawek Wojtowicz, the artist imagined a future scene on a distant planet, where only a few people are living inside the confines of tightly enclosed cities. These settlers have no access to the natural world that lies outside their walls. Wojtowicz proposes that the native ecology of the alien planet is far more likely to survive the onslaught of human civilization if humans are not allowed to roam around and expand at will.

In this future, while Earthlike planets are off-limits to individual settlers, the airless moons are open to aggressive colonization and construction. There are few, if any, limits on exploitation of natural resources there.

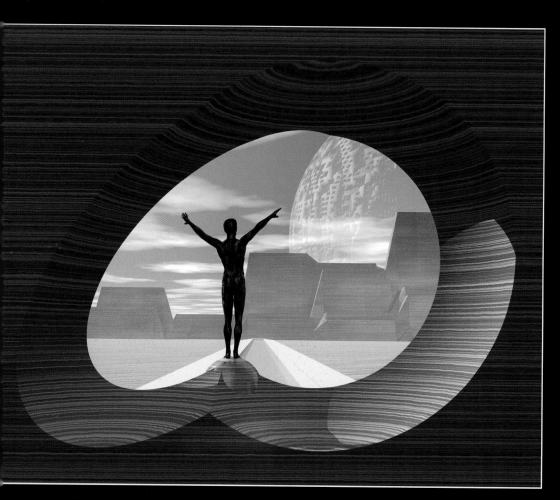

Swimmer

artist: Slawek Wojtowicz
software used:
Corel Bryce, Poser
by Curious Labs

Sky&Fog

Sky Preset 433

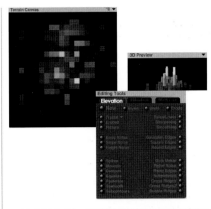

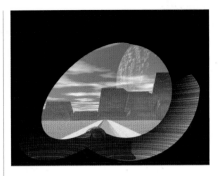

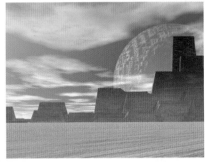

① I begin drawing my landscapes with some rough pencil sketches, capturing the essence of my vision, usually inspired by classical or New Age music. I then play with a layout and composition of main elements – still on paper. That process continues into the digital stage.

Bryce opens with a default blank scene showing the 3D space where you'll be working. If you like the sky and soil surfaces as they are, there is no need to change them. Otherwise, open the *Sky&Fog* menu and select one of the preset skies. The angle of light, colour of sun and a multitude of atmospheric attributes can be adjusted here.

② It was now time to create a moon that would appear to be totally covered with man-made structures. I inserted into the image a ball from the *Object* menu and added a custom texture to its surface. I enlarged the ball and moved it to the far back of the image, then adjusted the reflection and transparency to achieve a more convincing appearance of the moon.

③ To create the bunkerlike city, I used a shortcut. Instead of creating individual buildings, I created a generic mountain by clicking on the mountain icon at the top of the menu. I then edited that mountain with the *Terrain Editor* by pressing and dragging the *Posterize* function, while simultaneously holding down the Ctrl key. Then I positioned the object in the background and added a suitable texture.

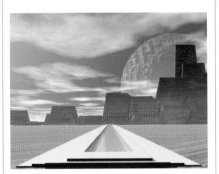

④ I then added the long, stone-enclosed aqueduct using preset water and stone textures. I usually create and save additional structures like this one in a separate file. This step gives me more flexibility to modify the image later if I decide that I don't like a particular aspect of an object. If the reflectivity of the water is off-key, I don't need to change the whole image.

⑤ The next task was to create an interesting shape to frame the window that the rebel swimmer will use to jump into the water. Although I had the shape drawn on paper already, the challenge was to create it with the relatively limited tools available in Bryce.

The window was built in three steps. First, I created a wall with the *Layered Rock* texture (the same preset that I used for soil) and changed its properties to *Positive*.

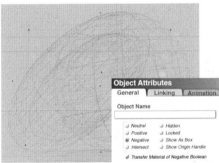

⑥ I then created a merged object consisting of a ball and egg, with the same texture as the wall. In *Properties*, I changed selection to a *Negative* object. Once the positive wall and negative object were merged together, the window with the desired shape appeared in the wall.

To balance the window visually, I added another small ball with the same texture and neutral properties and increased its reflectivity to make it look more interesting.

The final step was to create a human figure in Poser and to import it into Bryce. I placed it on the small ball in the window and played with different skin textures until I found one that I liked.

Futuristic Cities

How and where we will live in the future is something that science-fiction writers have had great fun exploring in the past, often predicting trends that we see today. Artists have built just as many cities of the imagination, and the futuristic habitat is an ever-popular theme in sci-fi artwork.

Besides landscapes, Bryce is an excellent tool for creating realistic 3D buildings. In *City*, Mirek Drozd used 3D primitives and procedural objects like symmetrical lattices to build an alien metropolis on the sea. Using the *Symmetrical Lattice* tool to model is a simple and handy process, but objects created in such a fashion can comprise a few to many millions of polygons, so a powerful computer is highly recommended for this approach.

Almost every element Drozd uses in his images is created only from Bryce elements, and he seldom uses imported objects. The demonstration that follows features many settings used by Drozd in the preparation of the image, which can be taken as a basis for creating your own city of the future.

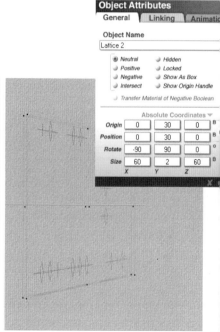

1 The first and most important stage is to make two pictures, which will be used to create the two main elements of our city, from a *Symmetrical Lattice* in Bryce. I used Photoshop, but any other bitmap-image editing software available should do the trick.

I made the strange objects/masks shown here by using the *Rectangular Marker* and *Elliptical Marker* tools to cut outlines from a white layer on a black background. I duplicated many simple shapes like squares, rectangles, circles and rings, transforming the individual elements repeatedly. Finally, I flattened all the layers and saved the image in greyscale mode. The size of each picture was 512 x 512 pixels.

2 Moving to Bryce, I went into the *File* menu and accessed *Document Setup*. I set *Document Resolution* to 800 x 600, then clicked on the *View Control* menu triangle-button in the main workspace window and chose *Camera View*. Deleting the Plane1 object, I saved the file four times. I named these files Apartment, Elevator, Building and City.

> **NOTE**
>
> In the following steps, when in Bryce I always kept the view set to *Camera View*.

3 To create the first element of the city, I opened the Apartment file. In the *Create* palette, I selected a *Symmetrical Lattice*. Clicking the A icon to reveal the object attributes, I set the following *Absolute Coordinates*: In *Origin/Position*, Y was set to 30 (unless stated otherwise, only the Y value of *Origin/Position* will be adjusted throughout this tutorial) and *Rotate* to X=90, Y=90 and Z=0. Then I resized the symmetrical lattice to X=60, Y=2 and Z=60. At this stage, the material was unimportant, so in the *Materials Lab* I applied Bryce *TerraCotta* from the *Simple&Fast* preset selection.

By clicking the E icon, I accessed Bryce's *Terrain Editor* and set the resolution to 1024 (*Massive Resolution*). Then, in the *Editing* palette, I clicked *Picture* and imported the apartment-shape image file prepared earlier.

City

artist: Mirek Drozd
software used: Corel Bryce, Adobe Photoshop

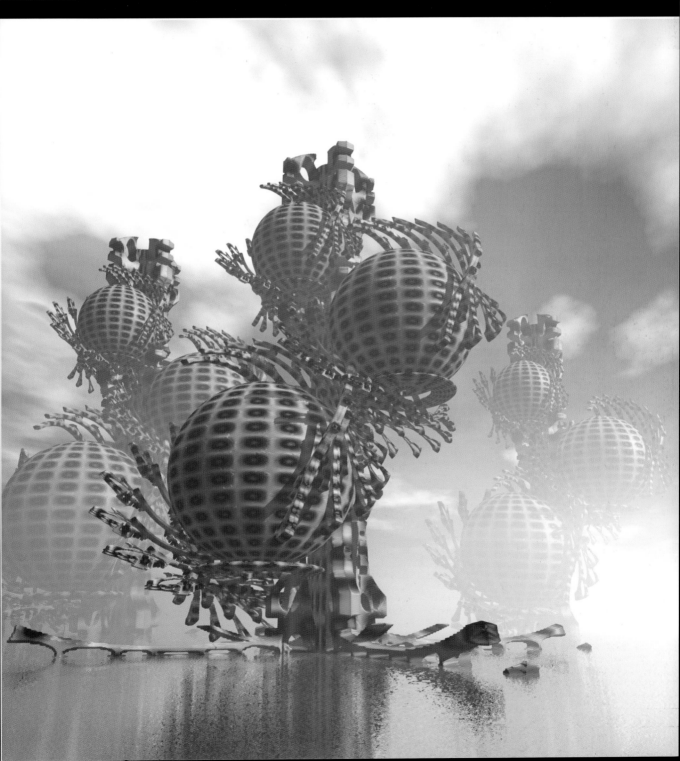

4 Next I tackled the replication process. Pressing Alt + Shift + D to bring up the *Multi-Replicate* dialog, I set the *Quantity* to 7, and *Rotate* as follows: X=10, Y=15, Z=-10. I left the *Size* unchanged and clicked *Accept*.

I then added a sphere and torus from the *Create* palette. Absolute coordinates and size for the sphere were: *Origin/Position*=33; *Size*: X, Y, Z=45. For the torus, the settings were as follows: *Origin/Position*=10; *Rotate*: X=-90, Y=0, Z=0; *Size*: X=30, Y=30, Z=2. After this, I clicked *Select All* from the main *Edit* menu, then grouped all the elements by clicking the G icon. The size was not important at this stage, so I went ahead and saved the scene.

5 To make the second element of the city, I opened the previously saved Elevator file with its empty scene.

Selecting a new *Symmetrical Lattice* from the *Create* palette, I gave it the following attributes: *Origin/Position*=30; *Rotate*: X=-90, Y=90, Z=0; *Size*: X=60, Y=2, Z=60.

Entering Bryce's *Terrain* editor once more, I clicked *Picture* in the *Editing* tools palette and imported the elevator-shape image file that I had prepared earlier.

Pressing Alt + Shift + D, I set the *Multi-Replicate* dialog's *Quantity* to 1 and *Rotate* to: X=0, Y=90, and Z=0. I left the *Size* unchanged and confirmed the operation. I added another element, a cylinder from the *Create* palette, and set its attributes to: *Origin/Position*=30; *Rotate*: X=0, Y=0, Z=0; *Size*: X=4, Y=55, Z=4.

Selecting all the elements, I grouped them as before and saved the scene.

6 Still in the open Elevator file, I selected the grouped object and copied it (Ctrl + C in Windows, Cmd + C on Mac). Opening the empty Building file, I pasted the object into it. I left the object attributes as they were and saved the scene.

Opening the Apartment file, I copied and pasted the grouped apartment object into the Building scene.

This apartment would be positioned low on the elevator, so I set the *Origin/Position* to X=-1, Y=18 and Z=7; *Rotate* to X=0, Y=-32 and Z=0; and *Size* to X=30, Y=32 and Z=26.

I then duplicated the first apartment and set the new attributes as *Origin/Position*: X=-9.50, Y=32, Z=-4; *Rotate*: X=0, Y=-32, Z=0; and *Size*: X=24, Y=26, Z=21. I now had the second apartment in the middle of the elevator. For the third and last element, I duplicated the second apartment and set attributes as follows: *Origin/Position*: X=-1, Y=44, Z=4; *Rotate*: X=0, Y=-32, Z=0; and *Size* X=18, Y=20, Z=16. I then selected all the elements and grouped them as before.

It was now time to apply a texture or material. I used Rusty Techno Grid – a free texture I found on the Web – but you can use anything suitable. I'd only suggest that it be something similar, a tightly woven, bright metallic net or grid on a dark background. Then the empty, dark spaces between the gridlines will imitate windows.

I set the texture-mapping mode in the *Materials Lab* to *Parametric* and saved the scene. I copied the saved object in the scene and closed the file.

Next was the *Cloud Cover* section. I turned on *Cumulus* clouds and clicked *Edit*. In the resulting *Deep Texture Editor* dialog, I clicked on the upper button in the *Combination* section and chose the *Sunset Clouds* texture from the *Clouds* list – I left the settings intact.

Back in the *Sky Lab*, I set the cumulus *Cloud Cover* to 100, the *Cloud Height* to 70, the *Frequency* to 50 and the *Amplitude* to 350. *Spherical Clouds* were turned on. In the *Sun Controls*, I turned on the *Link Sun To View* Option, set *Azimuth* to 110 and *Altitude* to 30 and changed the colour of the sun to white.

Moving to the *Atmosphere* section, I turned on *Haze* and set its colour to white, the *Density* to 20, *Thickness* to 20 and *Base Height* to 0. The *Color Perspective* was given the values of R=5, G=5, B=5. *Blend with Sun* was turned on, and its *Color* and *Luminance* were both set to 100.

My city scene was now complete, so I rendered it. I thought the resulting scene was a bit too bright, however, so I did some postwork in Photoshop to make it darker. You can also change colouring to make the scene more dramatic or add some light effects.

8 Using *Sky Lab*, I moved first to *Sky&Fog* and selected the *Simple Black Background*. In the *Sun & Moon* section, I turned on *Sun/Moon Visible* and set *Disk Intensity* and *Glow Intensity* to 100. The slider for *Sun/Moon Shadows* was set to 100 and the *Ambient* and *Sky Dome* colours were both set to white.

7 I opened the City file and turned off *Gamma Correction* in *Control/Render Options*. Clicking the grey triangle for *Control/Camera Options*, I chose *Edit Current Camera*. I set the following *Absolute Coordinates*: *Origin/Position*:X=-60, Y=50, Z=80; *Rotate*: X=-22, Y=150, Z=0. To change the perspective, I set the *FOV* to 60 and the *Scale* to 60.

To create the sea, I selected a *Water Plane* from the *Create* palette. I set its *Absolute Coordinates* as *Origin/Position*=15 and both the *X* and *Y Size* to 165. Entering the *Materials Lab*, I selected *Mercury Surface* from the *Waters & Liquids* materials.

I then pasted previously copied objects from the Building file into the new city scene. This middle building was given the following coordinates: *Origin/Position*: X=470, Y=460, Z=-815; *Rotate*: X=0, Y=40, Z=0; and *Size:* X=1045, Y=1000, Z=1045.

I duplicated the building and set the following coordinates: *Origin/Position*: X=3610, Y=1400, Z=-3090; *Rotate*: X=3, Y=10 , Z=0; and *Size:* X=3480, Y=3435, Z=3480.

A third building was created by duplicating the second structure, and the following object attributes were applied: *Origin/Position*: X=880, Y=1065, Z=-4800; *Rotate*: X=5, Y=35, Z=8; and *Size:* X=2780, Y=2735, Z=2780.

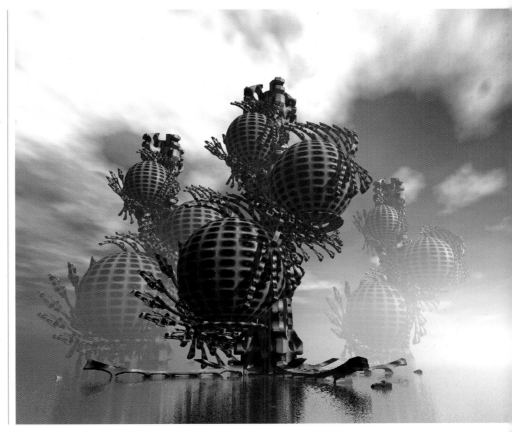

Life in the Future City

The huge cityscapes in films like *Blade Runner*, *The Fifth Element* and the *Star Wars* series have dazzled our senses and fired our imaginations. Even though it's impossible to visit these places, computer graphics allow artists to create their own versions of the metropolis to come.

One such experiment is a series by Rudolf Herczog depicting scenes taking place in a future megacity. Herczog's approach blends existing architecture and technology with the futuristic, the goal being to give the viewer something to relate to. In *Sub Levels*, Herczog offers a glimpse of the underground levels of his futuristic world. Doing his construction work in Bryce, Herczog uses Boolean operations for all modelling and rendering.

1 The idea for *Sub Levels* was to have a large underground shaft as the main setting, with light rays shining down from the ceiling. Once the rough details of the scene were finalized, I fired up Bryce and started to build a walkway. This was built in sections. I wanted to use flattened cubes for the floor and add Booleaned cubes with sloping edges for the undersides. Boolean modelling uses positive and negative primitives to create the shapes you want. When grouped, negative Booleans cut out a piece of the positive one. For the floor, I started by creating two positive cubes, placing them on top of one another and flattening them.

2 I then made two negative cubes, tilted them, and placed them so that they would cut off the edges of the bottom cube. Finally, I created four smaller cubes and put them halfway into the bottom cube. By selecting all the objects and grouping them, the negative objects (broken lines) could interact with the two main positive cubes (solid lines) and give the final shape.

3 The point of view of the scene is from a tunnel, connected to the underground shaft. For the railing, I used quite a lot of cylinders and spheres, modelling them in the same manner as before. Where they connect to the floor, I used smaller, slightly wider cylinders. Spheres were used for the bends of the top railing. At the end of the walkway, I used a cylinder to create the landing platform for the ship. Once the walkway was done, I started on the background wall.

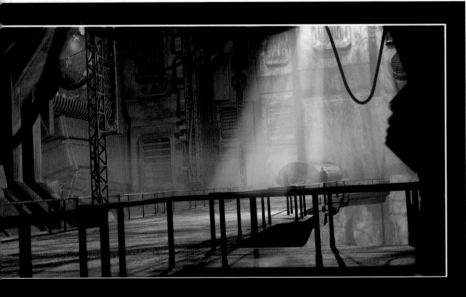

Sub Levels

artist: Rudolf Herczog
software used: Corel Bryce, Poser by Curious Labs, Adobe Photoshop, Universe Image Creator by Diard Software

4 I like irregularity, so when creating the wall, I wanted to imply that it had been built up repeatedly over time. Starting with a simple cube, I built a couple of bays and also used some rounded cubes embedded in the wall. Since I wanted to give the impression of old, uninhabited living quarters, I modelled several windows to attach to the wall. I used a number of these window models, stretching and resizing them to use as small vents in several places. I also modelled a few round vents with bars. These were made with one positive cone, hollowed out, and two negative cylinders and several small, neutral cylinders for the bars. These vents were easy to model, but very effective for use with walls.

5 I started on the tunnel surrounding the camera and the closest objects to the point of view. I used simple cubes to create something that resembles hangar doors for the left wall. Since I knew I was going to add some depth of field, I wanted to use some cables hanging from the ceiling, closest to the camera. To build cables in Bryce, you simply use small cylinder pieces. Make sure to add a thinner, dark cylinder inside the other one, to hide the gaps, then align them along a path.

Next I made a few beams with cylinders and put some cables inside them. I needed some old commercial signs as well, so I used a small application, Elefont, to create some DXF letters, which I imported into Bryce. I also imported a couple of Poser characters and an old spaceship model and placed them on the landing pad.

6 Finally, I did all the texturing and set up the lighting. Bryce offers an excellent materials lab where you can create really cool surfaces, but I mainly use photographic textures. I used one main rusty metal texture for most of the objects, and some different metal textures on details, like building parts, the platform and similar surfaces.

After choosing a suitable atmosphere, I used several ranged radial lights to light up different parts of the scene. For the light coming from the ceiling, I used an image with tree branches and a transparency map, and placed a strong radial light behind it. I was then ready to render the scene.

7 Even though I try to finish as much as possible inside Bryce, I do some degree of postwork on all my images, so once the render was complete, I opened up Photoshop. Depth of field can be applied in the latest version of Bryce, but it increases render time, so I decided to fake it instead with the help of layers. I opened up the finished render, then duplicated it. Next, I used *Gaussian Blur* (*Filter* > **Gaussian Blur**) to blur the layer. (How much blur you apply depends on your taste and/or the closeness of objects.) I added a layer mask on the selected layer, and with the *Gradient* tool set on *Multiply*, erased everything except for the cables and the walls closest to the camera.

8 I moved to the last part of the image, where I would add light rays to simulate sunlight shining down from the top of the shaft. This is an efficient way to add atmosphere to a scene. In Bryce, you can achieve this with volumetric lighting and get a very good result. However, it also increases render time considerably, and you can have a problem controlling the beams. Instead, I used Photoshop for the rays. With the help of a triangle shape and the gradient tools, I created a few rays and placed these where the light was strongest. Of five beams, I made one really wide to cover most of the lighted area, and softened it up with *Gaussian Blur* to simulate haze.

9 Since some rays covered parts of the constructions in the foreground, I created a layer mask for each ray and erased the covering parts. I wanted to keep the rays separate so that I could move them around if needed. Finally, I made some colour corrections in order to give the image a 'cold steel' look.

Distant Suns

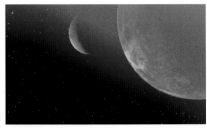

Star fields, solar systems and galactic vistas are a beloved staple of the sci-fi genre. For *Asteroid Belt*, Michael Loh created a space scene that contains asteroids, nebula clouds and planets, using just the basic functions in Vue d'Esprit. This is an affordable, powerful graphics-rendering package that contains all the necessary tools to create any environment, limited only by your imagination.

1 Vue comes with a number of atmosphere presets customizable to suit almost any environment a digital artist desires. When opened, the software presents you with a choice of atmospheres arranged in categories. To suit the space scene I wanted to create, I selected the *Outer Space* atmosphere preset found under the *Others* atmosphere category. This preset provides a black background with coloured stars sprinkled randomly in the sky. It also comes with a ground plain that did not fit with the scene I had in mind, so I deleted it from the *World Browser*.

2 The plain black, star-filled sky did not appeal, as I wanted my space scene to reflect the colourful nebula clouds you usually see in sci-fi films. To achieve this effect, I went into the *Atmosphere Editor*. Within the editor, I selected the *Sky* tab and edited the *Sky color map* by double-clicking from black to a band of several bright colours. This resulted in a more pleasing background, with the sky now represented by a band of overlapping colours.

If you want, you can play around with settings such as the *Color map position on sky dome*, *Sky color map distortion by sun* and *Fog in the sky* to redistribute the band of colours in the sky until you find a combination you like.

When Vue creates a new scene, the camera, by default, is pointing at the horizon. Reorienting the camera to point upwards brings more of the sky map into view. The image here shows a banded *Sky Map* with the *Camera* reoriented vertically.

3 There are several ways to create planets in Vue. You can use a sphere primitive and apply colour and bump maps to it, or you can apply a planet map onto a plane object, or you can just use the planet object that comes with Vue. The latter provides a selection of all the planets in our solar system. I chose to use two planets and positioned them in the scene accordingly.

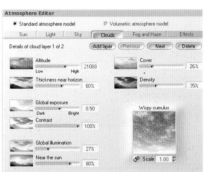

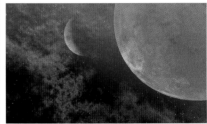

4 A space scene can never be complete without a nebula to add texture to the empty wastes of space. To get this, I used the *Clouds* feature in the *Atmosphere Editor*. Vue comes with a number of cloud presets suitable for nebula clouds. I first added a layer, then I selected the *Wispy cumulus* preset. This had the right amount of wispiness and cloud structure for the nebula clouds I had in mind. Vue allows for the stacking of cloud layers, which can result in very interesting cloud formations, but for my scene, I merely created two layers. Most of the clouds preset in Vue are white, but sci-fi nebula clouds are usually depicted in a variety of colours. Fortunately, Vue has a function to change the colour attribute of clouds, which works like the *Sky Map*. I experimented with several colour presets until I was satisfied.

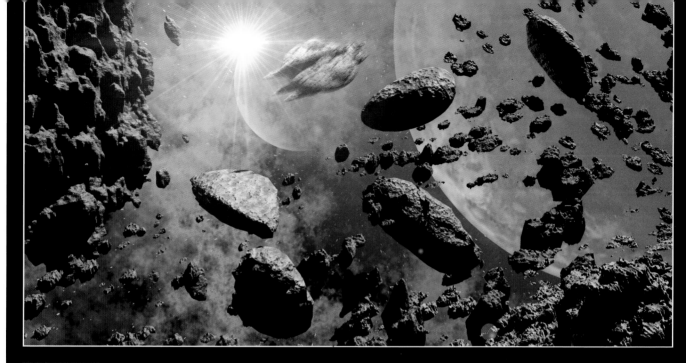

Asteroid Belt

artist: Michael Loh

software used: Vue d'Esprit by e-on Software

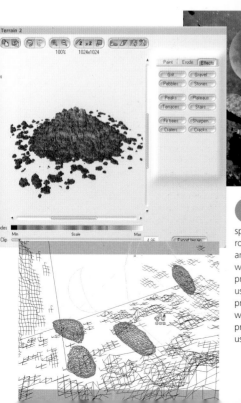

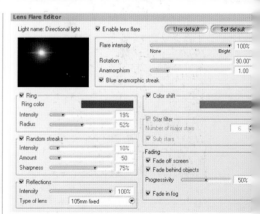

5 Asteroids can be created easily using the rock and terrain objects in Vue. For this space scene, I used four terrain objects and several rock objects and placed them in the foreground and background of the scene, as shown in the wireframe views to the left. Vue includes lots of preset rock and landscape materials, which can be used with the objects. I chose materials that I felt provided the necessary graininess and colour to work for the scene. This image sequence shows the process of building up the asteroid field gradually, using rock and terrain objects.

6 To dramatize the scene, a bright, shiny sun was added behind the far planet. This was achieved by adding a light object with the *Lens Flare* attribute set. The *Lens Flare* settings were then edited to produce realistic light streaks. A spaceship was also placed in the scene, taken from the model libraries included in the Vue d'Esprit package. Finally, to add a sense of motion to the spaceship, I used the animation features of Vue to create motion blur on the craft.

127

Digital Colouring for Comic Art

Some of the most cutting-edge sci-fi artwork can be found in comics. From Flash Gordon to Judge Dredd, sci-fi has always been a popular subject, and that popularity is still growing. The image on this spread was originally produced by Joe Benitez as an alternative cover for the Spilled Milk series

CiCi, written by Parker Smart. Sean Ellery found the black-and-white picture on the Spilled Milk website (www.spilledmilk.com) and set about adding colours to it just for fun. Here, using the Benitez image as a base, Ellery demonstrates the various steps needed to prepare and colour comic-book art in the digital domain.

1 I cleaned up the image in Photoshop by adjusting the Levels (*Image > Adjustments > **Levels***) until I had as clean a black-and-white image as possible. I made sure that the mode was set to RGB (*Image > Mode > **RGB***) to make use of the colour channels, then selected the blue channel and dragged it down to the copy icon at the bottom of the *Channels* palette. I renamed the new channel Alpha 1 and inverted the colours of this new *Alpha Channel* (Ctrl + I on PC, Cmd + I on Mac).

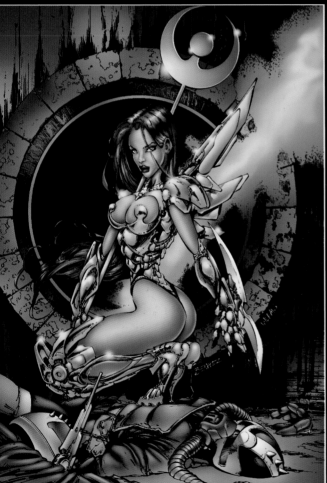

CiCi

pencils: Joe Benitez
inks: Joe Weems
color: Sean Ellery
software used:
Adobe Photoshop

2 I switched back to the *Layers* dialog box and deleted the original line-art layer. I created a new layer, selected *Load Selection* (*Select > **Load Selection***) and chose the Alpha 1 channel. I filled the image (*Edit > **Fill***) with a reddish-purple to show my selection of the entire black areas of the original line art.

© Copyright 2004 Spilled Milk®. CiCi® is a registered trademark of Spilled Milk® 2003.
All rights reserved. www.SpilledMilk.com

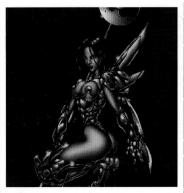

3 I created a new layer beneath the line-art layer and started to paint all the 'flats' of the picture. These are the broad block areas of colour that serve as the base over which everything else is painted. At this point, I chose a midtone for my colours, since I was to add darker areas and highlights later.

Because there is a distinctly separate background image, I used four separate flat layers consisting of the girl, the dead guy she's standing on, the rocks and water, and the sewer outlet background. These block in the major areas of each component of the picture and make it easier to paint the other sections without interfering with the foreground.

5 Next I painted in some faint, diffuse, muddy-purple shadows over the previous layer. This really deepened the shadows and made the other shades and highlights pop out even more. For this, I used my 200 custom brush and barely touched the edges of the brush to the side of the leg to get a very diffuse shadow effect. I then added a layer of very light skin tone to highlight the lightest areas, like the foreground thigh area. The final layer for the skin areas was used to add the secondary light sources. These can be just about any colour you like, since they indicate another light source of some kind. They are there to highlight the edge of the region and to give the picture a little extra pizzazz.

7 By now I'd completed all of the girl's armour, skin tones, lips and hair. The hair was highlighted by adding a section in a light tan colour, then using a small brush and the *Smudge* tool. I repeated this on another layer with an even lighter colour. Adding a very fine shadow on the piece of hair that goes over her face gave it even more depth. The lips were shadowed with a dark layer of red, then highlighted with a dot of orange and smudged to fit. For an even brighter highlight on the lips, you can also add a dot of white. As the armour is highly polished and reflective, I added very pale and diffuse green highlights to various sections and finally added some flare points to give it some 'bling bling'.

4 I've spent quite some time developing custom skin-colour swatches for my colour palette as well as the *Gradient* tool. I've also created a series of custom brushes by taking the default 100 brush setting and making two new ones at 200 and 300 settings on the diffusion level, but with all other settings the same.

For *CiCi*, I started painting in the darkest skin tones using the custom 200 brush, lightly brushing it past the edges in a series of passes until it covered as much of the area as I needed. In other parts, such as the main thigh in the foreground, I was able to use a custom gradient of skin tones. I added these dark tones to all of the skin sections.

6 I had to select each section of the armor individually with the *Lasso* tool and then use the *Gradient* tool set to *Circular* mode. The colours are a few shades lighter and darker than the chosen flat colour. The armour consumed the majority of the time it took to colour the picture.

8 I flattened the layers beneath the line art before beginning the same process on the background components. I used the *Smudge* tool on a small airbrush setting to gently rub colour into any areas not fully selected by the *Lasso* tool. For very small areas (such as the armoured outfit), I used the small airbrush to paint in a spot colour, then used the *Smudge* tool to push the colour into position. I then flattened all the colour layers beneath the line art before doing a final cleanup on a close zoom for any stray edges or bleeds of colour. I saved this as a separate file, then flattened the line-art and coloured layers together.

Weapon of Mass
Consumerism

artist: Philip A. James

The Gallery

4

The Gallery

Now you have seen some of the techniques and tools used by leading digital sci-fi artists, it's time to take a tour through some of their worlds of imagination. We could easily fill this entire book three times over with page after page of superb artwork, and the selection here is just a taster of what is possible with talent, powerful software, and an eye for what makes a great picture. If you want to see more, check out the listings on the last page, and enjoy your own journey through the realms of digital sci-fi art!

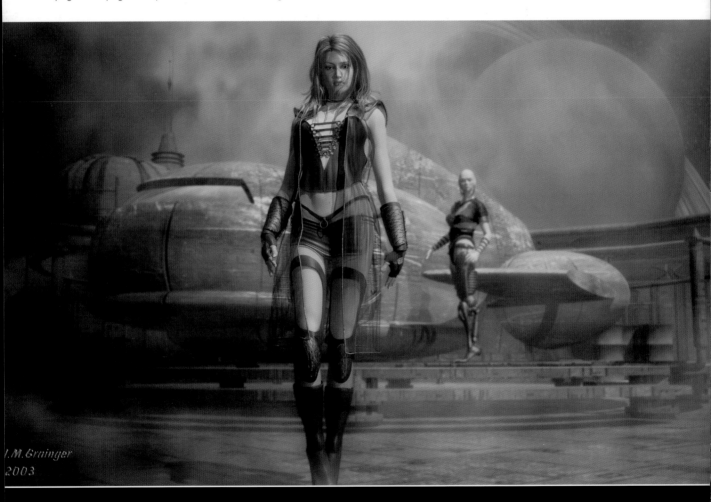

I.M.Grainger
2003

Planet Fall
artist: Ian Grainger

Savannah

artist: Kristen Perry

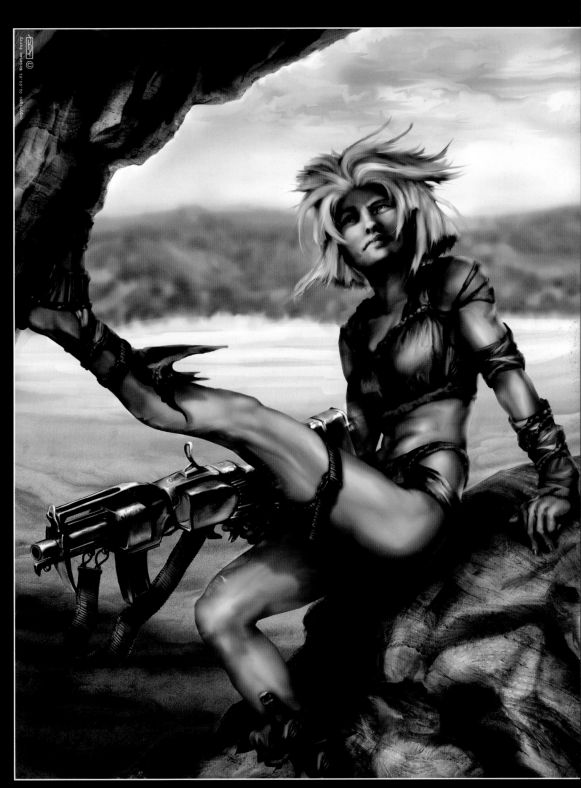

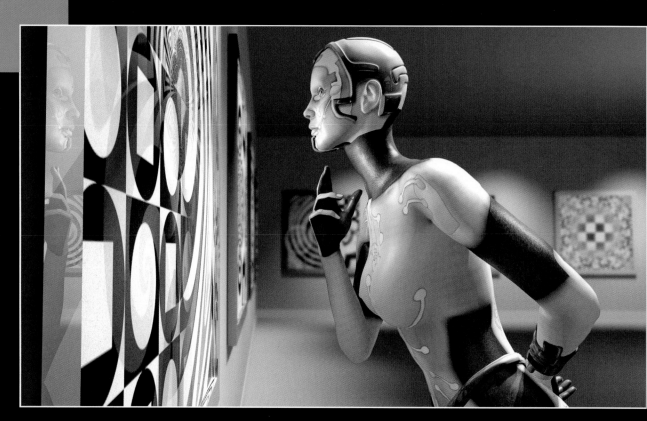

The AI Critic

artist: Adam Benton

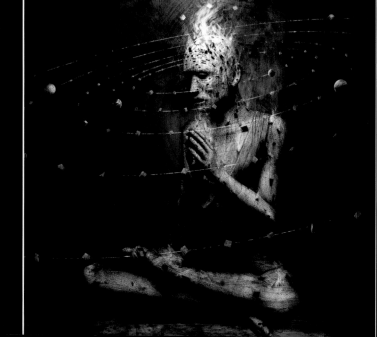

World Order

artist: David Ho

Origins 2

artist: Adam Benton

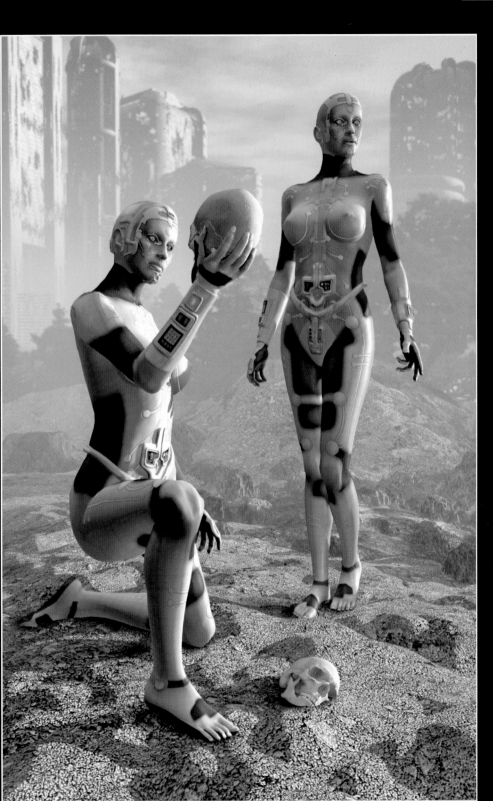

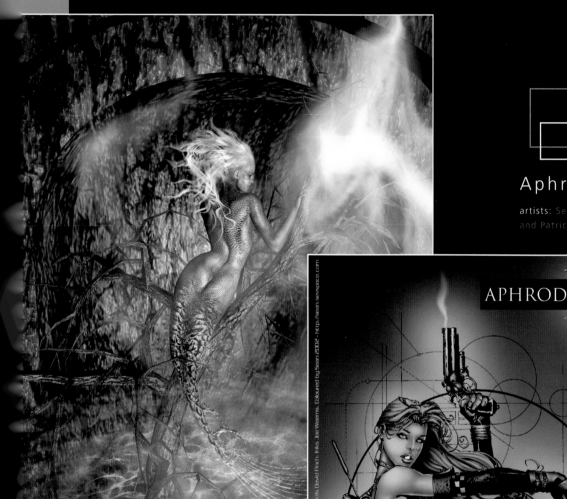

Pencils: David Finch. Inks: Joe Weems. Coloured by Sean 2002 · http://sean.sexyspace.com

Aphrodite IX

artists: Sean Ellery
and Patrick Blaine

APHROD TE IX

The Elements

artist: Michele Chang

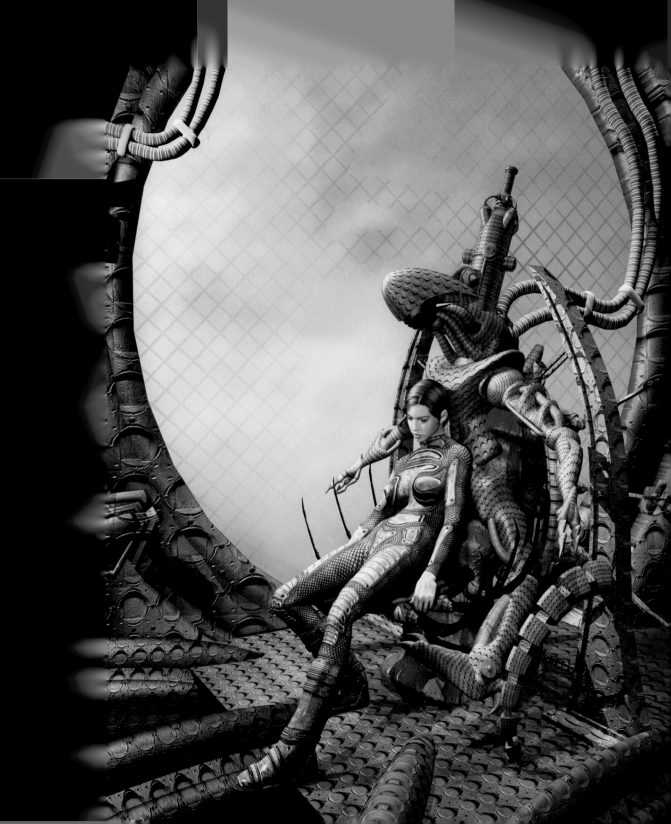

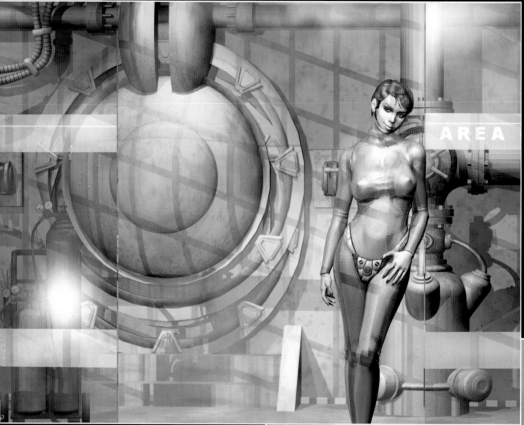

AREA

You Can Call Me Scotty

artist: Thomas Weiss

The Dealers

artist: Thomas Weiss

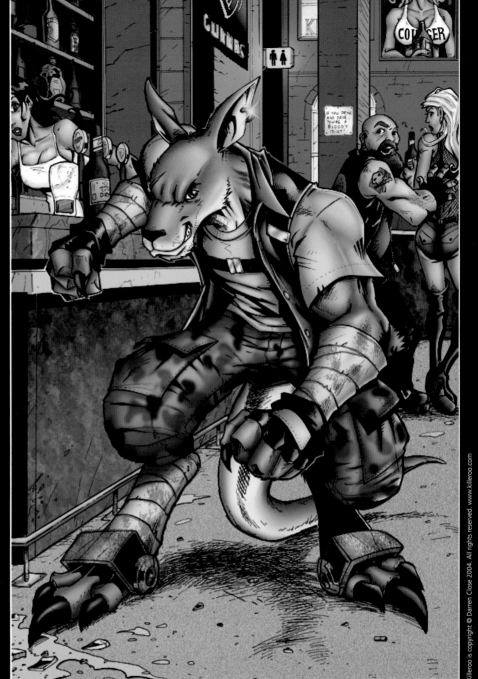

 Killeroo

artist: Sean Ellery

Killeroo is copyright © Darren Close 2004. All rights reserved. www.killeroo.com

Visitors from Earth

artist: Ian Grainger

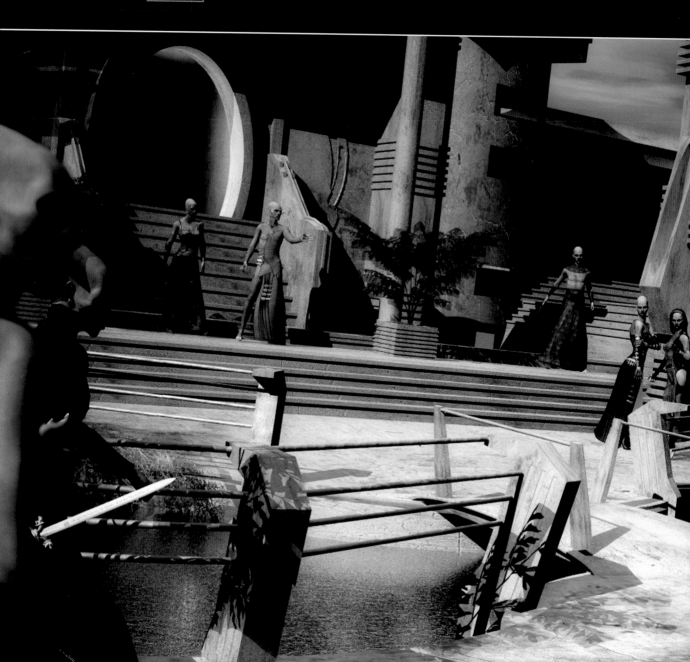

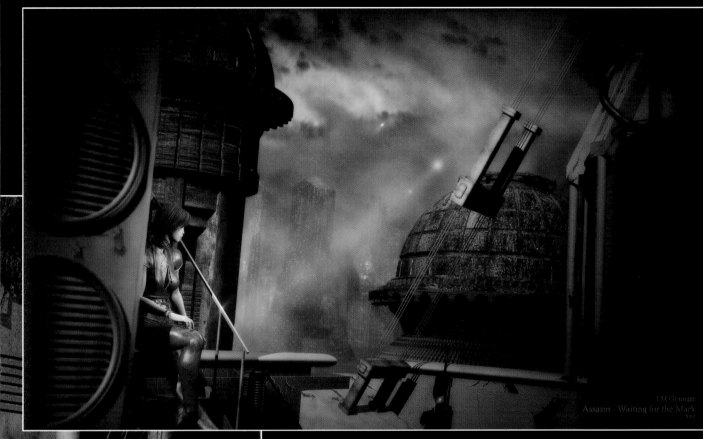

I.M Grainger
Assasin - Waiting for the Mark

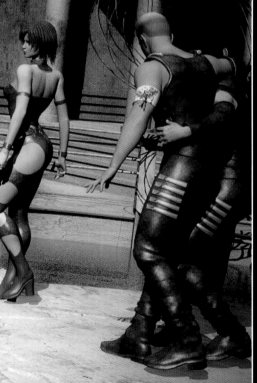

Assassin

artist: Ian Grainger

Suncatcher

artist: Mirek Drozd

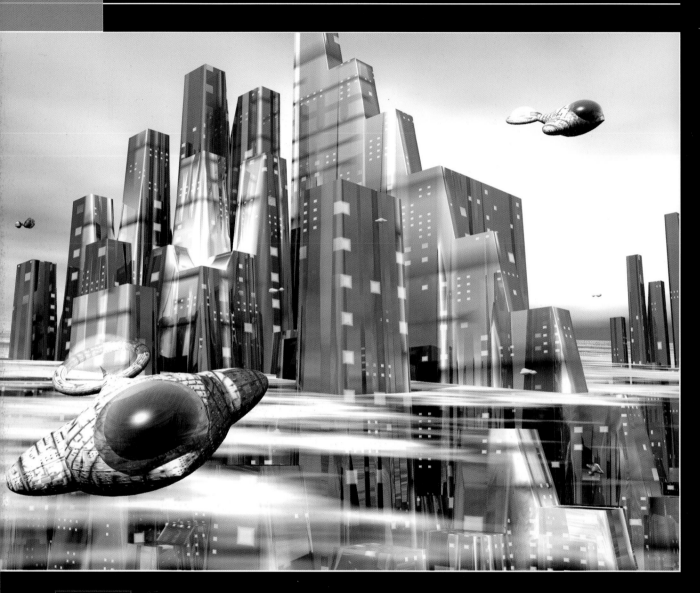

 City

artist: Slawek Wojtowicz

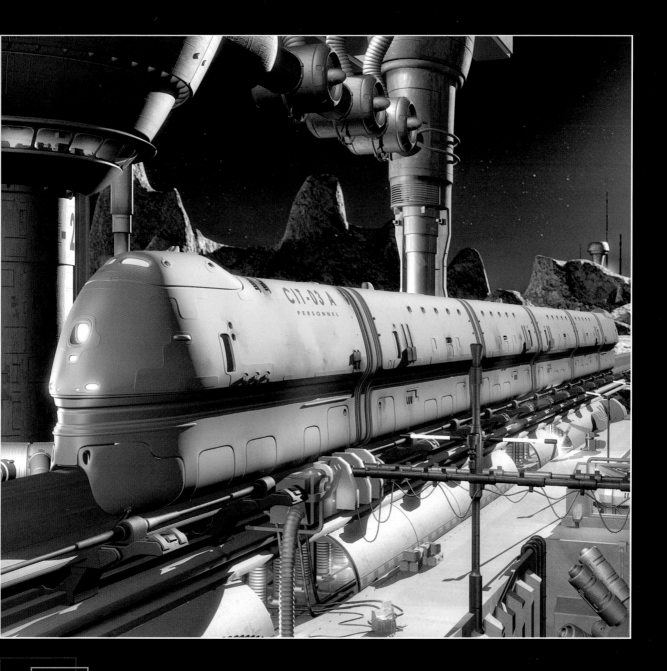

Outpost

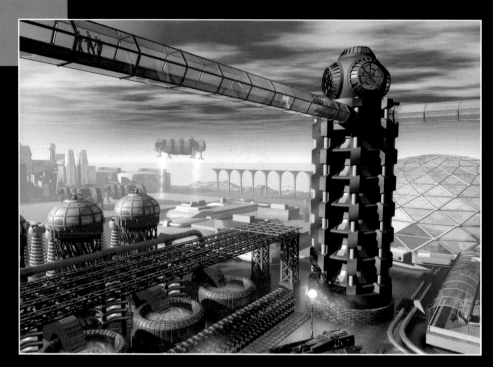

The Plant

artist: Robert Czarny

Alien Metropolis

artist: Robert Czarny

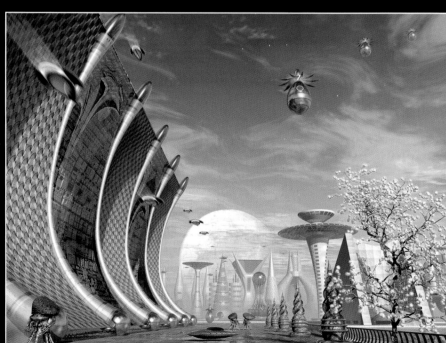

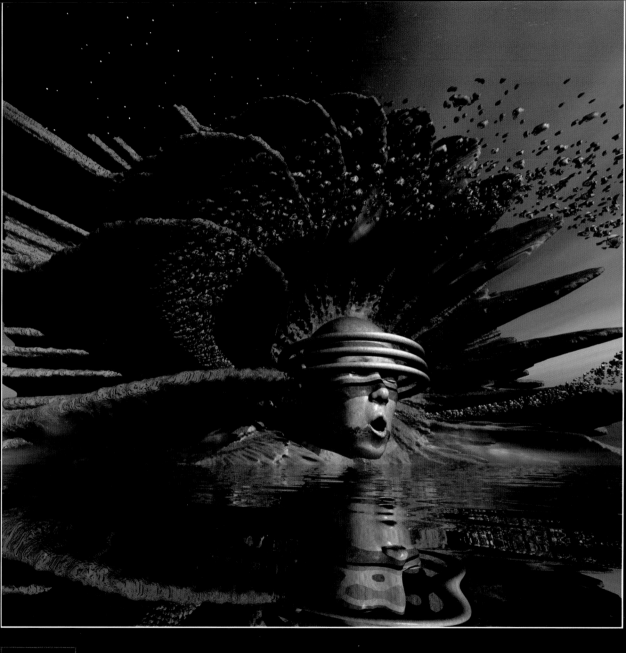

Siren Song
artist: Mirek Drozd

Patrol

artist: Dariusz
Jasiczak

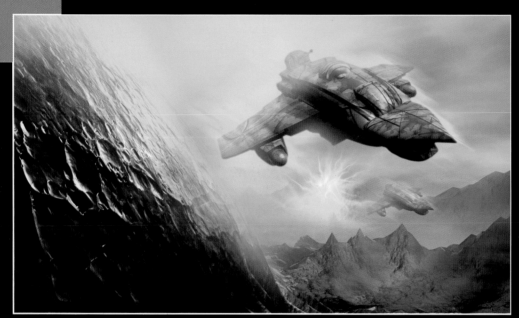

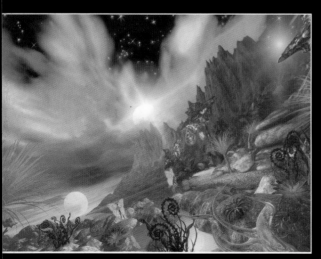

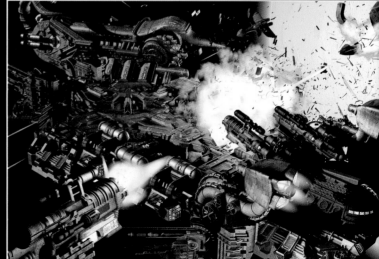

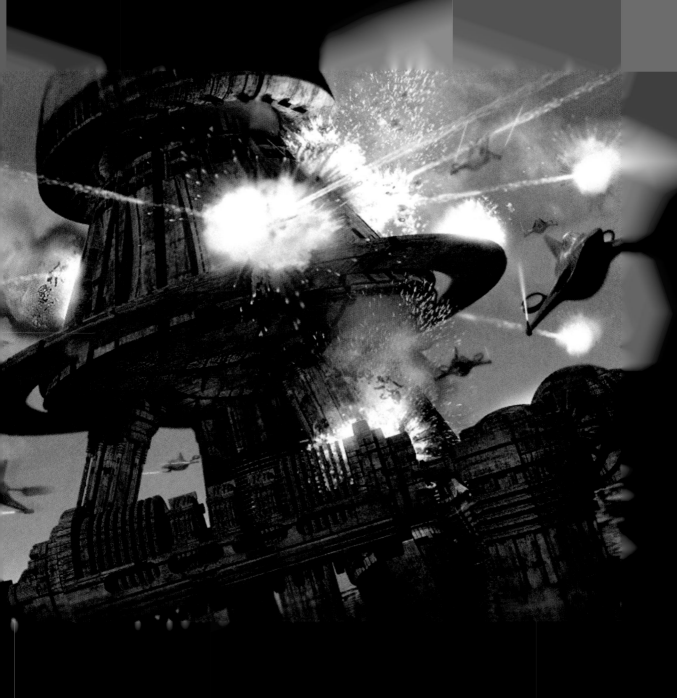

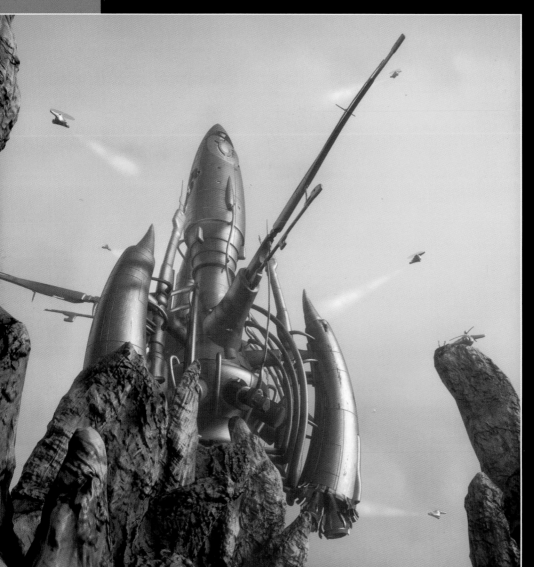

Machine

artist: Armin Schieb

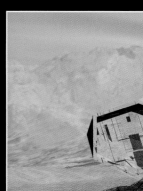

Aleph

artist: Armin Schieb

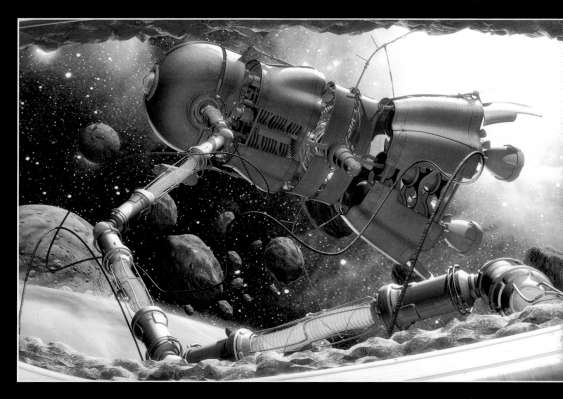

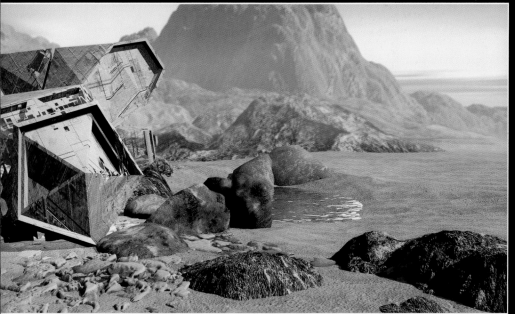

Pod

artist: Adam Benton

The Gallery

Statek 4

artist: Slawek Wojtowicz

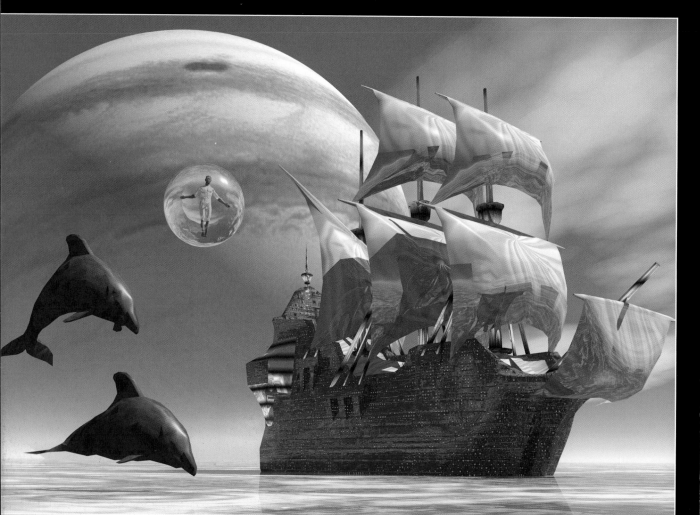

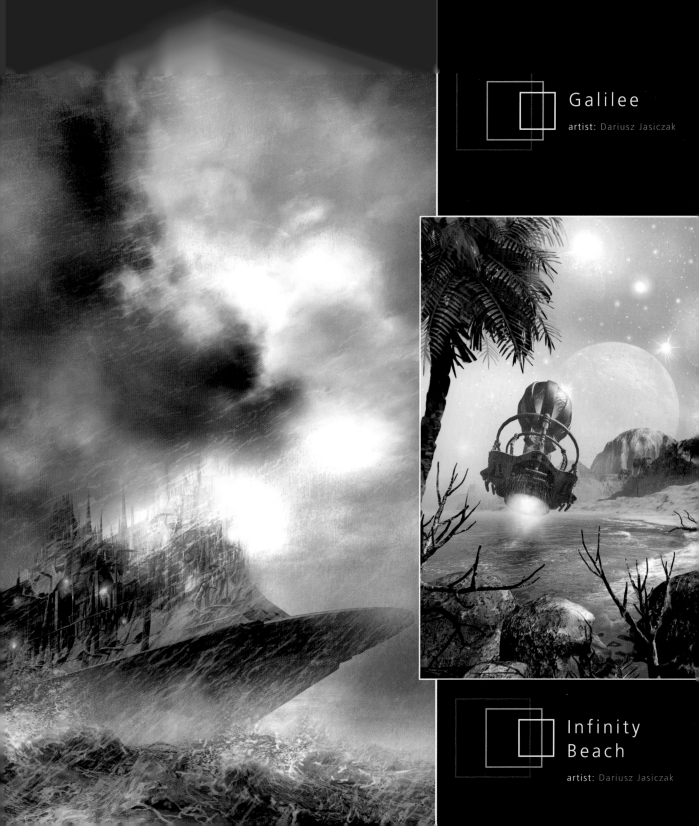

Galilee

artist: Dariusz Jasiczak

Infinity
Beach

artist: Dariusz Jasiczak

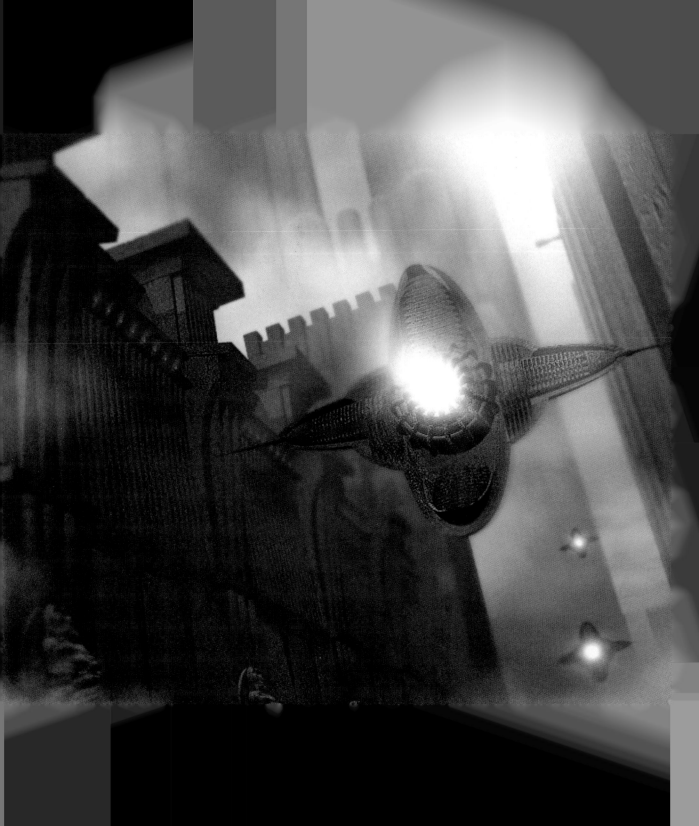

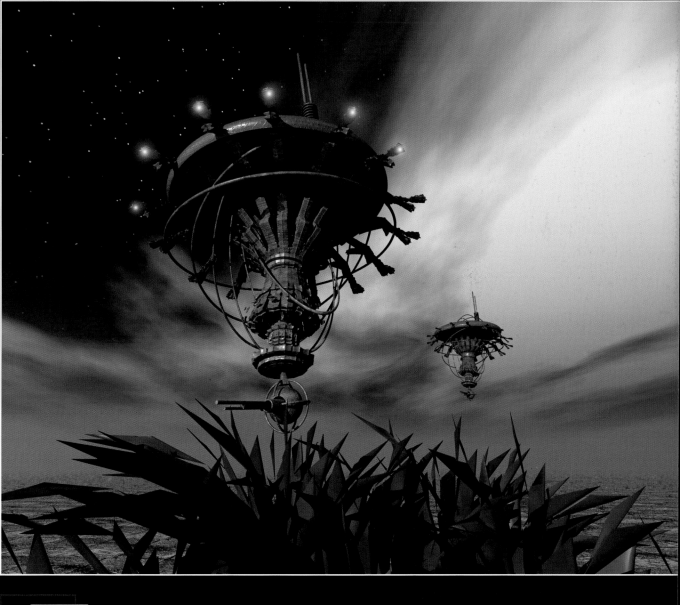

Visitors

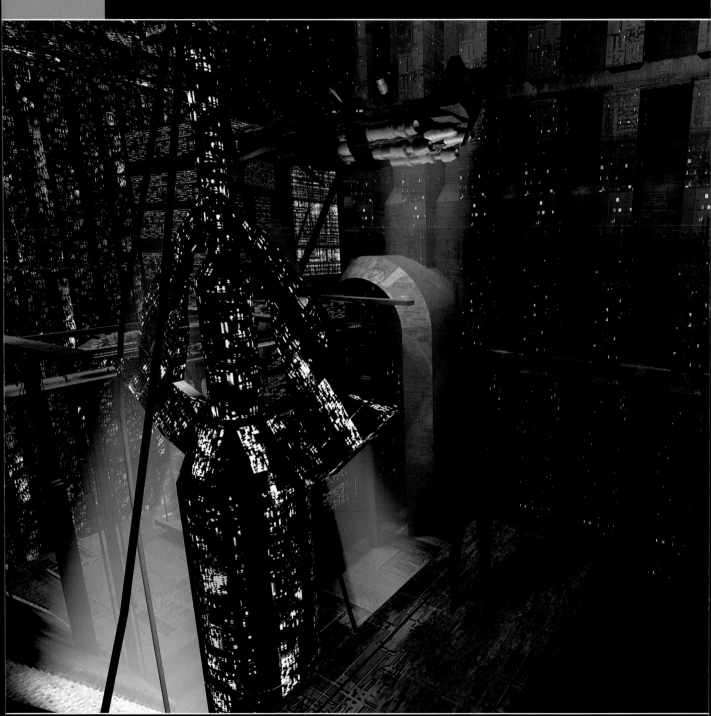

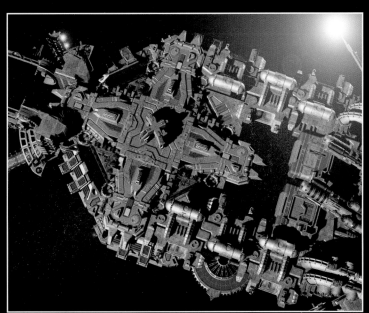

Before
the Impact

artist: Ivo Kraljevic

Megastruktur
Komplex 9

artist: Frank Meinl

Megastruktur
Komplex 1

artist: Frank Meinl

Sources

In the recent past, you would very likely have to have a commission from a record company or publisher for cover art for your work to be seen in public. The Internet and advances in personal computing has changed this, like so many other things. Artists can create artwork on a PC or Mac, build a website and have a personal gallery online – whether it's for personal pleasure or commercial necessity. Vast communal galleries also exist online, where members can display their creations (and even works in progress) and invite their peers to comment on their submissions. Among these online communities new 'names' have sprung up – renowned through recommendations and 'favorites' lists. While some of these artists have never appeared in commercial print form, they are the new leaders in the digital sci-fi art field. Some of them have kindly agreed to contribute to this book, but you'll find the rest and more in the following places:

ONLINE GALLERIES AND COMMUNITIES

Sites listed are merely useful examples of the many resources to be found on the Web. Many others exist, and new sites and communities continue to appear.

Renderosity
www.renderosity.com
Community, forums, massive gallery listing, and online store for digital artists.

Elfwood
www.elfwood.com
Huge not-for-profit site. Home to the online galleries of more than 1,500 artists.

Digitalart.org
http://digitalart.org
Gallery of more than 4,000 works of computer-generated art.

3D Artists
http://raph.com/3dartists/artgallery
Gallery site with large number of artists.

The Association of Science Fiction and Fantasy Artists
www.asfa-art.org
US-based not-for-profit community and gallery site.

CreativeCow forums
www.creativecow.net
Massive community of moderated forums for professional digital artists.

Information
Sites for discussion and information about 3D software and related issues, as well as commercial services.
3D Links – **www.3dlinks.com**
3D Cafe – **www.3dcafe.com**
3D Total – **www.3dtotal.com**

Highend 3D
www.highend3d.com
Industry news, events, Software updates, galleries and communities.

Digit
www.digitmag.co.uk
Online version of the cutting-edge mag for content creation, with daily industry news, reviews and tips.

Computer Arts
www.computerarts.co.uk
Tutorials, software downloads, and product news and reviews.

Computer Graphics World
cgw.pennnet.com
CG Industry news and reviews.

SOFTWARE USED AND REFERRED TO IN *DIGITAL SCI-FI ART*

Image Editors

Photoshop – Adobe
www.adobe.com

Painter – Corel
www.corel.com

Corel Photo-Paint – Corel
www.corel.com

The GNU Image Manipulation Program – GIMP
www.gimp.org

World Builders

Terragen – Planetside Software
www.planetside.co.uk/terragen

Animatek World Builder – Digital Element
www.digi-element.com

MojoWorld Generator – Pandromeda
www.pandromeda.com

3DEM – Visualization Software
www.visualizationsoftware.com/3dem

World Construction Set – 3DNature
www.3DNature.com

ScapeMaker – Matthias Buchetics and Dirk Plate
www.dplate.de/scapemaker /index_e.html

Scene Builders

Vue d'Esprit and Vue Professional –
e-on Software
www.e-onsoftware.com

Bryce – Corel
www.corel.com

3D Applications

Amapi 3D – Eovia
www.eovia.com

ZBrush – Pixologic
www.zbrush.com

Cararra Studio – Eovia
www.eovia.com

Cinema 4D – Maxon
www.maxon.net

Lightwave 3D – NewTek
www.newtek.com

Maya – Alias
www.alias.com

3ds max – Discreet
www.discreet.com

Rhino – Robert McNeel & Associates
www.rhino3d.com

trueSpace – Caligari
www.caligari.com

People and props

Poser – Curious Labs
www.curiouslabs.com

DAZ figures – DAZ Productions
www.daz3d.com/

Zygote models – Zygote
http://zygote.com

Dacort models – Dacort
www.dacort.com

Plug-ins

BodyPaint 3D – Maxon
www.maxon.net

Eye Candy – Alien Skin Software
www.alienskin.com

Shag-Fur and Shag-Hair – Leapfrog
www.leapfrog.co.uk

Operating System Suppliers

Mac OS – Apple Computer
www.apple.com

Windows – Microsoft
www.microsoft.com

Linux – Linux Online
www.linux.org

Index

Artist Acknowledgements

The author and publishers would like to thank the following for their contributions to this title:

Adam Benton
www.kromekat.nildram.co.uk

Jason Brynford-Jones
www.softimage.com

Roberto Campus
www.robertocampus.com

Christine Clavel and P.O. Boidard
http://christine.clavel.free.fr

Robert Czarny
www.graphique3D.republika.pl/

Mirek Drozd
http://tse60.digitalart.org

Sean Ellery
http://sean.sevspace.com

Mark Gibbons
www.scee.com

Rudolf Herczog
www.subspacegraphics.com

Ian & Dominic Higgins
www.livingposer.com

David Ho
www.davidho.com

Philip James
www.portfolios.com/jayjames

Dariusz Jasiczak
www.d-jasiczak.prv.pl

Soheil Khagani
www.renderosity.com/gallery.ez?ByArtist=Yes&Artist=soheil

Ivo Kraljevic
www.renderosity.com/gallery.ez?ByArtist=Yes&Artist=ivo-k

James Lee
www.renderosity.com/gallery.ez?ByArtist=Yes&Artist= jjsmlee

Michael Loh
www.e-maginaryarts.com

Frank Meinl
www.digitalwerk.rising-revenge.net

Daniel Murray
www.alpc.com

Cris Palomino
www.elektralusion.com

Lynn Perkins
www.lwperkins.com

Kristen Perry
www.merekatcreations.com

Jerry Potts
www.geocities.com/SoHo/Studios/1038/

Armin Schieb
www.3dluvr.com/drakath

Andy Simmons
www.andysplace.cwc.net

Glen Southern
www.southerngfx.co.uk

Byron Taylor
www.byrontaylor.com

Carlo Traversi
www.secretmorning.com

Eric Wadley
www.archetypal.com

Thomas Weiss
www.dreamlandworks.com

Slawek Wojtowicz
www.slawcio.com

Max Zimmermann
www.fiftyeight.com